INDIANA

FORGOTTEN HOOSIERS

PROFILES FROM INDIANA'S HIDDEN HISTORY

FRED D. CAVINDER

THE
History
PRESS

Published by The History Press
Charleston, SC 29403
www.historypress.net

Copyright © 2009 by Fred D. Cavinder
All rights reserved

First published 2009

ISBN 9781540220370

Library of Congress Cataloging-in-Publication Data

Cavinder, Fred D., 1931-
Forgotten hoosiers : profiles from Indiana's hidden history / Fred D. Cavinder.
p. cm.

1. Indiana--History. 2. Indiana--Biography. I. Title.
F526.C34 2009
977.2009'9--dc22
[B]
2009023592

Notice: The information in this book is true and complete to the best of our knowledge. It is offered without guarantee on the part of the author or The History Press. The author and The History Press disclaim all liability in connection with the use of this book.

CONTENTS

Introduction 7

American (Hoosier) Bulldog: General Walter Bedell Smith 9
Poet, Prophet and Philosopher: Max Ehrmann 17
Battling the Sin of Seriousness: Don Herold 27
The Sage of Potato Hill: Edgar Watson Howe 33
Hero in the Trenches: Samuel G. Woodfill 39
Old Borax: Harvey W. Wiley 45
Best Foot Forward: Dr. William M. Scholl 51
The Gentleman of the Press in Skirts: Janet Flanner 57
Cannonballing Coast to Coast: Erwin G. Baker 65
Byron of the Rockies: Cincinnatus Hiner "Joaquin" Miller 73
Spelunking and Spirituality: Horace Carter Hovey 81
The Jewell of the Wabash: Fred A. Jewell 91
The Mississippi Miracle Man: James Buchanan Eads 99
Beauty for Ashes: Mrs. Albion Fellows Bacon 109
Swing into Oblivion: Elmo Lincoln 115
Doughboys and Other Heroes: E.M. Viquesney 121
The Sage of Fort Wayne: George Jean Nathan 129
Finger Lickin' Recipe: Harland David Sanders 137
Pioneer, Showman, Promoter: Carl Graham Fisher 147
Politics and Poetry: John Milton Hay 155
The Reluctant Empire Builder: Alvah Curtis Roebuck 167
The Reluctant General: General Ambrose E. Burnside 175
Indelible Diplomatic Imprint: John Watson Foster 183

About the Author 189

INTRODUCTION

How quickly we forget the number of Hoosiers who have done important things in our culture. Part of the forgetfulness is generational; as the aging die off, youths find the recollection of past Hoosiers growing dimmer. More than the passing of torches consigns many Indiana luminaries to the dustbin of yesteryear. Hoosiers have touched so many developments—especially during the period of relatively slow progress before the space age—that remembering all of them is challenging.

Past Hoosiers have contributed to government, science, health, industry, arts and letters, music, the military and sports, and the list goes on and on. None of this takes into consideration the many movers and shakers who were not born in Indiana but rather came here during their productive years. This is offset, in its own way, by the many Hoosiers who spent precious few years in Indiana before going to prominence elsewhere. Abraham Lincoln, to use an extreme example, is a viable candidate for the Hoosier label; before rising to fame, he spent his youth in Indiana. Even Abe himself sometimes mentioned his Indiana period as "formative."

Countless others made fleeting imprints on the Hoosier spirit. Kenesaw Mountain Landis, the man who cleaned up baseball as its first czar, was a high school dropout at Logansport. But Landis was born in Ohio. Dr. John R. Hurdy, although instrumental in the organization of the Indiana Board of Health, also was an Ohioan. Author Rex Stout was born in Indiana. The Nero Wolfe creator only lived in Noblesville until he was one year old. He joked that he left "because I was fed up with Indiana politics." Herb Shriner—generally associated with Indiana by those who

still remember that droll comedian—was not a native; he said he "came here as soon as I heard about it." Clearly, deciding who among the former notables should be jogged into memory is a subjective task.

This volume tries to tiptoe through the maze of Hoosier accomplishments by choosing a few Hoosiers. Clearly, fame and accomplishment are close calls in many cases. Also clearly, no compilation of noted forgotten Hoosier could be considered remotely complete. Some of these Hoosiers have well-known names; the fact that they came from Indiana in the first place has lapsed in Hoosier memories. Whatever the reasons, all of these Hoosiers are worth remembering. You are welcome to make your own list of people from Indiana, beyond these, who should not be allowed to fall from the public consciousness.

American
(Hoosier) Bulldog

General Walter Bedell Smith

I am lost in admiration of your patience, ability and skill.
—note from General Dwight D. Eisenhower to General Walter Bedell Smith

Perhaps no Hoosier had a more pivotal role in World War II and is so widely forgotten as General Walter Bedell Smith. General Dwight D. Eisenhower called him the manager of the war. He represented Eisenhower at the surrenders of both Italy and Germany. An Indianapolis native, Smith had risen from private to four-star general without ever having attended West Point Military Academy or college. Even before the war, he was instrumental in a major army decision, although perhaps few realized its implications until later.

Smith, affectionately known as Beetle, was General Eisenhower's chief of staff. He was such an integral part of the Allied effort that, had there been television in those days, World War II might have been known as *The Ike and Beetle Show*. But before the war started, Smith was secretary for General George Marshall, chief of staff in the War Department. At one point during the job with Marshall, Smith recommended that the army purchase forty vehicles from the Bantam Motor Company. The vehicle became the jeep. Untold numbers were later purchased and used by the army.

The jeep was a mainstay of quick transportation for everyone from top officers on down in the war and for years afterward. Its name was later transferred to civilian vehicles, too.

A graduate of Emmerick Manual High School in Indianapolis, Smith had little public recognition, some say, because he never had

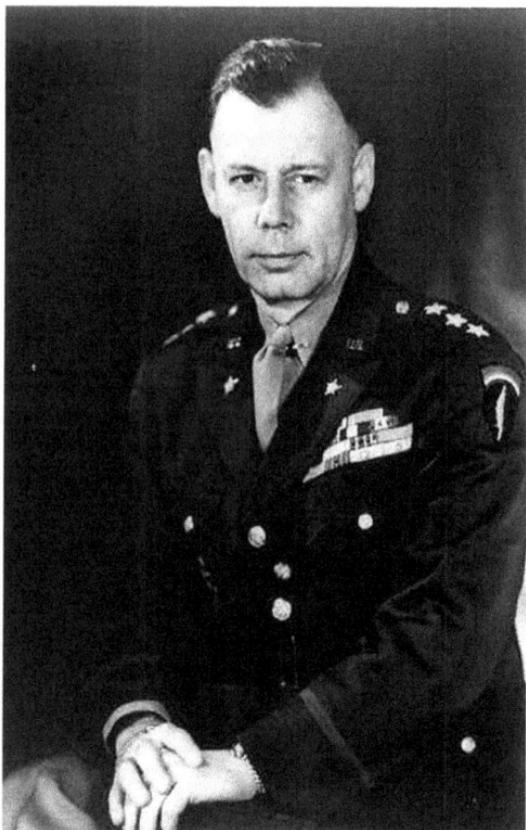

Walter Bedell Smith was wounded overseas in World War I but, as a general, supervised the surrenders of Italy and Germany in World War II.

an army field command. He labored mostly as an administrator, organizer, troubleshooter and expediter. The military gives more accolades to martial leadership as opposed to managerial skill.

Aside from that, though, Smith also was uncompromising, petulant, wrathful, stubborn and irritable. He was short tempered with underlings in his office, although he could be diplomatic with fellow officers.

Eisenhower called Smith the "best chief of staff ever." It may have been an exaggeration, but few had Smith's military experience. As Eisenhower's representative, Smith signed the Italian surrender document in September 1943, and in May 1945 he headed the group accepting the surrender of Germany in a schoolhouse in Reims, France. Smith's refusal to budge on complete surrender helped force the Germans to speed up their capitulation.

Immediately after the war, Smith was ambassador to Russia. He served a short time as director of the Central Intelligence Agency (CIA) (named by President Harry S. Truman), and Ike named him undersecretary of state in 1953. He was bitter, although he seldom publicly complained, that he had not received his fifth star as general nor had been named chief of staff or given public recognition.

The military always had been Smith's dream, but perhaps in the end it wasn't enough. "I always wanted to be an Army officer. I never thought about anything else, and my folks didn't have the money or the political contacts for me to go to West Point," Smith was quoted as saying.

Smith was born on October 5, 1895, to William L. Smith and Ida Frances Bedell, whose maiden name became his middle name. Smith attended Manual High School; later it moved to south-side Indianapolis. At Manual, Smith was trained as an engineer.

Smith joined the guard probably at the age of sixteen, though some sources say he was seventeen. He worked at several jobs: at a soda fountain for six dollars per week or as a mechanic. He enrolled in Butler University for a short time, but his father's illness caused him to leave. By the time he was eighteen, he was a sergeant in Company D of the Indiana National Guard.

One of his early assignments was to guard a bridge endangered by 1913 floodwaters. When Smith's uncle approached, curious about what his nephew was doing as a guardsman in the neighborhood, Smith barred him from the bridge. This firm obedience to orders helped gain Smith a recommendation to officer training camp at Fort Benjamin Harrison in Indianapolis, established with the onset of World War I to provide desperately needed officers.

On a short assignment overseas during World War I, Smith was wounded in the third battle of the Marne when shell fragments struck him during a machine gun attack. He came out of the war a second lieutenant. Between the world wars, Smith held staff and educational assignments in the military. And, as always throughout his career, he read widely, especially on military subjects. In 1925, Smith was assigned to the Bureau of the Budget as liaison between it and the U.S. Army. After four years there, he was sent to the

Philippines for two years. When he got back in 1931, he was sent to infantry school at Fort Benning, Georgia.

In 1933, Smith asked to be assigned to Command and General Staff school at Fort Leavenworth, Kansas. At the school were such later World War II military figures as Mark Clark, Matthew Ridgeway and Maxwell Taylor.

His graduation from there in 1937 ended Smith's formal education. Two years later, Marshall was made chief of staff in the U.S. War Department and sought a secretary. Omar Bradley, whom Smith had known at infantry school, recommended Smith for the job. Smith quickly became known for his skill at running headquarters and for being a master of detail. He made himself indispensable to Marshall. He also began to learn diplomacy, acting as Marshall's liaison with the White House. Some considered Smith "the toughest son-of-a-bitch in the War Department." He was, said one observer, "tougher than a 15-minute egg or a 25-cent steak, but a son of a gun who gets things done." He became Marshall's troubleshooter, decisive and tireless.

Smith liked hunting. He had a hunting dog named Sport and liked tying flies and, of course, fishing. He played poker and bridge and became, according to some, one of the best chess players in the army. Later, while coming out of a restaurant in Washington, D.C., while on Marshall's staff, Smith began to vomit. It was the first sign of an ulcer that would plague him the rest of his life.

With the dawning of World War II, Marshall chose Eisenhower as a field commander. Ike wanted a chief of staff and said that only four men in the army had the ability, and one was Smith. "From the moment of his appointment, Ike planned to have Smith as his chief of staff," said a biographer. Ike overcame Marshall's reluctance to part with Smith. "He is a natural-born chief of staff and really takes charge of things in a big way. I wish I had a dozen of him," Ike said.

In 1942, Smith's ulcer flared up, and he was hospitalized in England, but he checked himself out early. It was an example of his devotion to duty. At first, Eisenhower and Smith concentrated on the campaign in the Mediterranean. With the war winding down there, President Franklin D. Roosevelt began considering whom

to make commander of the Allied drive against Germany, named OVERLORD. Roosevelt named Eisenhower. During the start of planning for OVERLORD, even before he was made commander, Eisenhower was required to be away from his Mediterranean headquarters for months; he left Smith in charge.

Throughout the war and especially as the European invasion neared, Smith was in constant meetings with Allied leaders, including Winston Churchill and Charles de Gaulle. It was Churchill, due to many instances in which he saw Smith's tenacity, who dubbed Smith "the American bulldog."

Smith set up the Supreme Headquarters Allied Expeditionary Forces in London in 1944 while Ike was in Washington. Smith liked the British officers but did not care for the French. He disliked public speaking and press conferences.

Eisenhower gave Smith wide latitude. He also called him Beetle, a nickname picked up by everyone during the war. How that came about is obscure. As a child, Smith had been ill, and his family feared for his survival. He gained stoutness in his recovery. As a result, the family, which had always called him Bedell, began calling him Boodle. Somehow this later became Beetle.

Obviously, Smith was among the officers meeting with Eisenhower as they tried to decide whether the weather would break for the June 6 invasion date in 1944. The Allies were poised, and the weathermen said that a break was possible but uncertain. Said Smith, as one of the officers discussing the invasion, "It's a helluva gamble, but it's the best possible gamble." As the world later learned, Eisenhower took the chance, and the strike was made successfully at Normandy.

When it came time for the German surrender, Smith was an old hand at it. Smith signed the Italian surrender on Ike's behalf. As for the Germans, it was Beetle's show, Ike said. Smith had become as indispensable to Ike as he once had been to Marshall. At first, the Germans did not want to surrender on both the western and eastern fronts at the same time. They didn't want to surrender to the Russians. Eisenhower had already told Smith that the surrender had to be immediate and unconditional. Smith stood fast, and at 2:30 a.m. on May 7, 1945, total surrender was made. Smith then

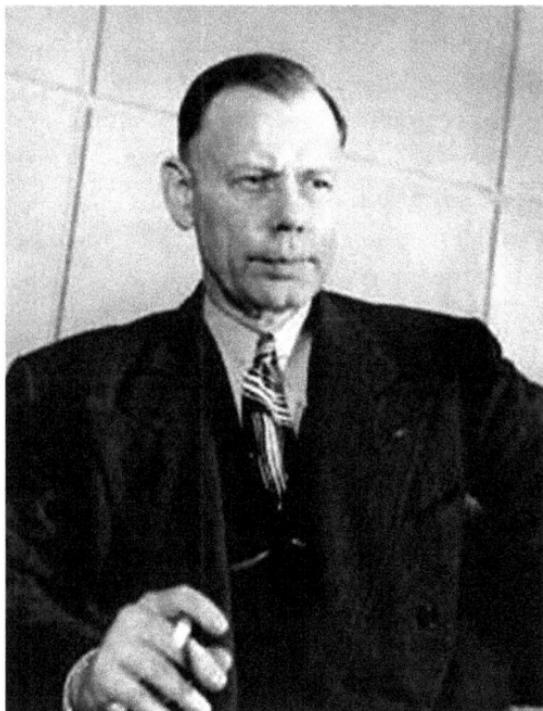

Walter Bedell Smith served as ambassador to Russia. "It serves those bastards right," said President Dwight Eisenhower, who appointed Smith to the post.

conducted German Field Marshal Alfred Jodl, the signer, into Eisenhower's presence to confirm the event.

In June 1945, Smith flew to Paris to be decorated and then flew to Bermuda. On a twenty-four-hour stopover there, he went fishing. On June 18, 1945, Smith flew to Washington and to a reunion with his wife, whom he hadn't seen since 1943. She was Mary Eleanor Cline, who had lived about three blocks from the Smiths in Indianapolis. The homecoming ended with a celebration in Indianapolis, which Smith had not visited in twenty-eight years. By this time, he was a lieutenant general.

After serving as ambassador to Russia, Smith commanded the First Army at Governor's Island, New York. He also wrote *My Three Years in Moscow*. In 1950, he became director of the CIA. In 1953, President Eisenhower named him undersecretary of state, serving under John Foster Dulles. He resigned and retired in 1954, bitter that his military career had ended with only four stars.

Smith worked for several businesses and served occasionally as a government advisor. If his army career had fallen short of a fifth star, his civilian career succeeded, aimed at making up for the financial rewards that were unavailable during his time in uniform. When he died, Smith's estate was worth about $2.5 million. Death came on August 9, 1961, in an ambulance en route to Walter Reed Army Hospital after a heart attack in his home. He was sixty-five years old and had been in the service for forty-three years.

Smith did have some honors, and one was unusual. Manual High School's ex-principal, E.H. Kemper McComb, checked in 1953 and found that Smith hadn't received his Manual diploma. Smith said it was because he had been "off somewhere with the guard." McComb sent the diploma to Smith, then head of the CIA. "I have received many honorary degrees from colleges and universities—doctor of laws, of military science, of letters. But I think I am proudest of all of that Manual diploma that it took me forty years to get," said Smith.

POET, PROPHET
AND PHILOSOPHER

Max Ehrmann

If, in an hour of noble elation, I could write a bit of glorified prose that would soften the stern ways of life, and bring to our fevered days some courage, dignity and poise—I should be well-content.
 –The Journal of Max Ehrmann

He almost became Indiana's forgotten poet. Max Ehrmann was a well-known and well-liked author in his native Terre Haute, where he lived his seventy-three years, rejecting the lure of bigger cities. But events conspired in the 1960s, more than fifteen years after his death, to threaten one of his best works with oblivion.

Even today, some mistakenly believe that "Desiderata" was found on the wall of a Baltimore church in 1692 and belongs to the ages. In fact, Ehrmann wrote "Desiderata" in 1927, a prose poem reflecting his outlook on life. It was among twenty-two books and pamphlets that he wrote during his fifty-year career. Much of his life was spent deceiving the outside world that he valued law and business above poetry.

"I soon found that I must pretend to be writing for money," he wrote, "and what is more, create the impression that I am making it."

"Desiderata" joins "A Prayer" as the hallmarks of Ehrmann's output. "A Prayer" also had a dramatic existence. It was written in Columbia, South Carolina, where Ehrmann was recovering from typhoid fever. Music from a dance nearby produced a mood of loneliness in the poet, and he rose from his sickbed to write "A Prayer." A friend rescued the prose poem after Ehrmann discarded it, and it was published in 1903.

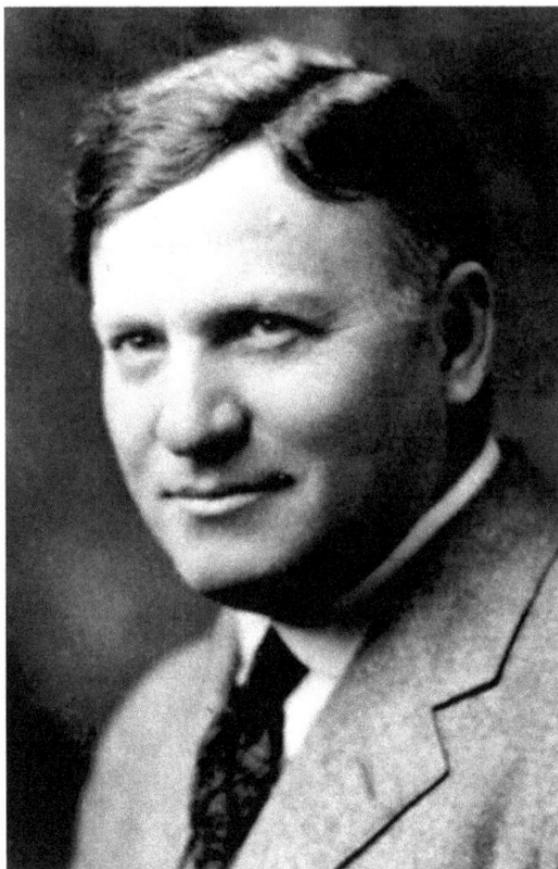

A reviewer once said that "*Desiderata* stands at the very head of devotional literature." *Courtesy of the Vigo County Historical Society.*

In 1904, "A Prayer" was exhibited at the St. Louis World's Fair. It was displayed along with James Whitcomb Riley's "When the Frost is on the Punkin" in the Indiana building. When "A Prayer" was stolen from its place of exhibition, it resulted in widespread publicity. It was printed in the Congressional Record in 1909 and has been translated into thirty-three languages and set to music.

"Desiderata" also has been used in hundreds of applications and set to music, making the Top 10 music charts in 1971. It has appeared on everything from placards to aprons and has been common on Christmas cards. It appeared in *Reader's Digest*, science fiction magazines and on the cover of a national Methodist Church magazine.

How "Desiderata" was mistakenly attributed to 1692 is mysterious. In the late 1950s, the Reverend Frederick Ward Kates, rector of Old St. Paul's Church in Baltimore, included the poem in a booklet of inspirational works, crediting Max Ehrmann. Parishioners evidently began using the poem, printing it on cards to pass around to friends. Eventually, people began asking the church about the poem, and the legend grew that it had been found on the wall years ago. Among those who inquired was Herbert A. Kenny, a book editor with the *Boston Globe*. He verified Ehrmann's authorship.

Ehrmann considered "A Prayer" the "most effective bit of work that I ever have done." "Desiderata" was also personally significant. He noted in his journal on January 1, 1936, "'Desiderata' shall be my guide. I wrote it for myself. It counsels those virtues I felt myself most in need of. To travel on serenely, doing one's duty and responding honesty to each day's problems is the right attitude."

In a sense, Ehrmann was a candidate to be forgotten. By all accounts, he was a man who lived austerely and simply. He never wanted fame or money, associates said. He shunned publicity and did not care for "things." The stuff of philosophy and the soul were his palette. The site of his birthplace is a parking lot without a plaque.

Ehrmann's first work, before he realized that he could not make a living writing, was *A Farrago* in 1889. It was a collection of writings about life at Harvard, where he was a student, which appeared in Boston newspapers. He also wrote plays, including *Jesus: A Passion Play* in 1917.

Ehrmann produced several pamphlets of poetry, including a scarlet women series on female foibles. He contributed to numerous publications of his era. It was said that his work was "prose that is truly poetry."

Ehrmann's life was remarkable in that he never lost his philosophical desire to see the world in its best light. He never forsook nature as a setting for seeking peace. His journal, which he kept from 1917 to 1936, concluded with a thumbnail of his creed: "Simplicity, sincerity and serenity."

Yet the Max Ehrmann outside of his books, outside the deep-thought ramblings of his journal, is elusive. The journal, as published in 1951 by his late-in-life wife Bertha Pratt King Ehrmann, gives scant attention to his private life, what foods he liked, what cars he owned and how he met and courted Bertha King for thirty-eight years.

Even names of his visiting friends are disguised with initials. He doesn't name professors who he commonly lunched with at Indiana State College (although Mrs. Ehrmann does in her biography, *A Poet's Life*). He never mentions his toupee, made of his own hair; his gold-headed walking cane; the dressing gown he consistently wore in his apartment; or his sources of money.

Max Ehrmann was born on September 26, 1872, one of five children of Maxmillian and Margaret Ehrmann. His brothers were Charles, Emil and Albert and his sister was Mathilda. A grade school teacher named Louis Peters inspired him to read. As an adult, his rooms in Terre Haute overflowed with books.

His father and his brother Charles opened a coal mining business. They were successful for a time and created a town called Ehrmanndale, Indiana, which at one time had some one hundred houses. Over the years it disappeared; people moved away and buildings fell into decay. Max worked in the offices.

Max's father died in 1893. At the time, Max was studying at DePauw University, to which he was sent by his brother Charles, a successful businessman who evidently saw potential in the youth. At DePauw, Max was a member of Delta Tau Delta fraternity and edited the *DePauw Weekly*. In 1938, he was asked to write an ode to the college's centennial. By that time, he had become fairly well established as a poet. He had foreseen his own future in a letter to his mother in 1895 in which he mused, "I have hopes to be a writer of books...I believe some day I might write a good one."

Ehrmann wanted to teach philosophy, but he rejected a job offer because it required a Sunday sermon on some philosophical topic. Throughout his life, he maintained a strong belief in God but an ever-weakening belief in formal religion. He thought church teachings were outmoded.

Thwarted at teaching, Ehrmann went to Harvard to study philosophy and law. There he began his writing, doing the series on campus life for the Boston newspapers. Max was editor of the *Rainbow*, a national fraternity magazine, and president of the northern division of Delta Tau Delta.

Although already distraught at "the dog fight that is called business," as he said, he took a job as a lawyer in the Vigo County prosecutor's office. He never quarreled with the need to earn a living, just the "brutal business world" that it involved. "For two years I was a deputy states attorney, dealing daily with filthy minds and bodies; for the witnesses against criminals frequently are of the same class," he wrote.

He considered public office as a Democrat. Eventually, he rejected politics as not befitting a poet. He became president of the Terre Haute Literary Club and gave a paper almost every year on a variety of subjects.

He escaped the criminal environment by becoming a lawyer and credit manager in an overalls factory operated by his brothers. His heart wasn't in it. "Had it not been for some other enterprise of the mind in leisure hours, I should have died," he wrote.

Meanwhile, Max accumulated bits of philosophy that later appeared in "Desiderata" on a table fashioned by his cabinet-making father. He was surrounded by books, busts of Dante and Shakespeare and a bronze paperweight of Buddha. Here also he began corresponding with Theodore Dreiser, a contemporary fellow Terre Hautean in whom Ehrmann saw great writing promise.

The poet had become settled in his hometown. By all accounts, he was a familiar sight on the streets and knew everyone from passing schoolchildren to the Terre Haute movers and shakers. He was remembered as a short, stocky, powerfully built man, usually wearing a derby hat, carrying a cane, well dressed, immaculate and, as many acquaintances remembered, "a real gentleman." Others considered him, in a kindly way, a delightful eccentric.

He traveled widely, although he didn't always enjoy it—to Greencastle, to New York in fall, to Florida in winter, to French Lick, which he called the Lourdes of Indiana, to a variety of cities for speeches and readings of his poetry. "I am washing myself

clean," he said during one stay at Turkey Run, "of the mental dust of the city."

Something happened about 1907 that was to change Max's life. Bertha Pratt King came to Terre Haute. She established a private school soon called King Classical School. She tutored all grades, from kindergarten to high school. However they met, King and Ehrmann seem to have been kindred spirits. She campaigned for women's suffrage, lectured and wrote on civic, literary and sociological problems for Terre Haute newspapers.

Ehrmann often expressed his strong belief in love, both platonic and physical, but his relationship with Bertha King is conjecture. Mrs. William J. Manning, who remembered him from the late 1930s, reported that it was common on Sunday for Max to pick up Bertha in his roadster, often headed for Deming Park on eastside Terre Haute for picnicking.

The poet told friends that when he was young, he could not support a wife. When he had acquired some financial security, he said that he thought he was too old to marry. Nevertheless, Ehrmann and King did wed on June 3, 1945. She closed her school at the same time. Within three months of the wedding, Ehrmann died during the night in St. Anthony's Hospital. Mrs. Ehrmann spent the rest of her days compiling and publishing his poems and unpublished material, including his journal. There were three editions of *The Journal of Max Ehrmann*.

The journal provided a lot of the data used in Mrs. Ehrmann's *A Poet's Life* in 1951; it denies the reader insight into Ehrmann's personality. "Both of us were deeply interested in the world in which we lived and in the work we did," wrote Mrs. Ehrmann. "He had his work; I had mine…He gave me many wise words about life and young people which I passed on. His need for a quiet life and solitude for his work I understood; he understood my love for my little institution. We had each other." It is the closest Mrs. Ehrmann came to a personal comment.

On summer nights we often sat on some high eminence, gazing in solemn silence upon the magnificent stretches of sky, watching the glorious pageant of the heavens. He often

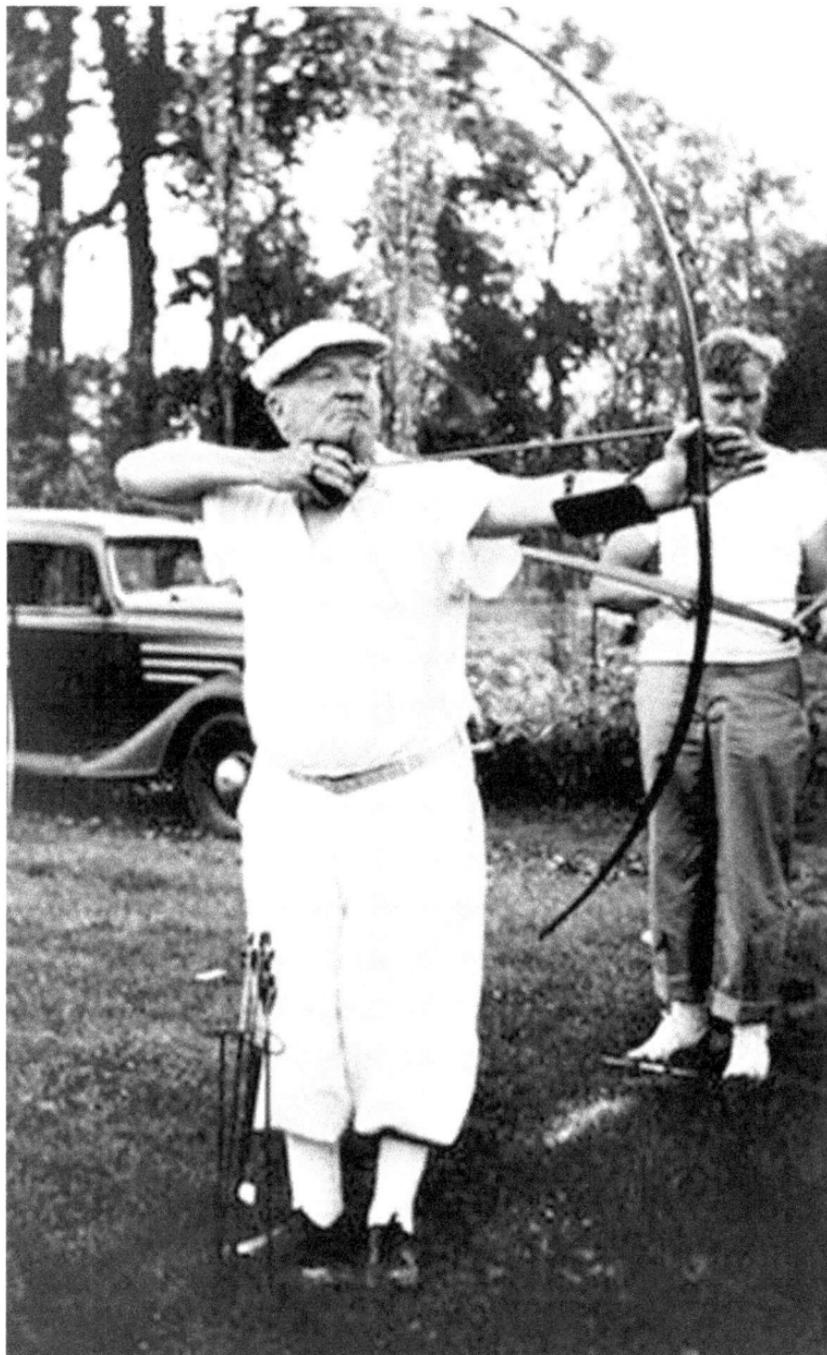

Max Ehrmann, the Terre Haute poet, enjoyed archery, probably in Deming Park. *Courtesy of the Vigo County Historical Society.*

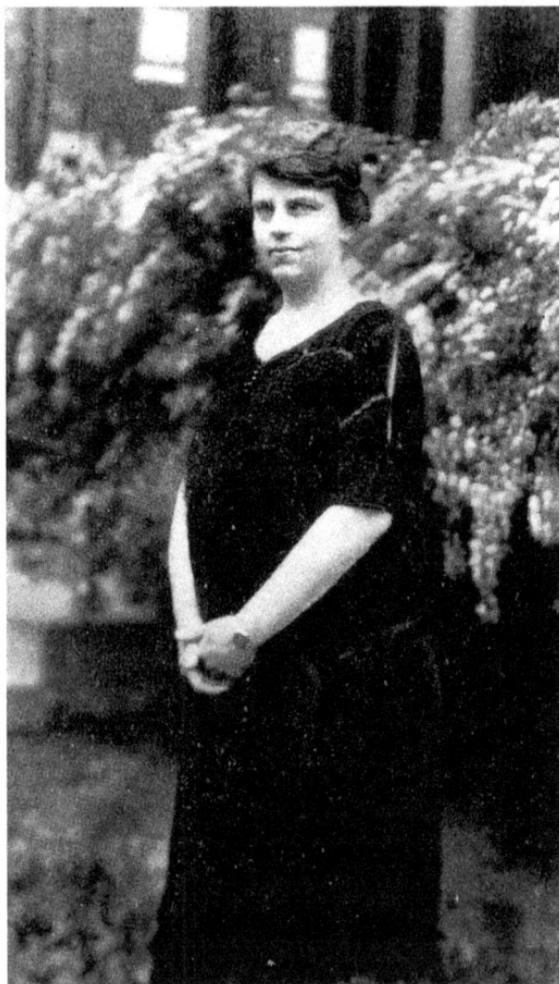

Bertha King Ehrmann had a long association with the Terre Haute poet. They later married. *Courtesy of the Vigo County Historical Society.*

said to me: We may be of no importance in this universe or in the cosmos, but we know we are of importance to those whom we love and we may make ourselves of some importance to our own group and community.

King died on January 16, 1962. Before that she donated a large number of her husband's manuscripts and papers to the archives of the Roy O. West Library at DePauw. Ehrmann material—most of it clippings, books and some letters—is also located in the collections of the Vigo County Public Library and at the Vigo

County Historical Society Museum. When Mrs. Ehrmann died, the copyright to Ehrmann's works passed to her nephew, Richmond J. Wight. In the 1970s, the rights were purchased by Robert L. Bell of Crescendo Publishing Co. of Boston, successor to Bruce Humphries publishers.

Ehrmann had few illusions about Terre Haute; he once wrote of it as a "smoky, commercial city that has not one bit of bronze or marble for the public eye—yes, even here let me keep my eyes open, my feelings warm, my understanding keen." He knew the town well, perhaps from his walks of thirty to forty blocks. Always keen on the outdoors, besides archery he skated, golfed, swam and played tennis as a youth. "I must keep my animal exercised," he said. He spoke in his journal of loving the Wabash River for fifty years.

Ehrmann sometimes wrote in the mornings at his table, but more often he wrote in the "midnight silence." He also worked under beech trees in Deming Park, listening to the "silent voice within." He once noted that maintaining his journal sometimes kept him from other writing. As he expressed it in a poem: "I somehow feel that I, poor fool, still do/ The work that's meant for me./ So on and on I write/ Into the night."

A former student at Browns Business College remembered taking dictation from Ehrmann in his room next door to the college. Ehrmann, unlike many others giving dictation, included every bit of punctuation, she remembered.

Nor was Ehrmann shy about his poetry. "He gave autographed copies to everyone who would stand still," said Dorothy J. Clark, the late secretary of the Vigo County Historical Society. "I don't know how many people brought them [copies of the poem] in to show us they were autographed by Max," she told a reporter.

Late in his life, Ehrmann offered a self-appraisal, deeming his early works "nothing." He preferred his later writing, such as *Breaking Home Ties*, a book of poems, and the plays *The Wife of Marobius*, set in ancient times; *Jesus: A Passion Play*; and *David and Bathsheba*. He also pondered his legacy: "May I not be ungrateful for the small public that reads and loves my writings. As time goes on, the number may increase. Perhaps even when I am dead, some browser in libraries

Max Ehrmann's grave has this simple tombstone in the cemetery just east of Terre Haute. *Photo by author.*

will come upon me, and, seeing that I was not altogether unworthy, will resurrect me from the dust of things forgotten."

Ehrmann was honored late in life at Terre Haute's Swope Art Gallery by professors, musicians, scientists, artists and friends. Dr. Allen M. Albert, then director of the gallery, read a tribute at the event on Sunday, June 25, 1945. Less than three months later, Ehrmann suffered a stroke. He died on September 9, within days of his seventy-third birthday.

Ehrmann was touched by the late-in-life tribute in his hometown, and perhaps it affirmed his writing goal. Once, when in a bookstore in New York City, he was bewildered at the mountains of volumes around him. He wrote in his journal of a hope, which almost died with the near oblivion of "Desiderata": "I would rather write one beautiful thing that might abide amid the perpetual flux even though I lived and died poor than to be the author of 40 commercial novels."

BATTLING THE SIN
OF SERIOUSNESS

Don Herold

All biographies are boresome to me until the grandparents are disposed of.
—Don Herold

He may have been the most widely read and least-remembered Hoosier humorist of his era. Don Herold certainly was the most widely read man from Bloomfield. When elected to the Indiana University Alumni Association, he proposed a chair of levity. He operated an advertising agency in New York City, although he didn't care much for Gotham and fled north of it. He worked for *Life* and *Reader's Digest* and wrote a dozen books, all humorous. What comes the closest to biography is Herold's *Strange Bedfellows; my crazy-quilt memoirs, life-maxims, and what-not.* It is a crazy-quilt of witty comments on Herold's life, life in general and contains only a few kernels of true biography. And those are suspect. In his seventy-six years, Herold produced dozens of epigrams, still appearing in quotation books and on the Internet.

Herold preferred play to work. He vowed to overcome the "sin of seriousness" and wrote about it in a *Reader's Digest* piece titled "If I had my life to live over." He wrote: "I would be sillier than I have been this trip. I know of very few things that I would take seriously."

In Bloomfield, after supper, on July 9, 1889, Herold came into the world to join two sisters born to Otto and Clara Herold. Bloomfield was a country community that Herold obviously loved. He wrote about its cisterns, livery stable, courthouse, country stores that lured idling citizens and the chickens in every yard—until they appeared on dinner tables.

Humorist Don Herald often returned to his hometown of Bloomfield, where the library had a section designated Don Herald Corner. *Courtesy of the Bloomfield Public Library.*

Herold spent a lot of time around Asbury Haines's barbershop, drawing pictures of those passing by. He was shy and devoted to his dog Flirt, which he bought with two dollars earned at a street fair. In high school, he published a newspaper called *Fleas*. He wrote a play his junior year called *Then*. Herold was editor and illustrator in 1907 for the *Owl*, the first Bloomfield High School annual.

That fall, Don's father sent him to Indiana University; he did not wish to be there. He had other plans. Herold dropped out of IU to attend the Chicago Art Institute—he had wanted to go to art school—but how that was arranged seems unclear. Later he returned to IU after working on the *Los Angeles Herald* as a reporter/cartoonist. He didn't graduate from IU until 1913.

"I don't believe college did me any permanent harm," he joked later. In 1912, he was editor of *Arbutus*, the IU yearbook, which

contained Herold's deft touches of wit. Introducing the drama section, Herold wrote, "Actresses can happen in the best of families." Other *Arbutus* comments included: "The love game is never called on account of darkness"; on music: "If you have lived with a cornet player, you can stand anything"; and on sports: "The Comedy of Errors is never appreciated when put on by the home team." In the senior annual, Herold wrote, "I stayed at I.U. for many years and finally established enough nuisance value to induce the university to give me an A.B."

Herold worked for a time at the *Indianapolis Star*, where he produced full-page comics for the Sunday paper. He also worked three years in Indianapolis for the Hollenbeck Press as an advertising writer. While there he wrote and sold pieces and pictures to magazines in New York City and soon moved there himself.

The city was a fertile spot for his creative output but otherwise undesirable. He called the city "a calamity and a pestilence unto itself." Herold and his family moved to Bronxville in Winchester County north of New York City.

One of Herold's major enterprises was the Don Herold Company, Inc., a direct-mail advertising firm. He also completed numerous industry booklets, such as *So You're Going to Be an Engineer* for college freshmen and *Freight on the Nose* for the B&O Railroad service. He did columns for house organs. He produced a handbook for *Reader's Digest* employees. Often the works and ad campaigns included his cartoons.

Herold married Katherine Porter Brown, an Indianapolis art teacher, in August 1916, the same year he moved to New York. Daughters Doris (1918) and Hildegarde (1925) both became copywriters in New York. For a time, Herold wrote a syndicated newspaper column. He served as dramatic and movie critic for *Life* magazine for twelve years and was associated with *Reader's Digest* near the end of his career. Meanwhile, he found time to write *So Human* and *Bigger and Better* (both in 1924), *There Ought to Be a Law* (1926), *Our Compassionate Goldfish* (1927), *Strange Bedfellows* (1930), *Doing Europe and Vice-Versa* (1931), *Typographical Handbook* (1946), *Love That Golf* (1952), *Drunks Are Driving Me to Drink* (1953), *The Happy Hypochondriac* (1962*), Humor in Advertising* (1963) and *Adventures in Golf*

29

How to Choose a Slide Rule

by don herold

During his long career in advertising and writing, Don Herald often portrayed himself in his cartoons, as on this book.

(1965). He also co-wrote a musical called *Crazy with the Heat*. His output was, by any measure, startling.

Images in Herold's artwork often closely resembled himself. The Herold "character" had a round, bald head with only a vague suggestion of hair, precariously perched glasses and a nose as pointed as his discourse. The Bloomfield one-man-band disliked going to the office and the office routine. He wrote: "A man who attends to his morning mail in the morning is letting other people decide how he is to spend his day." He began working at home.

Herold liked cigars and took up golf when he was about forty-five; Bloomfield lacked a golf course in his day. In his book *Love That Golf*, Herold suggested that golf clubs should have a consulting psychiatrist and psychoanalyst. In *Drunks Are Driving Me to Drink*, Herold noted that he was not against drinking, only against drunks (he had an allergic reaction to alcohol).

Herold was national president of the IU Alumni Association from 1943 to 1945. He felt that his presidency required a stated policy. So he favored "abolition of the common head-cold, extermination of ragweed and for lower berths in banquet tables." Also, he said, "I am for the establishment of a Chair of Levity in the University." In 1945, he was president of the Sons of Indiana of New York.

His affection for IU and his prominence as a humor writer brought him to Bloomington in July 1946 to speak on the topic "Should Writers Live in New York or Stay in Bed?" His subject originated, he related, because an illness resulted in appreciation of life on the percales; his book *Strange Bedfellows* was covered in what resembled bed ticking. The best thing about writing in bed, he said, was the lack of interruptions and the lack of a typewriter. Without a typewriter, he said, fewer unneeded words are written.

In June 1954, Herold was in Bloomington to receive IU's Distinguished Service Alumni Medal, as one of eighteen living past presidents of the Indiana University Alumni Association. Learning that Herold was coming to the state, the City of Bloomfield set up Don Herold Day on June 15. He had visited home frequently and mentioned it often in his writing. Twelve of the twenty-three members of his class of 1907 greeted him outside town with a

horse, instead of the usual celebrity Cadillac, and placed a sign in the high school saying "Don Herold Slept Here."

In introducing Herold, IU president Herman B. Wells gave his favorite Herold quote: "The most comfortable persons on a hayride are the horses." He could have cited many, still often appearing today in books of quotations: "Funerals are a lost art in the big cities"; "I had, out of my 60 teachers, a scant half dozen who couldn't have been supplanted by phonographs"; "Intellectuals should never marry; they won't enjoy it, and besides, they should not reproduce themselves"; "What this country needs is a clearinghouse for coat hangers."

Herold died on June 1, 1966, in his house at Vero Beach, Florida, where he spent winters, keeping busy at the drawing board even there. Herold, seventy-six years old, was cremated. The *Indiana Alumni* magazine noted his passing with an article one and a half pages long, including the note that he hated obituaries and didn't want his run. The magazine reported that one publication had quoted Herold as wishing this epithet on his tombstone: "I kept telling you I haven't been feeling well."

Since he also had once said the epithet should be "So this is Paris," it proves his lifelong attitude that every subject deserves more than one droll comment, which he demonstrated in his writings. Said the alumni magazine: "In reality, Mr. Herold is not dead. His books and cartoons will live for centuries." Unfortunately, many of his fellow Hoosiers have forgotten that he wrote them and drew them.

THE SAGE OF POTATO HILL

Edgar Watson Howe

I have never been one of those severe critics who expects the people to be without faults. All I recommend is reasonable effort in getting rid of the worse ones, and decent attempt to hide the remainder.
—Edgar Watson Howe

If Edgar W. Howe hadn't become a printer, the world probably never would have heard of him in the first place. But in Howe's time, material that he wrote in his Kansas newspaper, the *Atchison Globe*, and his widely circulated *E.W. Howe's Monthly* was quoted in newspapers and periodicals around the world. His wit and wisdom caused him to be dubbed "the Sage of Potato Hill." He once appeared in journalism textbooks. He was touted for governor and also for Congress—and declined out of hand.

Although he mildly protested the labels, Howe was a severe critic, pessimist and misogynist, who decried much in society. With his barbed pronouncements—just preaching common sense, as he put it—this Hoosier-born commentator equaled such humorists as Kin Hubbard, acerbic Ambrose Bierce, good-humored Don Herold and homespun Will Rogers.

Howe was a Hoosier by birth, a newspaper editor and magazine publisher almost by accident. His reputation has faded since his death more than seventy-five years ago. He was not impressed by being called a sage, as he was by a syndicated newspaper column. "To call a man a sage sounds impressive," Howe wrote in 1916. "It indicates that he knows many mysterious and hidden things. I know

nothing of the kind, so I am not a sage." He said he just kept his eyes open and applied experience to what he saw.

In 1904, Howe moved to a home he built in 1904 at Atchison, Kansas. He dubbed his new digs Potato Hill, a protest against fancy names often given to homes or farms. He disliked pretension in anybody, including himself.

Six years later, Howe retired from the newspaper he had founded in 1877. In "retirement," he started his monthly, a sixty-four-page pocket-sized magazine, later enlarged to newspaper format. It was, he said, devoted "to information and indignation." He died in 1937 after fifty years as a novelist, publisher and world traveler.

His newspaper, run with his half brother Jim, blustered with the comings and goings of his townspeople related in anecdotal form, interspersed with homilies, criticism, lessons and warnings. But he also boosted Atchison with the fervor of a one-man chamber of commerce.

Few photographs exist of Edgar Watson Howe, whose newspaper at Atchison, Kansas, contained his epigrams. *Courtesy of the Kansas Newspaper Hall of Fame.*

Many of his comments found their way around the world in numerous publications. They were such observations as: "Wit that is kindly is not very witty"; "After a man has been in Congress, he rarely goes back to real work"; "Half the people who make love could be arrested for counterfeiting"; "The worst feeling in the world is the homesickness that comes over a man occasionally when he is at home."

Howe's education was hard-knock—he left school early—and comprised things absorbed while accompanying his religious father Henry on weekend horseback preaching treks. Whippings, even for minor transgressions, were common for both Howe and his half brother.

Although details are misty and never clarified by Howe, he was probably born on May 3, 1853, on a farm where Treaty in Wabash County, Indiana, was later founded. His father came to Indiana at a young age, probably from Ohio, and married one woman, who died. He then wed Howe's mother, Elizabeth Irwin. When Howe was three years old, the family moved to Missouri, where his father bought a weekly paper at Bethany.

When Howe was fourteen, his father ran off with a sister-in-law, Aunt Lu, which caused the church to oust Henry Howe. This helped form Ed Howe's ideas toward women, marriage and religion. He never set much store in them. "I do not believe there is a devil, but we deserve one," he wrote.

Howe became an itinerant printer in Missouri and a proficient hand typesetter. At Falls City, Nebraska, he was smitten by Clara Frank, as well educated as he was not. After some more wandering as a printer, Howe returned to Falls City and married Clara.

It's vague why Howe and brother Jim chose Atchison for a newspaper. The town was relatively small. It had saloons, gambling, houses of prostitution and scandals—and two other newspapers; Howe was to outlast them. The first issue of the *Globe*, December 8, 1877, was devoted to gab, gossip and paid locals. For instance: "A couple who were only married about two months ago, were made parents last night by special dispensation of providence." Also: "Over in Missouri they hang a man for dealing himself five aces." That was the *Globe*'s mainstay—children, animals and humor.

The paper eschewed big words and also had a small staff, including Howe's son Gene. By 1880, its circulation was one thousand. Howe had horrible handwriting, we are told, and his typing was worse. He was quiet, courteous and amiable, and when he got tired of hard work he started to work harder, said an associate.

Howe produced his first novel, *The Story of a Country Town*, at night in his home by hand in ink. He printed two thousand copies at his newspaper, four pages at a time, and distributed it in 1883. Mostly autobiographical, it was the story of a family. Critics generally acclaimed it.

By 1891, Howe had churned out five novels, none particularly well received. Later, he wrote a play based on *The Story of a Country Town*. It was staged in a few places, including Atchison, with little success.

In Howe's later years, numerous periodicals, such as the *Saturday Evening Post, Ladies' Home Journal, Country Gentleman* and *Collier's Weekly*, printed Howe's stories and observations: "Many people would be more truthful were it not for their uncontrollable desire to talk"; "A thief believes everybody steals"; "After a man passes sixty, his mischief is mainly in his head"; and "Remember this: a man doesn't have to look the part."

Howe traveled to Europe, New Zealand, Australia, Africa and the West Indies and produced travel writing called the best of its kind. He lived in Florida for more than twenty winters, sending contributions, usually from Tampa, to his newspaper and including them in his monthly magazine. The magazine, which had started out at ten cents per copy and one dollar a year, later sold for ten cents per year and one dollar for a lifetime subscription and had a circulation of ten thousand by 1916, six years after its inception. Howe reportedly was making $25,000 a year, a very comfortable sum in the early 1900s.

Howe's married life was less successful, as might be expected. Some said that Howe was disenchanted to discover his wife had been interested in other men before she met and married him. Their relationship became respectful but not blissful. After thirty-seven years, Howe moved to a quiet cottage in the yard, technically desertion. Soon after the ensuing divorce, Howe moved to his Potato Hill farm and house.

Diphtheria took two of Howe's children early. The Howes had three others: Jim, born in 1879; Gene, born in 1886; and Mateel, named after a heroine in Howe's *Country Town* novel, born in 1883.

Both sons went into newspaper work—Jim worked with Associated Press and Gene became editor and publisher of three newspapers. Mateel wrote a novel, *Rebellion*, seemingly autobiographical and disliked by her father. Gene Howe committed suicide in 1952, cause unlearned. Jim Howe retired to California. Mateel Howe continued to write fiction, dying in 1957 in Westport, Connecticut.

Soon after the *Monthly* appeared in 1911, Howe started being quoted on editorial pages around the country: "No man ever loved a woman he was afraid of"; "A hot lemonade at night is good for almost every ill, from colds, headaches and gripe to rheumatism. The people should quit trotting after doctors and devote more time to lemons"; and "None of us can boast about the morality of our ancestors. The records do not show that Adam and Eve were married."

Howe was a Republican but spanked both parties and every candidate occasionally. His ability to rationalize his decisions was exceeded only by his capacity to change them. Many of his "paragraphs," which appeared in the newspaper under the heading "Globe Sights," were skeptical but filled with wisdom and touched on common topics. Howe always considered himself a common man. The epigrams live today in numerous books of quotations.

In the years when the *Monthly* was so popular, Howe began receiving honors due an elder sage, testimonials and anniversary dinners. He even made a few speeches. He devoured the attention. Howe got a couple of honorary degrees, ironic considering his lack of classical education and his opposition to it; he preferred a practical education. At a dinner for Howe in New York City, he was presented with a watch inscribed with "To E.W. Howe by admiring friends to commemorate his fifty years of inspiring service in American journalism. April 29, 1927."

In 1935, Howe had cataracts removed from both eyes in Baltimore. On July 17 of that year, he suffered a slight stroke, but paralysis gradually worsened and, added to age, brought

his death on October 3, 1937, at 2:20 a.m. He was just short of eighty-four years old. Funeral services were held in the Episcopal church in Atchison, no doubt one of the few times when Howe was in it. He had kept few formal records, no diary and little in the way of letters and family documents. Photographs of his childhood seem nonexistent.

HERO IN THE TRENCHES

Samuel G. Woodfill

There isn't much difference between stalkin' animals and stalkin' humans.
—Lieutenant Samuel G. Woodfill

He was dubbed the "outstanding" soldier of the Americans fighting in France in World War I. He was given honors for his exploits against the Germans by the United States with the Medal of Honor and by France, Belgium, Poland, Italy and Montenegro. He was the sole Hoosier to receive the Medal of Honor in that war. He was a pallbearer at the burial of the Unknown Soldier and also, years later, was a pallbearer at the burial of General John J. Pershing, who commanded the American forces sent overseas in World War I. Yet when he died, many years after killing nineteen enemy soldiers near the French town of Cunel, he was buried unnoted in a family plot of Hebron Cemetery near Madison, Indiana. Only later, when a reporter discovered the neglected grave, was this forgotten Hoosier soldier's body put to rest with honors in Arlington National Cemetery.

Lieutenant Samuel G. Woodfill's devotion to the military went beyond his impressive fight to aid his pinned-down unit in the war. He also served in the Philippines and in Alaska. After thirty years in the army, he retired. But when World War II came along, he volunteered, though fifty-eight years old, and was sent to Fort Benning, Georgia, where he trained officers. He also demonstrated again that he still had the keen eye with a rifle that he first developed while shooting on the family's Jefferson County farm.

Samuel Woodfill was cited as the biggest hero of World War I for his "stalkin'" of the enemy. *Courtesy of the Jefferson County Historical Society Research Library.*

Woodfill was tall and taciturn, but noted travel writer and broadcaster Lowell Thomas prevailed on Woodfill to recount his army career in his own words. The book, published in 1929, even then revealed Woodfill's reluctance to talk about his many honors. Thomas had to list them himself in an epilogue. Woodfill told Thomas that he considered the Medal of Honor the climax of his career.

Born in January 1882 on the family homestead near Bryantsburg in Jefferson County, Indiana, Woodfill joined the army, as he said, "as soon as I was old enough to be accepted"—March 8, 1901. He was just in time for service in the Philippines insurrection. His father had been his inspiration for military service.

John Samuel Goode Woodfill had served in the Mexican War and carried a scar on his arm from a bayonet wound. He also had served in the Civil War but came out unscathed from that conflict.

Samuel, the youngest of the four Woodfill boys (there also were two sisters), relished the battle tales that his father told. Woodfill had learned to use his father's muzzleloading rifle by the time he was ten years old. The elder Woodfill, sixty when Samuel was born, died when the boy was twelve.

The father's instruction left a lifetime mark on Woodfill, though. "He taught me to be a straight shot. Squirrels and rabbits gave me most of my rifle practice while I lived on the farm," Woodfill said. Much of Woodfill's hunting came near the Indian-Kentuck Creek, which joins the Ohio River about seven miles east of Madison and abutted the family farm.

Woodfill's unit served in Leyte in the Philippines. When he returned, he was discharged and reached the Indiana farm by March 1904. But the army was in his blood. When he saw a newspaper ad, he joined the Third Infantry, which was bound for Skagway, Alaska. Woodfill was to serve four hitches in Alaska. He liked the North Country.

Service there mostly involved maintaining far-flung way stations for the telegraph system. It was the only link with the outside for units, the northernmost of the army, on the edge of the Arctic. During the first winter, the mercury fell to fifty-three below; future winters were even colder. Woodfill, adapting to the cold easily, became an official army hunter, killing moose, caribou and sometimes goats and bears for the troops and for Indians in the area. He also fished and hunted duck. In Alaska, he developed the ability to trek, stalk, creep forward and shoot, all talents that would be valuable later.

Once discharged and back in the states, he reenlisted with a unit heading back to Alaska, but it was sent elsewhere. Woodfill took a two-month leave and went home. There he met and courted his first girlfriend, Lorene "Blossom" Wiltshire. In the spring of 1914, he headed with the Ninth Infantry to Mexico during unrest there, hunting deer along the Rio Grande. The war was kicking up in Europe and was finally declared.

Woodfill took special training when the war opened and became a second lieutenant. In autumn of 1917, he was made a captain and helped to organize a company at his post in North Carolina. On a ten-day leave, he married Miss Wiltshire.

After Woodfill's unit reached France, the first shelling occurred when the men moved to the front on foot. Numerous bombs and shells fell within feet of Woodfill but failed to explode.

"You got so numb you didn't even notice the cold and wet," Woodfill recalled. At one point, enemy fire pinned down the unit, and men took shelter in holes already dug, probably by the Germans. "The one I picked couldn't have been more than 14 inches deep," said Woodfill. Three bullets plowed into his pack. His peril prompted him to dig a photo of his wife out of his pocket and write to her on the back of it, speaking of his love for her and his faith in heaven.

Again Woodfill escaped death. "There was no German ammunition with my name on it that day," he said. On the morning of October 12, 1918, he and his unit were advancing near Cunel under the deadly rain of machine gun bullets.

"I didn't believe in askin' any of my men to do something I wouldn't do myself," Woodfill told Thomas. He made a dash and found fire coming from three points—a church tower, a stable and somewhere in front of him. He took the church tower first, firing a clip of ammo, which halted fire from the foe. The same result came when he fired into the stable.

Woodfill began moving forward, from one shell hole to another. He took cover behind a pile of gravel and spotted the third machine gun in a clump of bushes. Woodfill caught a flash of light on a helmet, fired and killed the gunner. He also killed the four men who tried to take the gunner's place. Another man tried to escape, but Woodfill shot him with his automatic. Continuing forward, Woodfill stumbled over a German, who sprang to his feet and caused Woodfill's rifle to fly into the air. Woodfill shot him with his handgun. "If his Luger had been in his hand instead of in its holster he could have got me," Woodfill said. He took the Luger. "I kept on through the trees and brush—crawlin', crouchin', and runnin'—dashin' from one point of cover to another, movin' forward in that hail of bullets and shells," he said. The next machine gun nest contained five enemies. "I got all five the same as I had the crew on that first gun," said Woodfill.

Noting fire from another machine gun nest, Woodfill crawled close. He spotted the nest in woods near a trench. Again he picked off five men, one by one as they came into his sights. Jumping into a trench, Woodfill killed two Germans with a pick maddox that he found there.

Soon others joined Woodfill. "More men were crawlin' up, and I was able to organize part of the company," he said. They dug in against shells, which had abated, but the machine gun fire continued fiercely.

Later in the afternoon, the shelling stopped. Typical for army men, the first thought was for food. The mess sergeant appeared soon with gas-proof containers of food. He gave Woodfill an apple pie. "Reward for wipin' up the German army, Lieutenant," the mess sergeant said, according to Woodfill. "I don't think any medal I ever got pleased me half as much as that apply pie," said Woodfill.

Woodfill and sixteen others went to Chaumont to get the Medal of Honor and lunch next day with General Pershing. Within a month of Woodfill's exploits, the war was over. Besides the honors from all the other countries, Woodfill got the well-known ticker tape parade back home in New York City. The big city press greeted him as a "Twentieth Century Daniel Boone." He was fêted in Washington at the White House, and Congress lauded him.

To Woodfill, the battle exploits had been only natural. "It was using the same tactics I had used in big-game huntin' in Alaska ten years before. It's all in outwitting the other fellow," he said.

After returning home, Woodfill came to realize that the army was his life. So he reenlisted, losing his temporary rank as captain in doing so and reverting to the rank of sergeant. Woodfill remained little known, even in the army, until 1921, when General Pershing selected pallbearers for the burial of the Unknown Soldier. Pershing chose Sergeant York, Colonel Whittlesey of the Lost Battalion and Samuel Woodfill. Said Pershing upon seeing Woodfill's name on the list: "Why, I've already selected that man as the outstanding soldier of the A.E.F." Woodfill and his wife went to Washington for the ceremony.

Then Woodfill returned to anonymity in the army. A note came due on the farm that he and his wife had bought, and Woodfill got leave to work on a dam being built near Fort Thomas, hoping to

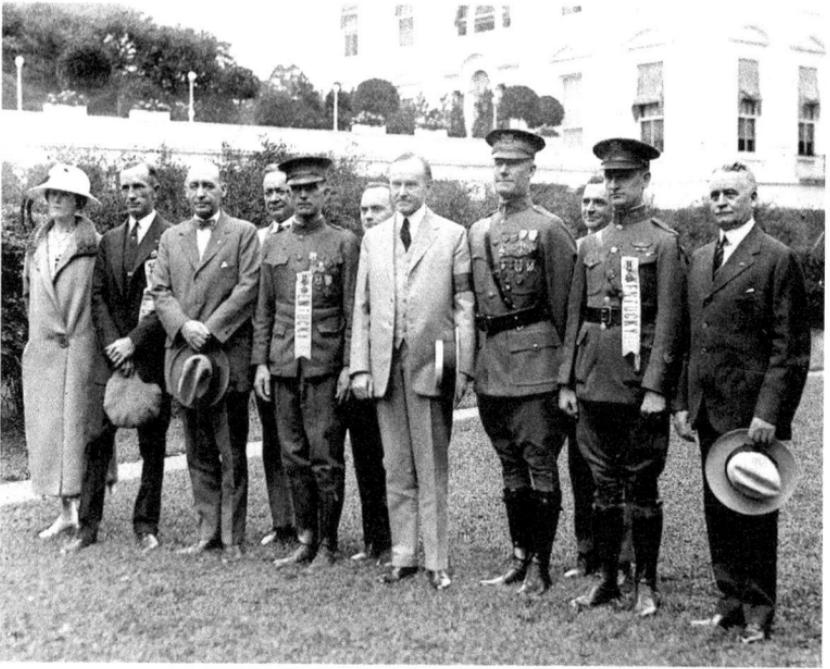

President Calvin Coolidge (straw hat in hand) here received Samuel Woodfill (to his left) in Washington for the burial of the Unknown Soldier. *Courtesy of the Jefferson County Historical Society Research Library.*

pay off the mortgage. At this news, a collection was started that raised $10,000 to pay the note and purchase an insurance policy.

Woodfill completed his twenty years in the army in December 1923. When World War II broke out, Woodfill offered his services. He became an inspector of eleven replacement training centers and schools. After that, he returned to the farm. In 1948, he served as a pallbearer for General Pershing.

Woodfill settled in Vevay. He was found dead in his apartment in August 1951, evidently of a heart attack. Discovery later of his weed-covered grave caused Woodfill's story to be uncovered and retold. It resulted in his burial in Arlington National Cemetery on October 15, 1955, near the Tomb of the Unknown Soldier and not far from the grave of General Pershing. The southern Indiana farm boy who had saved his unit from withering fire in World War I was at last resting in the proper place of heroes.

OLD BORAX

Harvey W. Wiley

I have fought vice all my life and I would never run for an office with vice in it.
—Harvey Washington Wiley, when asked to run for vice president

Unbiased evaluations of foods, required content labeling, warnings of food contamination, discussions about irradiated food and routine recalls of tainted products are common in the twenty-first century. But they only reflect a battle won years ago by a Hoosier. Harvey Washington Wiley fought against adulterated food, a common practice in his day, despite resistance from the canning industry, meatpackers, whiskey makers and even U.S. presidents. His determination led to the first federal pure food and drug act in 1906.

The Hoosier food legislation of 1899, first in the nation, also was due to Wiley's influence. In that era, families obtained most of their food through farm animals, gardens and orchards, plus game and fish. Spoiled or impure commercial food was a threat to wellness. That's where Wiley came in.

"It is doubtful," wrote one observer of the era, "if any one capable, law abiding citizen ever had such powerful or vicious enemies as did Wiley at this time."

Wiley was born on October 18, 1844, in a log cabin near Kent. Wiley's schoolteacher father, although poor, subscribed to *Atlantic Monthly*, believing in its philosophy of antislavery. Harvey read articles in the magazine by luminaries of the day.

When Wiley was seventeen, the Civil War broke out, and although too young for military service, he joined the Indiana home

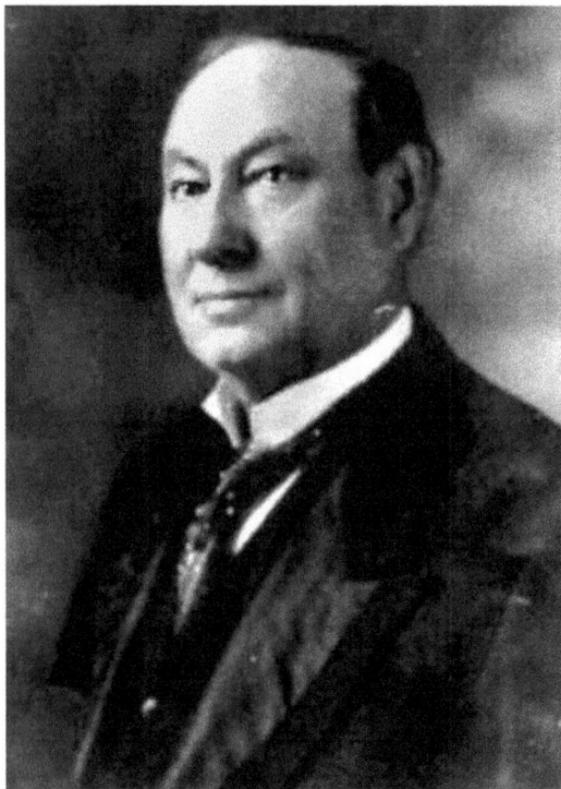

Harvey Washington Wiley earned the nickname "Old Borax" because of elements used in one of his food experiments.

guard. At nineteen, Wiley decided to leave the dirt farm to enter nearby Hanover College, hoping to become a doctor. He made his way in college, although some remedial classes were necessary. He graduated in 1867.

Wiley walked home Saturdays for breakfast and a full day of farm work. He continued this work during summer vacations. His father paid him one dollar, used for his clothing and books.

Hanover closed during much of the Civil War, and Wiley spent his freshman year and part of his sophomore in the military. He came home severely ill, probably with hookworm; he dropped from his usual 200 pounds to 119.

Wiley was abed much of his sophomore year, though he was able to keep abreast of his studies. Back at Hanover the next year, he "batched," or lived with his brother. As a sophomore, he prophetically read an essay titled "The Importance of Health."

After graduation, Wiley sought work in Lake County, Indiana, and eventually became a principal in Lowell. While there, he "read medicine" from a local doctor.

Wiley soon got a job as a Latin teacher at Butler College (now university) in Indianapolis. He immediately also enrolled in Indiana Medical College and taught at Indiana Central High School (later Shortridge). The regimen put him to bed with cerebrospinal meningitis. He also nearly lost a leg, but he got his medical degree in 1872.

When a medical college professor took a job with the United States Department of Agriculture, Wiley became chemistry teacher, but he insisted on taking a year off for advanced work in chemistry, which he did at Harvard. He spent five to eight hours a day hearing lectures and working in the lab. Obtaining some waivers, he got his degree. He was appointed as chemistry professor at just-opened Purdue University in 1874.

In nine years at West Lafayette, Wiley set up the laboratories and had his students collect pure chemicals, displayed at the Philadelphia Centennial Exposition in 1876.

He also caused a scandal. Wiley rode a high-wheel bicycle around town, wearing knee breeches. This activity "frightened horses, attracted attention and grieved the hearts of staid president and professors, as well as the board of trustees," Wiley said. He offered to resign, but the board decided against it.

On a leave of absence to study in Berlin in 1873, Wiley was inspired by a chemist from the imperial health office, who had him study adulterations in sugars and syrups. The experience caused Wiley to turn from medicine to the test tube. Wiley left Purdue in 1883 to become chief chemist of the Department of Agriculture in Washington. Here he was to launch his pure food campaign, elevating the department above just another humdrum federal office. His attacks on food impurities brought denunciations, even threats.

Wiley objected to glucose in honey and criticized ingredients in patent medicines and shameless advertising lies. He campaigned against sulfur dioxide for bleaching and preserving, the use of flavored alcohol as whiskey, adulteration of sugar and molasses, use of chemicals as preservatives and toxic colorings and color

enhancers (copper sulfate was used to keep canned peas green). All of this brought Wiley wide attention and attacks from the beleaguered food industry. Some outright threatened him.

Wiley's most publicized tactic was, in retrospect, brilliant. He recruited twelve volunteers, purified their diets and then fed them offending chemicals and recorded the results. "I believe in trying it on the dog," said Wiley. The five-year experiment began in 1902. Ridicule, satire and tearful protests followed. A reporter dubbed the group the Poison Squad. Some enemies dubbed Wiley "Old Borax" because the first tests were with boric acid and borate of soda. The label stuck. But the adverse effects on the Poison Squad of boric acid and borax, salicylic acids and salicylates, sulfuric acid and sulfites, benzoic acid and benzoates, formaldehyde, sulfate of copper and saltpeter began to gain public support.

Despite the fiery opposition, especially from the food industry, a pure food and drug law was proposed, and testimony began. "Experts" said that banning preservatives would double the death rate from food poisoning. Wiley countered each criticism, proving some to be outright lies. In the end, the bill passed. "They [the legislators] did not care to go back and explain why they voted against the pure food bill," Wiley said. President Theodore Roosevelt signed the bill on June 30, 1906.

The battle was over, but the war continued. Critics took their case to Roosevelt, who was incensed that Wiley considered saccharin harmful. Roosevelt summoned Wiley to hear the accusations personally. When the lobbyists mentioned saccharin and Wiley said it was harmful, Roosevelt turned purple with rage, wrote Wiley. "Why, my doctor gives it to me every day. Anybody who says saccharin is injurious to health is an idiot,'" quoted Roosevelt. Roosevelt established and named the Remsen Board, which illegally supplanted Wiley's Bureau of Chemistry. For a time, this move virtually invalidated the new legislation.

Wiley was undeterred, however. He attacked food processors for using glucose and calling it corn syrup. Foes tried to bribe Wiley and tried to bribe others to undercut his evidence.

Wiley declared Coca-Cola to be "habit forming and adulterated," and started prosecution but was ordered to stop. An Atlanta,

This stamp used the image of Harvey Wiley to commemorate the agency that his law helped found.

Georgia newspaper editor pressed to have the case heard. During a trial in Chattanooga, Tennessee, Wiley's charge was upheld. The Coca-Cola Company had pleaded that caffeine in the drink was natural. As a result of the court actions, eventually reaching the Supreme Court, Coca-Cola agreed to alter its formula.

Wiley had weathered the storm. The nation had a pure food and drug act, and Department of Agriculture analyses had been improved and standardized. But the man from Indiana was beset by disputes over one man he had hired, and there was trouble ahead. He resigned on March 15, 1912. "I realized conditions in the Department of Agriculture would be intolerable," he wrote.

Now sixty-eight years old, he joined *Good Housekeeping* magazine, experimenting in its kitchens, advising readers on adulteration and diet and lecturing around the country.

At sixty-six, Wiley married for the first time, on February 27, 1911, to Anna Campbell Kelton, a former librarian at the agriculture department, whom Wiley had adored from afar for ten years. She was half his age. Their sons came along in 1912 and 1914. "One could always expect the unusual from Harvey Wiley," noted one observer.

Wiley got more awards in other nations than he ever got at home for his work. Democrats did ask him once to run for vice president. He declined, saying that his battle against vice weighed against it.

Wiley remained with *Good Housekeeping* until 1929. That same year, he wrote *History of a Crime Against the Food Law.* He also had written *Principles and Practices of Agricultural Analysis* in three volumes, and *Foods and Their Adulteration.* He died on June 30, 1930. He was eighty-four years old.

A plaque was erected at Wiley's hometown in June 1982. His spirit lives on in the laws regulating food standards. They continue to change and may be imperfect, but they could be less had it not been for Old Borax.

BEST FOOT FORWARD

Dr. William M. Scholl

Early to bed, early to rise. Work like hell and advertise.
—Dr. William M. Scholl, attributed

You can rise from milking Hoosier cows to such stature that your name is recognized worldwide. It was done by Dr. William M. Scholl, whose passion was improving foot comfort by working almost ceaselessly, rarely sitting down and rarely forgetting business. Few recall that the foot doctor was born near LaPorte before founding his foot care empire in nearby Chicago. Scholl died in 1968 in his eighty-fifth year. Family members—Dr. Scholl never married—continued running the international business he had built.

Dr. Scholl's success shows the value of advertising. The ad budget approved by Scholl was at least $1 million per year, even during the Depression. In the 1960s, the ad budget had expanded to more than $2 million per year.

Dr. Scholl did watch some costs. His brother, Frank J. Scholl, joined him in the business and was sent to Canada. Wrote Dr. Scholl: "I am delighted to read your report and see the orders you have booked in Canada. At the same time I have noticed your hotel expenses. Now I want you to live well when you are traveling for the company…but when I see you are spending three dollars a day!" That was 1909.

Personal information about Dr. Scholl is scarce, quotations by him rare. For years he lived in a single room with a bath down the hall at the Illinois Athletic Club in Chicago, although he did have

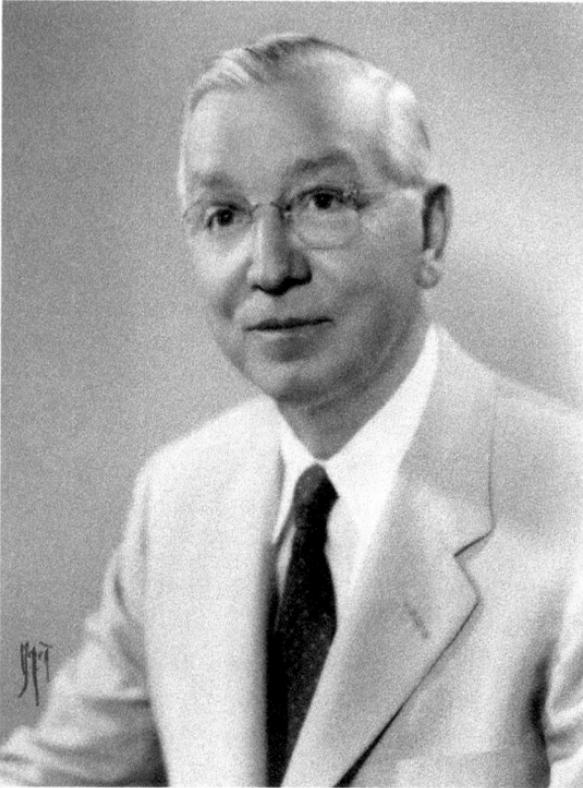

Dr. William M. Scholl's company was lauded in the Congressional Record by Congressman Shepard J. Crumpacker Jr. of South Bend. *Courtesy of Dr. William M. Scholl College of Podiatric Medicine.*

homes at Michigan City, Indiana, and Palm Springs, California. He traveled the world—he had plants in Paris, London and Frankfurt, Germany—and was a passenger on the maiden flight of the Graf Zeppelin and the first flight of the Hindenburg from America to Germany.

William Mathias Scholl was born in 1882 in a square brick house near LaPorte, the third son in a family that ended up with ten boys and three girls. His brother, Frank J., came eighteen months later.

Scholl mended harnesses for the farm horses as a small boy and helped repair plows and other machinery. At fifteen, he designed and sewed a harness for the horses, making his own waxed thread. He became the family cobbler, using his grandfather's tools.

He worked for three dollars per week for a Michigan City shoemaker, opened his own repair shop in a small Lake County town and moved to Hammond and, finally, Chicago. There he

was a salesman in Ruppert's Shoe Store and showed a knack for making shoes to improve foot problems. Feet and their abuse grew clear to him.

Scholl worked nights, attending daytime classes and clinics. While studying at Illinois Medical College (later Loyola University) and Chicago Medical School, Scholl also read everything he could find on feet. By the time he got his MD in 1904, Scholl had developed the tri-spring arch support for clubfeet or flat feet. He was twenty-two years old. According to legend, a new arch support caused a customer to remark: "It's a real foot easer, isn't it?" Foot-Easer became the device's name, later registered as a trademark.

Using $500.00 in capital, Scholl rented a small apartment for $4.00 per week in Chicago and used it as a workshop, consultation room, fitting booth, office and living quarters. His first customer came in June 1904, and he made $815.65 the rest of the year. His first ad cost $12.00.

Brother Frank came to Chicago and opened two menswear stores, and William, recognizing his brother's business acumen, suggested that they join forces. Frank agreed and went to Canada in 1910 to sell shoes. Later, after Dr. Scholl found England and Europe to be promising territories, he set up operations in London and asked Frank to run it. Frank accepted, began advertising and soon wrote: "We have rented a typewriter now. If things keep going like this, we shall have to buy one."

By 1911, Dr. Scholl had added greatly to his foot aids and started his catalogue called *Scientific Correction for Ailments of the Feet*. It soon required revision and reprinting.

Scholl's correspondence courses for shoe fitters began, using the book *The Study of Practipedics*. Schools followed—Illinois College of Chiropody and Orthopedics in Chicago in 1912 and Scholl Orthopedic Training School in Chicago, later also New York. He started a monthly magazine for shoe retailers and a line of shoes and was adding five to six new items a year.

During World War I, Scholl wrote *The Human Foot: Anatomy, Deformity and Treatment* and *The Dictionary of the Foot*. Inventions accumulated apace. By the peacetime of 1918, Scholl's company volume topped $1 million. He started promotions: National Foot

Comfort Week, prizes for window displays, contests to select the most perfect feet and walking contests (he was a longtime walker himself).

His separate company, Arno Adhesive Tapes Inc.—for tapes, adhesive plaster and padding—opened in Chicago in 1930, later moving to Michigan City, Indiana. He opened chiropody schools in 1931 in London, later Berlin, with the three sons of Frank among the first students. Dr. Scholl traveled widely as the firm expanded. In 1929, he rode the German dirigible Graf Zeppelin to Europe. "I wouldn't have missed the trip for a million dollars," he told a reporter. In May 1936, he took the dirigible Hindenburg from New Jersey to Frankfurt, Germany.

Dr. Scholl often walked unidentified into European stores and bought his own products, testing quality. Abroad, he kept in touch with the home office via a blizzard of telegrams, letters and postal cards.

During World War II, the Scholl plant in England made surgical instruments and hospital equipment. In Chicago, the installation made parachutes, helmet straps and other military equipment.

In California, after a bout of illness, Dr. Scholl invented a plastic arch support, foot wings and the Ball-O-Foot Cushion in his garage workshop. As World War II ended, Dr. Scholl invented the compact display fixture with the familiar blue and yellow colors.

In 1960, the company erected a 100,000-square-foot addition at Chicago. At an expansion in Michigan City's Arno plant, the doctor, age seventy-seven, arrived by helicopter for the groundbreaking. In 1965 came a new headquarters in Rutherford, New Jersey; in the early 1970s, a new plant was established in Australia.

In 1966, Dr. Scholl suffered a stroke from which he never fully recovered. His brother Frank died in Chicago on February 13, 1967, at eighty-three. Two years later, Dr. Scholl died. Frank's children began operating the company.

Almost to the end, Dr. Scholl was deeply involved in the business. He had no hobbies but amassed a collection of rare and historical shoes. Customarily, he arose at 7:00 a.m. and breakfasted with friends at the Illinois Athletic Club in Chicago. At work, he often missed lunch until well into the afternoon. Sometimes he read all

of the daily mail. By the 1960s, however, he was no longer working Sundays at the plant.

Scholl was, his associates said, exacting but kind. Numerous top executives stayed with him for thirty years and more. "As long as fashion, instead of good common sense, dictates our choice of footwear, we'll be in business," he once said.

Some might consider foot care a pedestrian calling. But for Dr. Scholl, it was a passion that absorbed his life to the exclusion of almost everything else.

THE GENTLEMAN OF THE
PRESS IN SKIRTS

Janet Flanner

If you don't go home after ten years, you know you're hooked.
—Janet Flanner

F ew know the name of Janet Flanner. For one thing, for most of her writing life she used the pseudonym Genet, which, she said, her editor thought sounded French for Janet. For another, she lived and worked in Europe, mostly in France. Also, once she departed Indianapolis she seldom came back to Indiana.

In fifty years, starting about 1920, she wrote untold "Letters from Paris" for the *New Yorker*, published a novel, mainly autobiographical, and began keeping journals after World War II, published in two volumes. She did some short stories, some translating and some radio shows and wrote for magazines other than the *New Yorker*. She wrote profiles of notables of the time—Lily Pons, Queen Mary, Elsa Schiaparelli, Elsa Maxwell, Pablo Picasso and Adolf Hitler. She covered the war trials at Nuremburg. She worked the war years in the *New Yorker*'s offices.

Her friends overseas included Ernest Hemingway, Gertrude Stein, Alice Toklas, James Joyce, F. Scott Fitzgerald, T.S. Eliot, Ezra Pound and Colette. Her U.S. friends included Franklin P. Adams, Heywood Broun, Dorothy Parker, Robert Benchley and Harold Ross, whose founding of the *New Yorker* became pivotal in Janet's career.

Near the end, she became weary, depressed and lonely. Long bisexual, she had become frail by 1977, her memory a shambles. The love of her life, Solita Solano, had died in 1975.

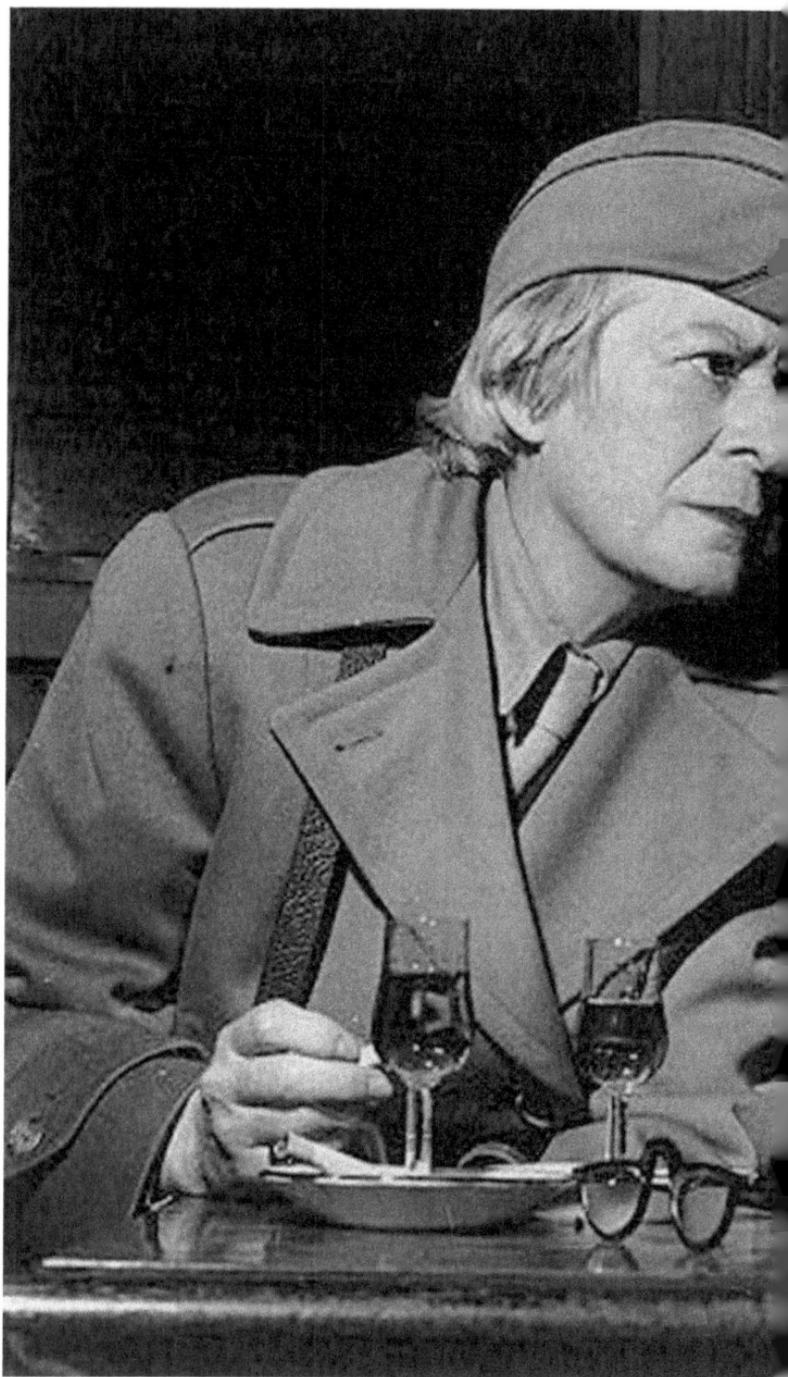

Janet Flanner and Ernest Hemingway got together when both were in uniform. She found Hemingway "extravagantly male."

Janet Flanner passed away on November 7, 1978, en route to a Manhattan hospital.

Janet was born on March 13, 1892, to Frank and Mary Flanner. Frank joined Charles J. Buchanan in a mortuary. Janet's mother was always a bit ashamed of the family business.

The Flanner and Buchanan families seemed close. They had properties at Tippecanoe Lake far north of Indianapolis and spent summers there together. In 1910, the Flanners moved to Berlin, Germany, for a year, visiting Janet's sister, Mary Emma. Janet loved Germany. While in Europe, Frank began to show despondency. After the family returned to Indianapolis, Frank entered a room in the mortuary one day, drank a solution of prussic acid, strychnine, carbolic acid and morphine and lay down to die. The reason for his suicide never was clear.

Janet grew up as a precocious child, outspoken and strong willed. She was reading by the second grade. In 1905, she was president of her class at Tudor Hall, a private girls' school. At fifteen, she wrote a story, "The Adventures of Mynheer, the Prefect of Police, and the Guinea Pig," which was printed in a school publication. As a senior, she edited the school yearbook.

At twenty, Janet went to the University of Chicago—her father had left her some money—and met William Lane Rehm, called Rube. In two years, she was back in Indianapolis. At twenty-four, she began to call herself Jeanette.

"I wanted to write," she said. The *Indianapolis Star* drama department gave her a job reviewing burlesque and vaudeville, popular in that era; Janet's mother thought it was beneath her, but Janet loved it. She later became a movie reviewer, possibly the first in Indianapolis.

Janet married Rehm unexpectedly on April 25, 1918. She later said it was only to get out of town. The couple went to Greenwich Village in August. Rehm, a bank clerk, helped Janet manage her small income from her father's estate. About this time, Janet realized that she was attracted to women. One was Solita Solano, who remained her lifelong love. "Rarely does a day go by that I don't think of you," Janet wrote some years later.

Janet, still married, became pregnant. Whether she aborted or miscarried is unclear. Solano and Janet went to Greece in 1921, where Solano took pictures for *National Geographic*. Janet did a piece for the *New York Tribune*. It was much like her later "Letters from Paris." The pair traveled to Rome and Vienna, and in 1923, they found a place in Paris.

One room on the fourth floor rented for one dollar per day. In sixteen years there they acquired three more rooms. Flanner later explained, "Americans with little private income, like me, who want to write, could afford to live on their hopes and good bistro food on the Left Bank."

"Leaving home was part of our sense of liberty," Janet also said. "That's why we were able to begin anew." When Harold Ross began the *New Yorker* on February 21, 1925, he asked Janet to do one thousand words a week for forty dollars, but she only got thirty-five. "The trick," she said, "is never to say I." Ross, she admitted, helped her develop her style. Soon Janet found that Genet, her alter ego, fitted well into her life. To develop her column, Janet reportedly read at least eight newspapers a day.

In 1926, Rehm went to Paris and arranged a divorce. Janet embarked on profiles for the *New Yorker*; dancer Isadora Duncan, writer Edith Wharton and designer Paul Poiret were subjects. She also started translating and writing short stories and began writing for more publications; writing provided her sole income.

Although still with Solita, she also fell for Noel Murphy. Janet soon was traveling Europe, covering the 1936 Olympics in Berlin and shuttling between London and Paris. And she had added Natalie Murray to her love list. In 1936, she made a brief visit to Indianapolis, hoping to find work in the United States. Failing that, she returned to France on April 7. "I felt I was living both at home and abroad—with American friends and French culture," she said.

With war looming, Janet returned to the United States in 1939 to the *New Yorker* offices. During the four years of the war, she wrote a variety of material, often using her own name as byline. Back to London in November 1944 and thence to France, Janet found the Paris of old changed and confusing. But she resumed

her letters from Paris, also doing radio broadcasts and traveling around Europe.

In 1947, the fatal illness of her mother took Janet to California, where the family lived. Mary Flanner had been ill for some time. Janet arrived in time to be alone in the room when her mother died.

The next year, Janet began a diary. She was fifty-five years old and had been on the go for thirty-two years. She said she felt "old," but she headed back to France to resume her tiring routine. When her sister Marie died in 1949, Janet did not return to the United States.

Ross died on December 6, 1951. His replacement, William Shawn, a longtime *New Yorker* staffer, was supportive of Janet, and some of her writing was collected in anthologies.

Janet had written *The Cubical City*, mostly autobiographical, early in her career. Now she worked on a book, *Men and Monuments*, a collection of her profiles on French artists, published in 1957. That same year, she was diagnosed with arteriosclerosis. Publication of *Men and Monuments* was delayed several times. "I suppose I have been a modest historian," she once wrote. She noted that she had spent thirty-five years in hotel rooms and had few possessions. Photographs in the later years showed her gaunt, her large nose seeming more prominent because of her slightness.

With flight now common, she shuttled between Paris and the United States frequently. She attended ceremonies at Smith College in 1958 for an honorary degree. With her steadily weakening health, everyday tasks were done for her by friends—cooking, editing copy, typing. In 1960, Janet began taking pills for high blood pressure.

She appeared on *The Today Show*, which she called "a breakfast show for the gentry." Her *Paris Journal* was nominated for a National Book Award. She was invited to the White House and received an Indiana Authors Day award from the Indiana Writer Conference. In 1967, she was named among one hundred American women of accomplishment.

Her private life, however, was often in turmoil and was complicated. She was a lover of ribald humor and capable of lewd remarks herself, but she kept her sexuality quiet. In fact, she

deplored displays in New York of homosexuality. She said they showed a lack of class.

In August 1968, she suffered a small stroke. In 1971, at age seventy-eight, she fell and cracked two ribs. The second volume of her *Paris Journal* brought her an appearance on *The Dick Cavett Show*, and *Paris Was Yesterday*, a reminiscence, got mostly good reviews. She was eighty years old and travel was tiring. Janet left France in 1975, and except for a short visit in 1976, her French life was over. In two years, she was gone.

Much was made of the fact that she had worked fifty years for the same publication. Some said that she had not made enough use of her talent. She often wrote and rewrote and rewrote.

Once she mused: "I wonder for whom or what I would have written" if the *New Yorker* had not come into existence. Not long before her death, she said it was not her fifty years of work she wanted remembered. "Let it be said that once I had stood by a friend," she urged.

CANNONBALLING
COAST TO COAST

Erwin G. Baker

It ain't all sunshine over there [at the Indianapolis Motor Speedway].
—*Erwin G. "Cannonball" Baker*

Today it's difficult to imagine the transportation of the early 1900s. But one Hoosier knew the challenge of inadequate highways and made his mark overcoming time and distance. He established a legend and was the inspiration for six movies. He was Erwin G. "Cannonball" Baker and is as forgotten today as the Model T Ford. Baker was a speed pioneer on the motorcycle. He had tried racing automobiles, but the experience was unhappy. Later he returned to driving autos but mostly for testing.

Cannonball was the first man to cross the United States from California to New York on a motorcycle, which he did in 1915 in eleven days, twelve hours and ten minutes, riding an Indian. According to Baker, interviewed shortly before his death in 1960, only four miles of his transcontinental route were paved at that time. By 1941, at age sixty, Baker went from Los Angeles to New York in six days, six hours and twenty-five minutes on a new rotary valve motorcycle. This 3,047-mile trip signified not only developments in motorcycles but also vast improvements in highways.

After completing his first Los Angeles–New York record run, a newspaperman dubbed him "Cannonball." He liked the nickname so much that he had it copyrighted. On that run, Baker said that he had to ride railroad ties for sixty-eight miles at night to cross California's Imperial Valley and that the trains were running at the time.

Erwin Cannonball Baker illustrated his driving style at the Indianapolis Motor Speedway museum, probably about 1940. *Courtesy of Eric Wild.*

Baker himself said he lost track of his car and motorcycle speed and endurance records. But he reported crossing the country 143 times, amassing 5.5 million miles in forty-five years. Unofficially, he was the inspiration for a national cross-country speed run from New York City to Redondo Beach, California, which was held five times between 1971 and 1979 and served as the core of six movies. Cannonball himself spanned the continent in 1933 in a Graham

automobile in fifty-three hours and thirty minutes. In 1926, he had crossed the continent in a Model T Ford in five days, two hours and thirteen minutes. For that feat he got a telegram from automaker Henry Ford that said, "Congratulations, wonderful run." The terse wire had cost the wealthy Ford forty-eight cents and became one of Baker's souvenirs.

Baker completed numerous speed runs between U.S. cities and some between cities in Indiana. He also raced in Hawaii, one of the toughest places, he said, and in Australia, New Zealand, Cuba, Panama and Jamaica.

One of the secrets of his runs, especially cross-country, was his meticulous research. He studied the roads, sites for fuel and especially weather—mud was one of his frequent adversaries.

Baker was one of the first to race motorcycles at the Indianapolis Motor Speedway, winning the ten-mile event in 1909 before the 500 Mile Race came into being. Racing and testing at the Speedway took him an estimated forty-eight thousand total miles, he declared. One of Baker's record-making motorcycles was given to the Speedway Museum, but is not always displayed.

Born in a Dearborn County four-room log house on a farm near Weisburg, Baker came to Indianapolis when he was twelve. He learned the machinist's trade at an Indianapolis forging company and punched bags at the German-founded South Side Turners. Restless as a machinist, Baker joined the Fox Zouave Drill Team, Indianapolis men in vaudeville.

After one season, Baker met Bill Irrgang, also of Indianapolis, and they formed a theatrical team; Irrgang did acrobatics, Baker punched the bag. On the West Coast, Baker said that he had a premonition to cancel the tour and return home. "It was like someone had tapped me on the shoulder," Baker told an interviewer. He and Irrgang boarded a train for home; on board they heard about the San Francisco earthquake.

Back in Indiana, Baker became interested in motorcycles. He took first and second places in his first two outings at a Crawfordsville track. Baker became attracted to cars and drove in the 1922 Speedway race, the only 500 that he ever entered. He came in eleventh place, averaging seventy-nine miles per hour. But

Cannonball Baker illustrated the rotary valve engine motorcycle on which he crossed the country in 1941. *Courtesy* Indianapolis Star *files*.

he said the race cost him $350 out of his own pocket and left him disillusioned. He switched to running tests at the Speedway, doing long-distance runs for several automobile companies.

In 1941, Baker tested the reliability and economy of the rotary valve engine that he had helped design, going east from the West Coast. During the run, Cannonball made his longest stop in

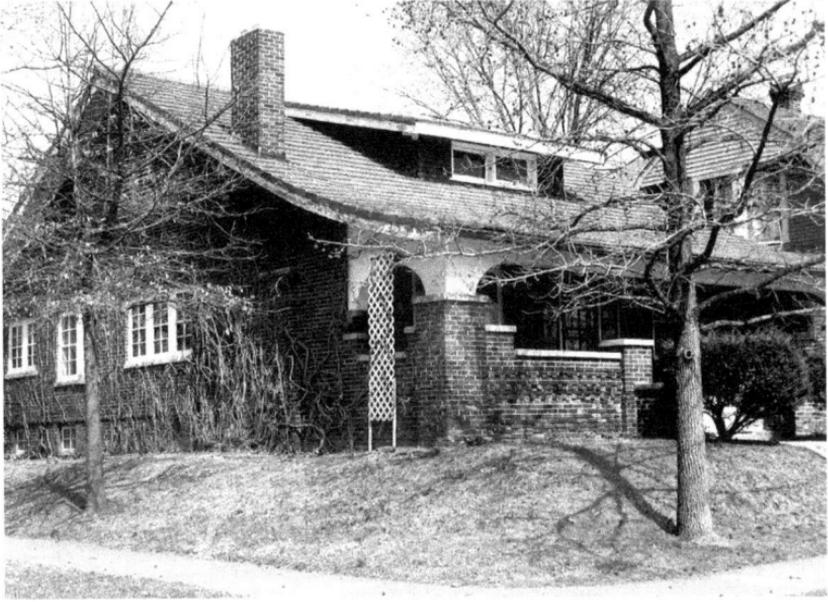

Cannonball Baker's house was built on a corner in Indianapolis after he paid to have another house on the site moved and turned ninety degrees. *Photo by author.*

Indianapolis; he spent nine hours treating himself to a bath, shave, some sleep and good food.

On a trip to California in 1950, his wife, Eleanor Baker, suffered a stroke in an Arizona motel. Baker called home to arrange for him and his wife to be met at the airport with an ambulance; he hoped he could fly his wife home. She died during the night, however. Baker's uncle, Clarence Baker of Speedway, flew to Arizona and drove his nephew home, an odd change of roles for Cannonball.

In 1951, Cannonball met the widow of a cousin, who later had married the pastor of the church the Bakers had attended. Emma Feckler became his second wife in 1950.

Cannonball died on May 10, 1960, in Community Hospital in Indianapolis of a heart attack. He was seventy-eight years old. He was buried in Crown Hill Cemetery. Until his death, he had tried in his spare time to develop an economical carburetor "for the poor man."

𝔉rom 𝔐y 𝔥ouse
𝔗o 𝔜ours

𝔐erry 𝔠hristmas
𝔥appy 𝔑ew 𝔜ear

𝔈. 𝔊. "𝔠annon 𝔅all" 𝔅aker

This Christmas card sent by Cannonball Baker featured his Indianapolis house, his wife and his deceased son. *Photo by author.*

Two of his many speed feats were driving a Franklin automobile from New York to Chicago in 1928, beating the time of the Twentieth Century Limited train. He shook hands with an engineer in Los Angeles and reached San Francisco ahead of the train without ever exceeding the legal speed limit.

"I figure that the success of speed boy is one-third nerve, one-third common sense, and one-third caution," Baker once told an interviewer.

In 1947, Cannonball became the first commissioner of NASCAR, a tribute to his role as a pure stock car driver. He was one of eight speedsters selected as inaugural inductees into the Motor Sports Museum and Hall of Fame at Novi, Michigan, in 1989. Others selected were A.J. Foyt, four-time 500 winner, stock car racer Richard Petty, drag racer Don Garlits, dirt track legend Barney Oldfield, aviator James Doolittle, hydroplane pilot Bill Muncey and Phil Hill, America's first world driving champion. Cannonball Baker might be forgotten by most Hoosiers, but the list of his fellow inductees shows that he could hold his own in some pretty fast company.

BYRON OF THE ROCKIES

Cincinnatus Hiner "Joaquin" Miller

Tell the folks back in the good old Hoosier state that I am glad they are alive.
Tell them that it depends upon God whether I ever get back to Indiana.
—Cincinnatus Hiner "Joaquin" Miller

Among Indiana eccentrics and mad-hat oddballs, perhaps one of the most talented, weirdest and most forgotten today was Joaquin Miller. He wrote successful poems, plays and prose, although many criticized the works and dubbed Miller unlettered. According to biographers, Miller never read any books other than his own.

His was a career of rags to riches, success and failure. At one time or another, according to him, he was a fugitive, an Indian fighter, a judge, an avid conservationist, a toast of society and a hillside hermit. A magazine called him a combination of Lincoln, Tom Mix and (Lord) Byron, who some considered to be a phony. To one critic Miller was "the greatest liar living. Half a mountebank and all the time a showman." One observer said that Miller had four loves: women, whiskey, poetry and trees—in that order.

Miller's epic poem "Columbus" was once memorized by schoolchildren all over the nation. It provided a motivational spark welcomed in any age, especially in its closing lines: "He gained a world; he gave that world / Its grandest lesson: 'On! sail on.'" The "Columbus" poem was commissioned for the 1892 World's Columbian Exposition marking the 400th anniversary of America's founding. Miller received fifty dollars for it.

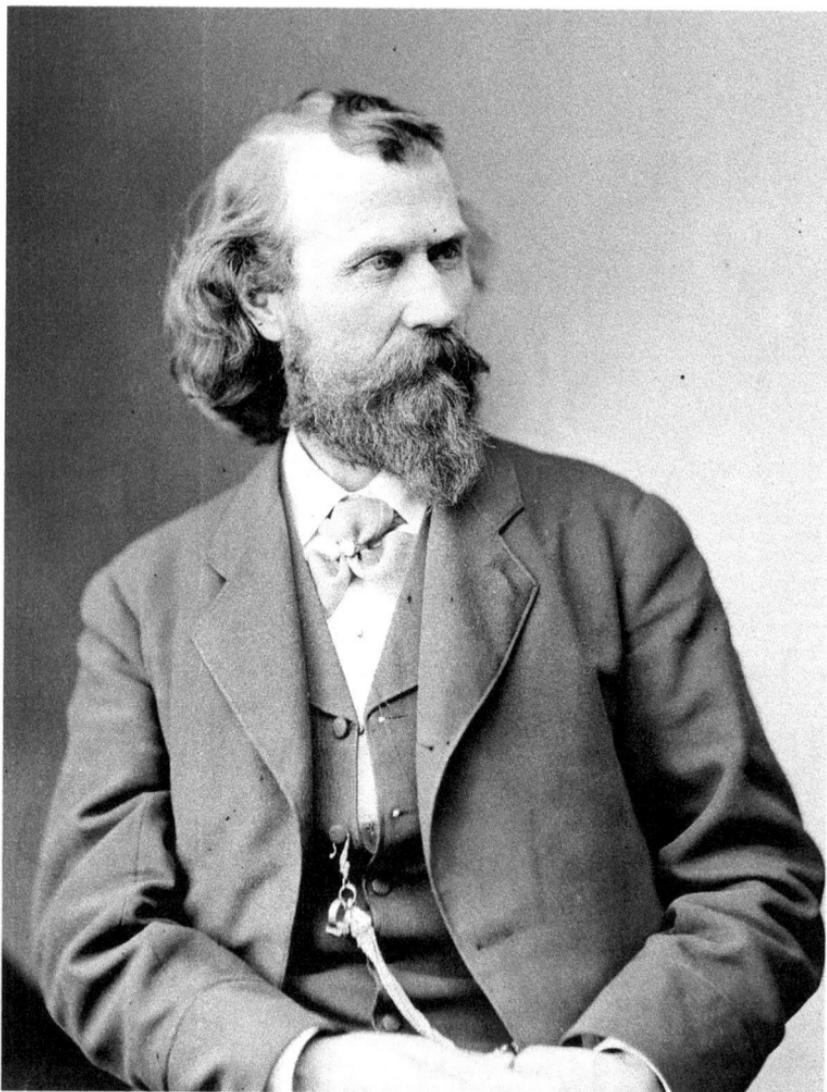

Cincinnatus Hiner "Joaquin" Miller moved to a spot above Oakland, California, and created an estate that attracted many visitors. *Courtesy of Oakland City Park.*

Miller was born at Liberty in southeastern Indiana in the opinion of most in 1937, or 1939 or 1941 or 1942—but probably 1937. He said that the family Bible was lost in a fire. He was christened Cincinnatus Hiner Miller because his father had come to Indiana from Cincinnati, and the doctor who delivered the child was named Hiner.

Because of Miller's carelessness with the truth, written segments about his life differ. His death is certain, February 17, 1913, because he was cremated, actually re-cremated, on a pyre he built on his California mountain retreat; the flames could be seen for miles.

He had at least three wives and numerous affairs. He was casual about divorces and said that his first wife, an Indian chief's daughter, had died.

Joaquin's parents were Hulings and Margaret DeWitt Miller. Hulings, like his son, held several jobs in Indiana—merchant, justice of the peace, teacher, mill hand. The family headed for Oregon in the early 1850s. There Miller fell in love with the West. Hulings wanted 640 Oregon acres offered by Congress, but he got only about 320 acres.

At seventeen, Miller—six feet tall and 170 pounds, although somewhat delicate for his size—ran away and became a cook in a gold mining camp. He got scurvy from his own cooking. He wrote his first poem, which the miners disparaged, but Miller considered himself a poet. In later life, he called himself *the* American poet. The miners called him "crazy Miller."

Miller's ensuing escapades included helping to establish an Indian republic at Mount Shasta in northern California and a marriage to an Indian girl named Cali-Shasta, who died in an accident. He got involved in horse thefts, was jailed, sawed his way out and returned to Oregon, where he enrolled in college. He then studied law in Washington Territory and became an attorney in 1861 in Idaho.

Of course, all Miller tales had to be believed with caution. Once in later life, Miller retorted to a critic, "I am not a liar. I just exaggerate the truth." Sometimes he told of meetings with well-known people who had been long dead. Once, he finished an account of the Yukon while still on the boat en route.

Miller left law for partnership in a pony express firm at Walla Walla, Washington, took time out to help his dad avoid losing the farm and then bought the *Democratic Register* in Eugene in 1863. There friends started calling Miller Joaquin after he wrote in defense of Mexican bandit Joaquin Murrieta; Miller liked "Joaquin" and adopted it as a pen name.

His poetry attracted the attention of Minnie Theresa Dyer of Port Orford, Oregon, or perhaps she attracted the attention of Joaquin. They exchanged letters, and Miller sped to visit her unannounced. Arriving on Thursday, he drove off her boyfriend at gunpoint and married her on Sunday.

Miller started a second newspaper, but his editorial comments raised the possibility of a lynch mob, so he left town. Shifting to Canyon City, Oregon, Miller practiced law, founded a literary society, published two volumes of verse and began planting trees, a practice he continued off and on all his life. In fact, his conservationism was cited even by his critics as one of his consistent contributions to society.

Miller led a Canyon City Militia company to quell an Indian uprising and as a result got a county judgeship; his plan to run for the Oregon Supreme Court fell through when Minnie accused him of desertion.

Buoyed by his two volumes of verses, *Specimens* and *Joaquin et al.*, Miller sought the San Francisco literary circles. Failing acceptance, he headed for England to visit the shrines of such poets as Burns and Byron. Miller's *Pacific Poems* brought applause in Britain. London literary circles embraced him. American critics at the time termed Miller a hayseed Lord Byron. The poet even affected a limp, like Byron, but unfortunately Miller often limped on the wrong foot. Later Miller had cards printed that read "Byron of the Rockies."

Indoors and out he wore a broad-brimmed sombrero, red shirt and scarf, a waist sash, unpressed trousers and heavy western-style boots, often two Bowie knives attached to his belt. He let his hair grow long and added a waist-length beard and a mustache. Sometimes he carried a miner's pick. Other times he sat on a bearskin and bade admirers to gather around its fringe. The outlandish western getups enchanted Londoners. Sometimes Miller ate goldfish as dinner appetizers. He fell down in excitement while reading his poems and once nibbled at women's ankles. "It enlivened the dinner—otherwise dull," he explained.

In 1871, he published *Songs of the Sierras*. The British loved it, Americans not so much. They pointed out his errors and rhyming *Goethe* with *teeth*. Miller traveled, eventually returning to England.

Maybe, as he claimed, he visited Brazil, spent a year in Italy and possibly went to the Near East. Between 1873 and 1907, Miller published some fourteen volumes of poetry and prose, including *Complete Poetical Works of Joaquin Miller.*

The poet found his third wife in Abigail Leland, a refined, cultured eastern hotel heiress. (Maybe he was divorced from Minnie, maybe not.) Miller and Abigail didn't mesh. They went to Washington, D.C. The new Mrs. Miller soon left, taking their daughter Juanita with her to New York. Miller moved into a cabin near D.C., enjoying the cabin, the adulation that it brought him and the notables who visited him. Twenty-seven years later, when the cabin was endangered, it was saved by California and Indiana congressmen, dismantled and re-erected in a Washington park.

Miller bought into an Indiana railroad line, but the stock plummeted. He did more traveling—Louisville, Kentucky, New Orleans—then sold his cabin for $5,000 and went back to California. He took a job as editor of the *Golden Era* magazine in 1886 and became associate editor of a literary magazine.

By now Miller seemed to be a confirmed ascetic, and he chose a rocky, treeless site one thousand feet above Oakland to build an estate. He planted trees on ninety acres of the Hights, including 100,000 trees in the shape of a cross visible for miles. He also planted an orchard. He called it the Hights because he thought the "e" was unnecessary.

Miller built a tiny house called the Abbey. He lived mostly in the open air, cooking outdoors. He usually slept from 7:00 p.m. to 7:00 a.m., often writing poetry in bed until noon. The Abbey later became a national landmark. Its single room was almost too low for a person to stand upright; it was later expanded to three rooms. Miller also later added a kitchen. As time passed, Miller built huts the size of packing crates for guests, plus a central dining room. By 1:00 p.m. lunch time, Miller usually was well into his daily quota of whiskey.

The poet hoped to attract budding writers and artists to the Hights and sometimes did so. One Japanese student visitor, Yone Noguchi, stayed there for four years; another, Takeshi Kanno, stayed for several years. Visitors to the odd, but magnetic, Miller included

This cottage was one of several constructed on Joaquin Miller's lofty estate called the Hights.

Presidents William Howard Taft and Theodore Roosevelt, writers Jack London and Ambrose Bierce and actress Sarah Bernhardt.

Miller erected a tower, a pillar and a pyramid as shrines to Captain J.C. Fremont, the California explorer; the British poet E.B. Browning; and Moses. "When I came here there was nothing but hillsides covered with sand and rocks. At first the task was hard and many a man would have ceased trying, but I do love to win a victory and I have won. I have earned the rest I am now having," Miller told a visitor. Mail came weekly. Miller kept no books—they were for people who can't think, he opined. "Nature is the only book man needs," he said.

Miller's daughters Maud and Cali-Shasta came to the Hights, although Cali-Shasta was bitter. Both girls died before Miller did. Miller always had women and numerous actresses at the Hights. Miller's mother lived at the Hights for many years. What some considered her senility others thought was caused by the whiskey Miller provided. She died in 1907, age ninety-two.

Daughter Juanita, who lived there for a time, inherited the Hights and was entrusted with Joaquin's burial. He wanted to be cremated

on the eight- by ten- by ten-foot pyre of 620 black flint rocks he had built, his ashes blowing toward San Francisco.

Miller once lectured the Indiana General Assembly on his Hoosier boyhood, and the *Marion Chronicle* invited Miller to a homecoming; in boyhood he once had lived at Jalappa, near Marion. That event never occurred. "Nothing would be finer for me than to walk barefooted down the roads where I used to live and let the dust creep up between my toes," he wrote in giving his regrets.

Although Miller had some harsh critics, his "Columbus" poem, which Tennyson lauded, was generally well received, as well as portions of his other poetry. One poem has made some serious quotation books and is cited on the marker at Liberty:

> *In men whom men condemn as ill*
> *I find so much of goodness still,*
> *In men whom men pronounce divine*
> *I find so much of sin and blot,*
> *I do not dare to draw a line*
> *Between the two, where God has not.*

In 1911, Miller became ill. Some sort of paralysis, it was reported. But he fled the hospital and was soon sending funeral invitations to Bay Area ministers, asking them to draw lots to see who would read the funeral sermon, which Miller had written. Weakness of age overtook him, and he rarely left the Hights. His wife Abigail came from the east to join Juanita at Miller's side. Death, which came at 3:00 p.m. on Monday, February 17, 1913, was attributed to diabetes, uremic poisoning, arteriosclerosis and organic complications. The "Poet of the Sierras," as he was sometimes called, had been only intermittently conscious for four days.

Health authorities thwarted Miller's funeral pyre plan, and he was cremated, instead, in the usual way. Despite his expressed objections, he was given rites at the Hights. Many friends came, but also hordes of mob-like strangers, whose souvenir searching required police intervention. On the next day, February 20, rites were given in the First Unitarian Church in Oakland. On May 25, 1913, the urn containing Miller's ashes was set aflame atop

his pyre. The urn melted and Miller's ashes were scattered by the wind. His estate, valued at about $100,000, was shared by Juanita and her mother.

There are memorials paying tribute to Joaquin in three locations—Union County in Indiana; Washington, D.C., where his cabin once was saved and moved to a park; and Oregon. Oakland purchased the Hights from Juanita in 1919 for $33,000 to become a city park.

SPELUNKING AND
SPIRITUALITY

Horace Carter Hovey

I question if the public will ever demand my biography.
—Horace Carter Hovey

Tourists and explorers regularly visit Indiana caves, such as Wyandotte and Marengo in Harrison County. But probably few who enter Indiana's underground splendors know that caves all over the nation owe their descriptive explorations and geology to a Hoosier. In fact, Horace Carter Hovey is said to have opened the world to the field of spelunking.

Hovey also was a successful clergyman. For more than fifty years after he wrote it, Hovey's *Celebrated American Caverns* was considered a standard geological reference. He was an early lobbyist for a national speleological society. He saw fulfilled his wish for Mammoth Cave in Kentucky to become a national park.

At Hovey's death, the Geological Society of America cited his role in bringing spelunking into the limelight by writing: "Cave-hunting was little else than a bizarre and venturesome underground diversion, seemingly impelled by curiosity alone" before Hovey devoted a lifetime of interest to it.

Hovey was born on January 28, 1833, at Rob Roy in Fountain County in a log cabin with a puncheon floor and a stick chimney. His parents had come from New England late in 1831 to minister to an area without a school, a church or a newspaper. The Reverend Edmund Hovey soon embarked on founding churches. His credentials were degrees from Dartmouth College and Andover Theological Seminary. He also had a Phi Beta Kappa certificate.

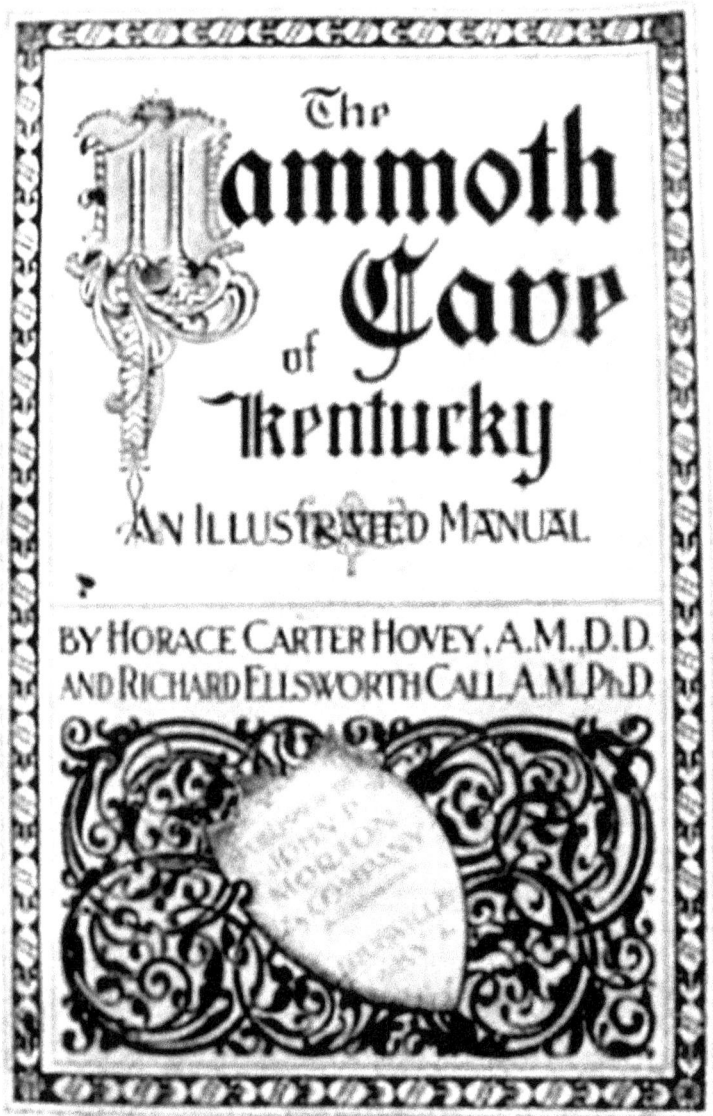

This volume by Horace Carter Hovey still is available in some form at Mammoth Cave in Kentucky, which Hovey explored.

The reverend began planning for Wabash College about twenty miles from Rob Roy and, within a year, had taken the lead in establishing the charter. In 1935, the Hoveys moved to the Wabash College campus.

Soon after reaching Indiana, Reverend Hovey began what was to be correspondences that "would fill a volume" with noted geologists. He served Wabash College as professor of geology, the second great interest in his life after religion.

Naturally, Horace Hovey developed his own interest in the ministry and in geology, plus cave exploring. When only nine years old, Horace explored streams and gullies near the campus. He brought his father chunks of limestone that seemed built completely of fossils. Soon his discovery became world famous as the crinoid banks of Crawfordsville. Horace also studied anthropology, invertebrate zoology, paleontology, mining, sociology, education, history, genealogy and nutrition. He played the flute and was a college singer and choir director.

At fifteen Hovey explored "the charming grottoes near Madison, Indiana." A plan to visit Mammoth Cave, then gaining wide publicity, fell through, but a book about the cave "fired my boyish imagination and it gave shape to much of my after life," he wrote.

As Hovey was graduating in 1852, Wyandotte Cave's vastness was being discovered. In 1854, he joined a group studying dozens of caves in southern Indiana. He helped map Wyandotte Cavern, described it before at least two scientific groups and wrote about Hoosier caves for the *Indianapolis Journal*. The stories were reprinted in the *New York Tribune*.

Geology then unlikely as a career, Hovey turned to the Presbyterian ministry like his father. He entered Lane Theological Seminary after getting a master's degree from Wabash College. His musical background brought him a job teaching music in Cincinnati public schools. Also teaching there was Helen Lavinia Blatchley of Connecticut. They married November 18, 1857. Hovey's religious career started with ordination by the presbytery at Madison April 16, 1858. His first post was located in North Madison, with visits to Vevay on alternate Sundays.

When a son arrived, Hovey took a better-paying job traveling as district secretary of the American and Foreign Christian Union, an administrative post covering several states. Soon he took jobs in Michigan, Massachusetts and Virginia and worked as a chaplain in the Civil War. He returned to Indiana in 1866, pastor of the Second Presbyterian Church of New Albany, where he would stay for three years.

Soon afterward, he wrote his father: "My attention has been called to a book on Wyandotte Cave by J.P. Stelle, in which he quotes from my articles on the cave, crediting them to Judge Hovey. Some he does not credit at all but plagiarizes out and out. I had a great deal of amusement and some vexation in looking over the volume.—Possibly I shall revisit the cave next week."

Hovey's financial needs took him to Peoria, Illinois, Kansas City and New Haven, Connecticut, and from there his writing and lectures gained in stature. His salary was the highest it had yet been, permitting him to live in genteel poverty.

Hovey visited caves to obtain the best possible data. As one researcher wrote: "His keen observation, a pleasant journalistic style, and a courteous and impressive personality brought him a reputation as the authority on American caves and comfortable supplementary income." In 1878, Hovey arranged with *Scribner's Monthly* to subsidize a trip to Mammoth and Wyandotte Caves.

This page and next: Horace Hovey explored most of the caves in Indiana, including Wyandotte Cave, one of his favorites.

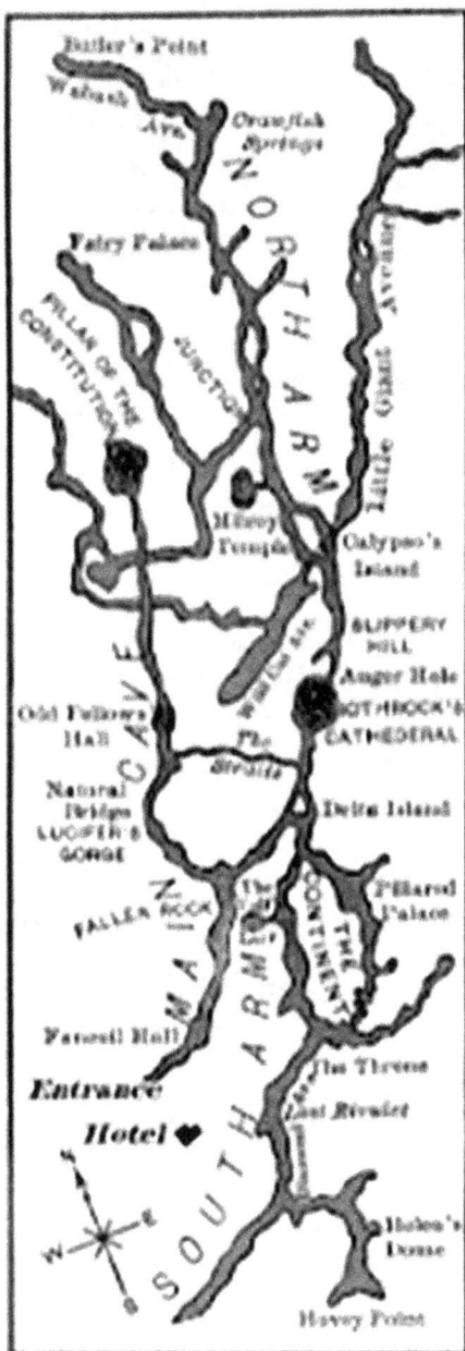

R. D. Servoss N.Y.
MAP OF WYANDOT CAVE, CRAWFORD
CO., INDIANA. TOTAL LENGTH,
23 MILES.

Scenes like this in Mammoth Cave are common for visitors today. Horace Hovey popularized spelunking.

About this time, he developed a study on Mammoth Cave's subterranean temperatures.

About the same time as the Mammoth and Wyandotte trips, Luray Cavern in Virginia was discovered. Hovey was sent there by *Scientific American* and produced articles that scooped the magazine world. His subsequent papers raised him quickly to the zenith of what some called "the unlovely term speleology."

By 1880, he was writing a wide variety of articles for *Scientific American*, and he began to systematize his notes. In 1882, he published *Celebrated American Caverns* and wrote the first of his celebrated Mammoth Cave guidebooks.

Hovey explored more than three hundred caves by his own estimation, far more than anyone else in America at the time. He rejected lurid tales about caves, insisting on reliable information. He provided a base for further technical studies of caves. In 1883, his articles began appearing in *Encyclopædia Britannica*. He was active in scientific and geological organizations.

His description of Wyandotte, which he called Wyandot after the Indian tribe, is written in an adventuresome, engrossing style, giving the reader almost a feeling of the movie *Journey to the Center of the Earth*. "We slaked our thirst at a crystal reservoir, scooped from the crown of a stalagmite, and filled by falling drops. A goblet rested on the rim of this dainty fountain, which each tried in vain to lift from the stone to which it was sealed by a transparent film," he writes during exploration.

Hovey wrote a lot about Wyandotte Cave, but Marengo was not discovered until 1883, the year after his caverns book was published. Both Indiana caves became national landmarks.

In his later years, Hovey said that his vacations for some fifty years had involved cave explorations. Subsidies from magazines covered much of the travel, so Hovey often went where his editors dictated. He often visited his three favorite caves, however: Mammoth, Luray and Wyandotte. In 1898, Hovey toured numerous French caves.

Hovey's philosophy of investigation was outlined in 1912 when he stated, "There is plenty of time. Wait and investigate. Pigeonhole every fact and wait. Many things beyond our immediate comprehension are worthy of patient and prolonged investigation."

Horace Hovey retired at age seventy-six to Newburyport, Massachusetts, the area where his father had been ordained. He continued to write on a variety of subjects. His final work, a bibliography of Mammoth Cave, reached him just before his death on July 27, 1914. As a biographer put it: "As a popularizer of American caves, Hovey is unmatched in American history. Directly or indirectly he served as catalyst alike for spelunking, descriptive speleology, and scientific investigations."

THE JEWELL OF THE WABASH

Fred A. Jewell

I grabbed the baritone horn because it was the littlest one I could get.
—Fred A. Jewell

F ew people know Fred A. Jewell's music today. For one thing, he
wrote the kind of marches that professional musicians played in
city or circus bands. Jewell also missed stardom because he lacked
self-promotional skill and public relations know-how.

Jewell wrote so many marches that no full roster of his songs
has ever been compiled. He sometimes used a pseudonym in his
own music publishing business, fearing that nobody would believe
that one man created so much music. Besides marches, he wrote
waltzes, serenades, overtures, caprices and a funeral march played
at his own burial.

During the heyday of the circus, it was seldom that the big top
musicians didn't play several Jewell marches. Jewell himself played
with circus bands, including directing the Barnum & Bailey Big Top
Band. He started so young that he was asked to grow a mustache or
beard to look older. "I grew a mustache, and it was a poor one, but
it was the best I could do at the time," Jewell told his family.

Jewell was bandmaster with the Hagenbeck-Wallace Circus.
He directed several city groups, including the Tampa (Florida)
Orchestra and the Long Beach (California) Band. He organized
the Indiana Masonic Home Band (Jewell was a Mason), whose
youngsters toured all over Indiana. He conducted the Murat Shrine
Band in Indianapolis and also taught music.

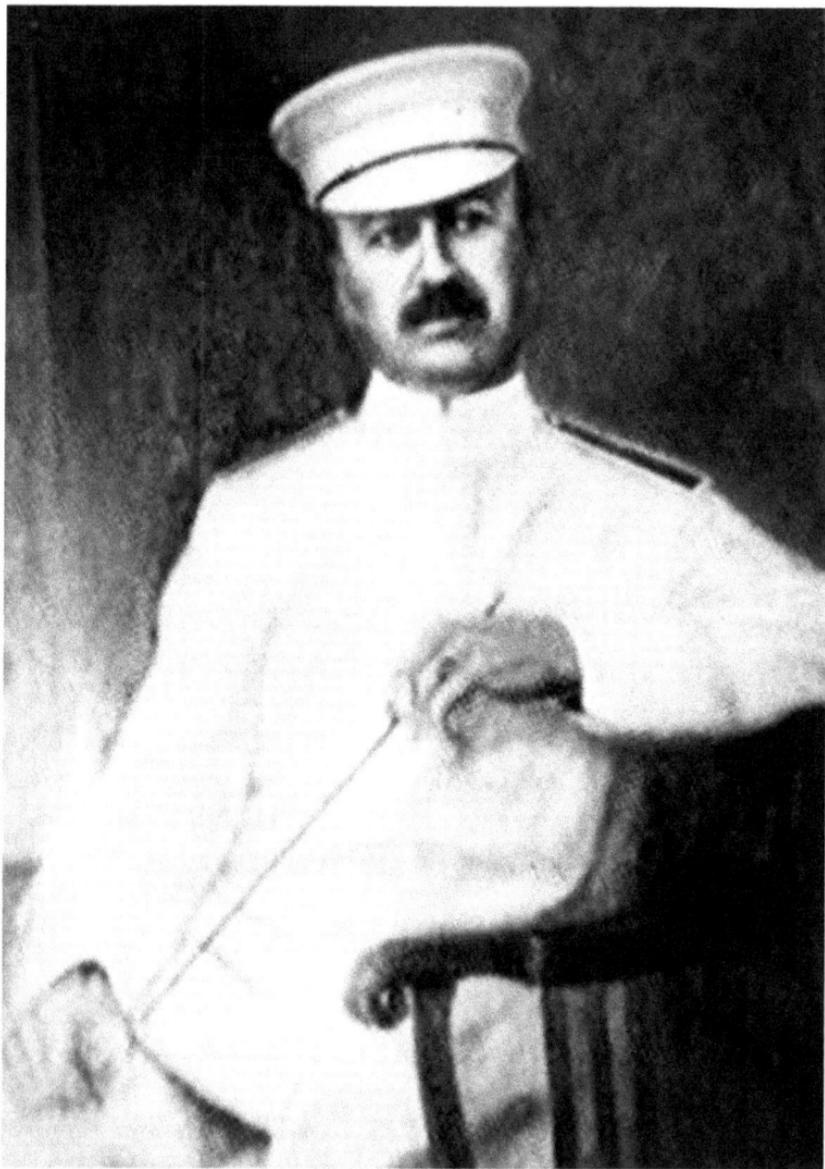

Fred Jewell played with circus bands at such a young age that he was asked to grow a mustache to appear older.

Fred Jewell was born on May 28, 1875, at Worthington, one of eight children of Dudley Jewell. Fred Jewell's son, Bud, a musician and attorney, was one of the few able to assemble the details of his father's life. Bud Jewell died in 2002, ending one of the last sources of information about the march maestro.

Dudley Jewell was a music teacher. He traveled, organizing church choirs and teaching members to sing—a kind of Music Man. In 1888, a minstrel show became broke and was stranded in Worthington. To get money to leave Worthington, the troupe sold all of its instruments to Dudley.

Dudley began teaching his family to play. Fred Jewell, then about fourteen, seized the baritone horn because of its small size. He had been taking some music lessons from his father since he was nine. The formation of the Jewell Family Band brought some success. In that era—before movies, radio or television—musical performances were highly rated.

Fred was only in the family band for about two years. At sixteen, he ran away from home. Reaching Bloomington, Jewell joined the Gentry Brothers Dog and Pony Show, playing the baritone horn, and stayed with that troupe for six years. Then he became a bandmaster for the first time, starting with the Wallace Circus. In 1899, he left Wallace for Gentry, this time as bandmaster and writing music played for circus bands. One of his first was "Gentry's Triumphal March," a tribute to the Bloomington-based show.

In 1902, Jewell moved to Otto-Floto Show in Bloomington as bandmaster, staying with that show as bandmaster under new ownership as the Sells-Floto Show with headquarters in Denver, Colorado. For the 1907–8 season, Jewell gave up directing and played baritone horn soloist for the Ringling Brothers, Barnum & Bailey Circus.

Inexplicably, Jewell left the circus to become maestro of the Long Beach Band from 1911 to 1915. Maybe illness was the reason. Jewell had contracted malaria in Brazil while on tour with Barnum & Bailey. He was treated by a Worthington physician who would soon pass on and leave a widow—Mrs. Myrtle Gray. Jewell returned to Worthington for a visit in 1912 and married the widow Gray.

Leaving Long Beach—nobody knows why—Jewell was bandmaster for Hagenbeck-Wallace from 1916 to 1917, and then he went to Oscaloosa, Iowa, to direct the Iowa Brigade Band; he led the high school band, led orchestras for theatricals and stage shows, played at movies and composed more and more. For some time, Jewell had been publishing his music through C.L. Barnhouse Music publishers, but realizing the need for his own label, he started a firm in Iowa using the name J.E. Well.

Myrtle had disliked the travel of circus life. She forbade it when Bud Jewell was born in 1920. The family returned to Worthington in 1923, and Jewell opened his music publishing firm there. The family moved to Franklin in 1926 when Jewell started the Indiana Masonic Home Band, youngsters traveling around Indiana and giving performances at Masonic lodges. "Dad loved kids and he loved to teach them music," Jewell's son told a reporter.

Jewell had become a Mason in 1908 at Worthington, Greene Lodge No. 577. He also conducted the Murat Shrine Band in Indianapolis, beginning in 1926. Jewell conducted the Tampa Orchestra for two years but returned to Worthington in 1929, writing music and teaching at Worthington High School and at Martinsville. He also helped towns organize and present concerts.

"I really don't understand how he did what he did," Jewell's son told an interviewer. "I'd come home and Dad would be writing music. I believed everybody's Dad could write music." Jewell played piano, tenor horn, baritone horn, clarinet, cornet, trumpet and violin. He could play jazz or ragtime. "He played what people wanted to hear," observers noted.

When the Navy Band made a recording to celebrate the nation's bicentennial in 1976, it included nine of Jewell's compositions, such as "Trooping of the Colors," "El Campo," "Old Circus Band" and "American Legionnaires." Jewell wrote "Pageant of Progress" for the Chicago World's Fair in 1933. He wrote "Checker Flag" in 1928 for the Indianapolis 500 Mile Race, but it was only played a few times.

One list of Jewell's compositions, certainly incomplete, shows eighty-four songs that he wrote using his own name and fourteen that he published under the name J.E. Well. In the late 1960s, at

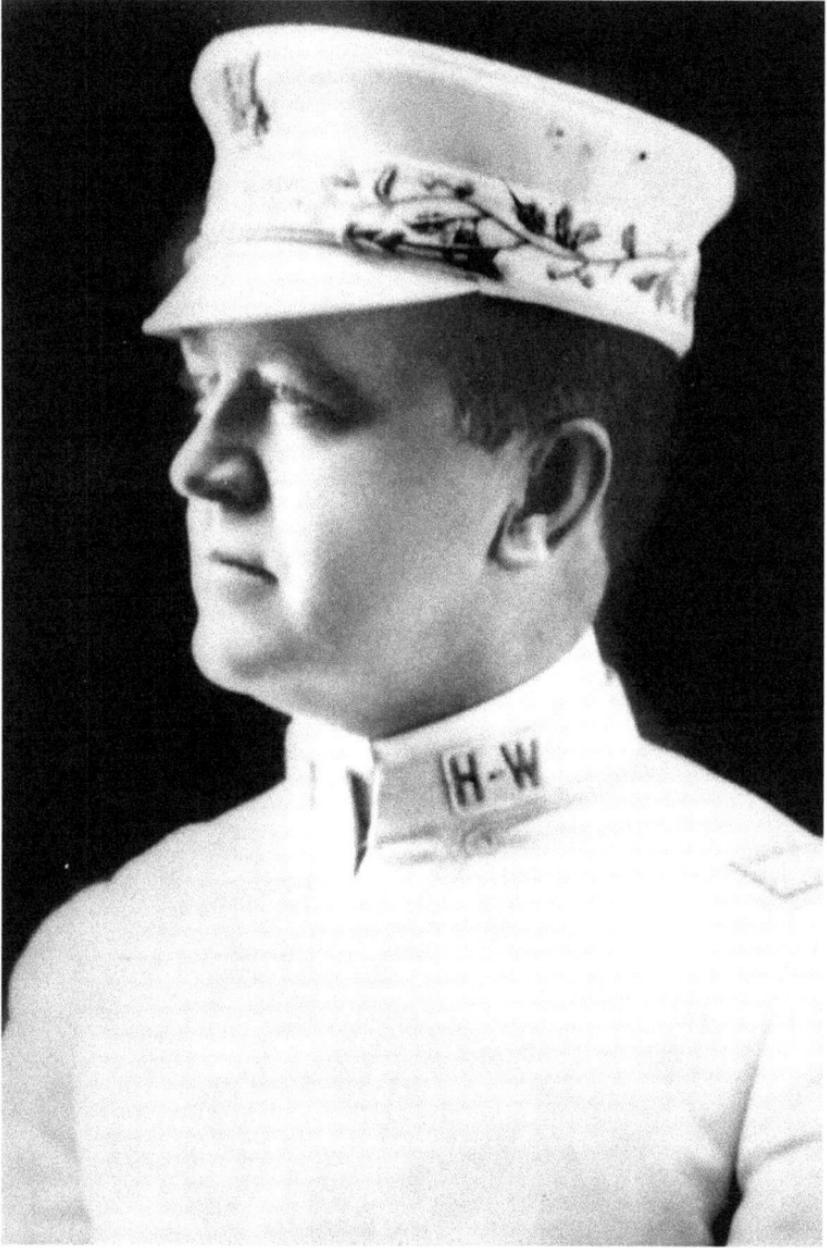

This page and next: Fred Jewell in progression until probably a few years before his death at age sixty-one. *Photos courtesy of Becky Henry.*

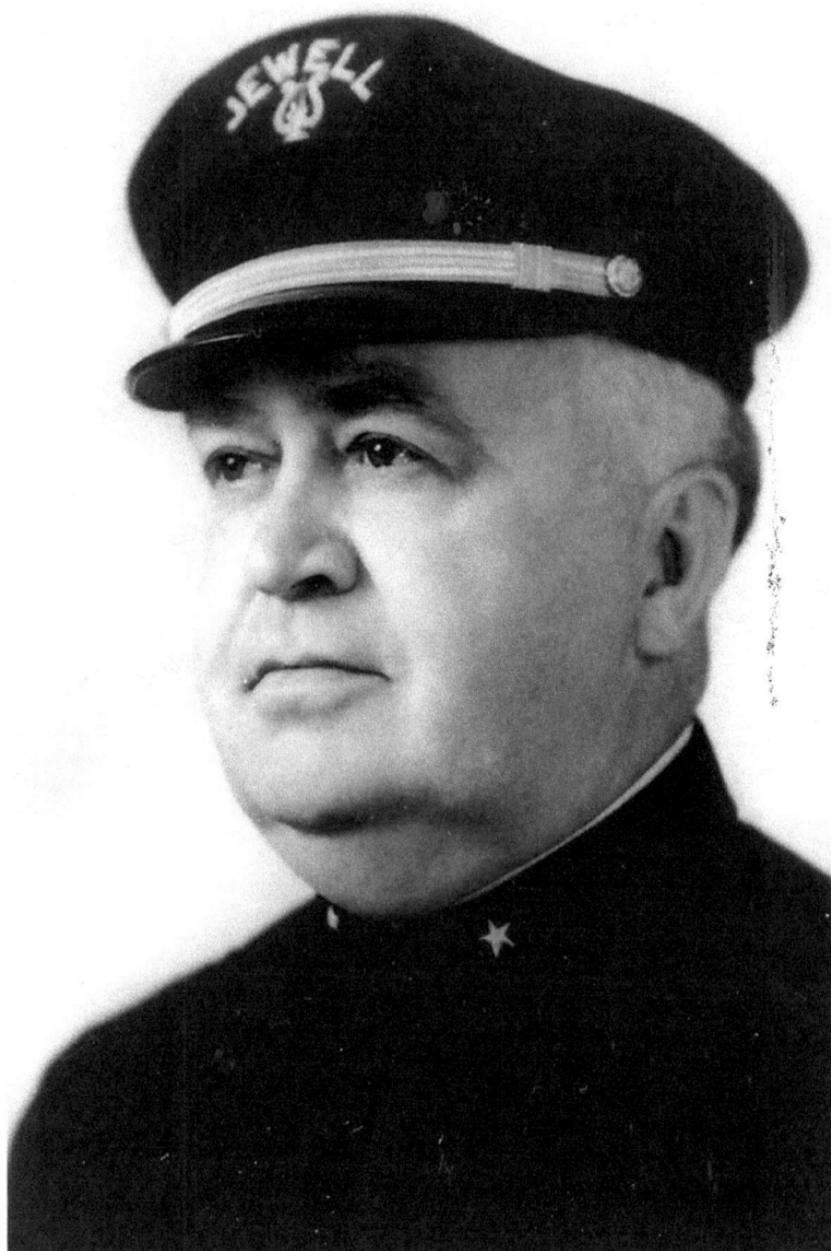

least one hundred Jewell songs were purchased for the Purdue University music archives. "The university would love to have the complete works," said Al Wright, then band director.

Jewell taught music at Worthington High School until the spring semester of 1935. He became ill that summer and was hospitalized in St. Vincent Hospital in Indianapolis.

Jewell was not only a contemporary of John Philip Sousa, but his talent was also recognized by the famed march king. When Sousa appeared in 1900 in Oscaloosa, Iowa, where Jewell was conducting a concert, Sousa told the audience, "There are people who say I am the March King, which could be true. But after me, there is this man." Sousa then introduced Jewell. Sousa visited Jewell in Worthington in 1930, two years before Sousa died.

Jewell never recovered his health after the 1935 hospitalization. He died on February 11, 1936, at only sixty-one years of age. At least thirty-five members of the Murat Band, joined by other musicians, went to the funeral rites in Worthington and, without rehearsal, played "Last Call," a funeral march composed by Jewell. Jewell was buried in the Worthington Cemetery with a modest footstone.

"I regret that I did not follow my father's career as closely as I should have," Bud Jewell told an interviewer in 1973. There have been a few tributes to Jewell. In August 1963, the Bedford Municipal Band presented a special program "honoring Indiana's greatest municipal band director and composer." In 2003, the Brazil (Indiana) Concert Band and the Jackson Township Community Band produced a CD of twenty Jewell marches called *The Jewell of the Wabash*. There were only one thousand copies made.

Once in a while, a Jewell composition may sneak into band concerts today. But as time passes, fewer and fewer will recognize it or the Hoosier who wrote not only it but also hundreds of others.

THE MISSISSIPPI
MIRACLE MAN

James Buchanan Eads

I will give the Mississippi River a deep, open, safe and permanent outlet to the sea.
—*James Buchanan Eads*

He was far ahead of his time. Self taught and inspired by his knowledge of river currents, James Buchanan Eads performed engineering feats that many said couldn't be done. Flying in the face of consistent criticism, he left behind landmarks still considered marvels and eventually received worldwide recognition for his accomplishments. And yet today he gets little more notice than twigs passing swiftly down the Mississippi River that he loved.

Born in 1820 in Lawrenceburg to Thomas C. and Ann Buchanan Eads, James was three years old when the family moved to Cincinnati. His father was a merchant who had little success. In the summer of 1833, Ann Eads and her three children—James, Genevive and Ann—left Louisville by boat to reunite with Thomas Eads, who had gone ahead in pursuit of success.

Before the family reached St. Louis, the paddle-wheeler on which they traveled burned, destroying all their belongings. James worked in St. Louis at a variety of jobs at Williams and During's dry goods. His mother let rooms.

James Eads, already fascinated with the river, was inventive. He built a treadmill for rats, his first invention, and created a six-foot-long steamboat that he operated on Sundays on Chouteau Pond west of St. Louis. Eads pored over the volumes in Williams's library.

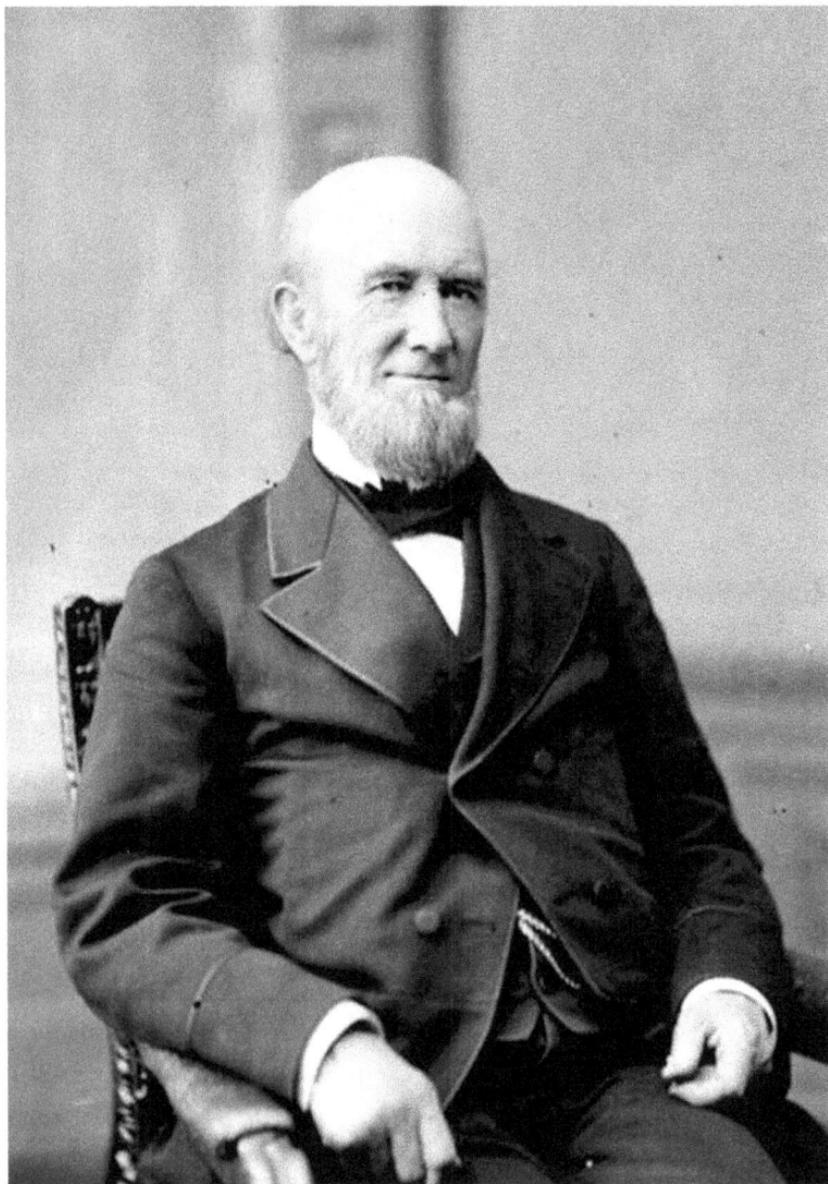

This page and next: James Buchanan Eads, a self-taught engineer years ahead of his time, cleared rivers and built bridges.

When Mrs. Eads at last went to join her husband at Parkhurst, Iowa—the town he helped to develop, later called Berlin—James stayed in St. Louis. The budding engineer's first job on the water in 1939 was as a second clerk on the riverboat *Knickerbocker*, checking freight. But the *Knickerbocker* hit a snag and sank, a foretaste of Eads's role in making the rivers safer for boats.

In nearly three years on the Mississippi, Eads learned a lot about the river's currents. He also knew the heavy losses suffered when cargo-laden boats sank. Swift currents and changing topography often concealed boat hazards, as did sediments.

In 1842, Eads invented and patented a diving bell, which he called a submarine, built in Kentucky. He intended to find and salvage many of the wrecks that he knew littered the Mississippi River bed. Eads discovered, among his first targets, a boatload of lead near Keokuk, Iowa. He was twenty-two years old.

Eads formed a partnership and prowled the Mississippi for wrecks. "I walked the bottom four hours at least every day (except Sunday) during this time," he wrote. He was successful in getting bids for salvage once considered a total loss.

Eads met and wooed Martha Dillin in St. Louis. She was reluctant, and her father was against the wedding. Eads sold his interest in the submarine and opened a "respectable" glass company in St. Louis, the first glass firm west of the Ohio River. It worked. James and Martha married on October 21, 1845. The glass company failed, and he closed it in debt $25,000.

Borrowing $1,500, Eads regained his submarines and built two more. Now he was walking the river again, sending letters home via passing boats between his occasional trips home. In 1846, his first daughter was born. A son was born in 1848 but died in less than a year. A second daughter arrived in 1851. By that time, Eads had four submarines in operation and also developed a method for raising boats and their cargo by pumping out the water and the sand.

Martha died on October 12, 1852. Eads met and married Eunice, the widow of his cousin, on May 2, 1854.

In 1855, Eads paid $185,000 for government snag boats. He converted them to bell boats for use in his salvage efforts. Soon he had twelve submarines and sought U.S. legislation to clear the Mississippi, Ohio, Arkansas and Red Rivers of debris for an annual fee. The measure passed the House of Representatives but failed in the Senate.

Despite being thwarted by Congress, Eads had become successful and wealthy. Forming the Western River Improvement Company, Eads took his salvage system to insurance companies, which were glad to pay well for the recovery of cargo. Eads made $500,000 in the venture.

Eads had become a chess player of some ability. He was called genial, witty and sometimes startling in his conversation. He and wife Eunice had built a large home on Compton Hill in St. Louis. Eads often sent his friends fruits from his gardens and wines.

At the onset of the Civil War, Eads urged gunboats to patrol the Mississippi to keep the river open for commerce and to battle

Southern fortifications. The upshot was a U.S. contract for Eads to make seven gunboats in sixty-five days. He had one boat ready in five weeks, naming it the *St. Louis*. He financed it himself, with the government to pay on delivery; the government, not surprisingly, was late in paying.

Eads fulfilled his amazing promise of gunboats by having more than four thousand men working all over the country on components for the boats, which incorporated new ordnance inventions that Eads patented. Six more boats followed the launching of the *St. Louis*. An eighth gunboat was obtained by modifying one of Eads's salvage boats. No one had seen river craft that were as strong and ferocious. During the course of the Civil War, Eads built fourteen armored gunboats and converted others into what were called "tin-clads." Their armor and firepower were unmatched.

The Civil War effort undermined the inventive engineer's health; he was put to bed in 1863 suffering from fatigue and strain. By 1864, he had regained his strength and formed his bridge firm, the St. Louis and Illinois Bridge Company. There was talk of needing higher bridges to accommodate increasingly larger river craft. Eads sailed to Europe with Eunice and his daughters for rest and recuperation, but by September 9, 1866, he was back in St. Louis.

Congress had introduced a bill in 1865 calling for a bridge across the Mississippi at St. Louis with a center span of five hundred feet and a clearance of fifty feet. Such a thing had never been done, and many engineers called it impractical if not impossible. But Eads thought differently. In 1867, his plan for the bridge was approved. He traveled and conferred with bridge experts and found a compressed air system in Europe that he thought workable on the St. Louis structure.

No one had worked at such depths with compressed air. The construction preparations in pneumatic caissons drew crowds of onlookers. Because Eads was familiar with the power of the river's current, he insisted that the pilings reach bedrock ninety-three feet down, which took four months of perilous work until February 28, 1870. The pier driving received widespread publicity. Tourists came to see it.

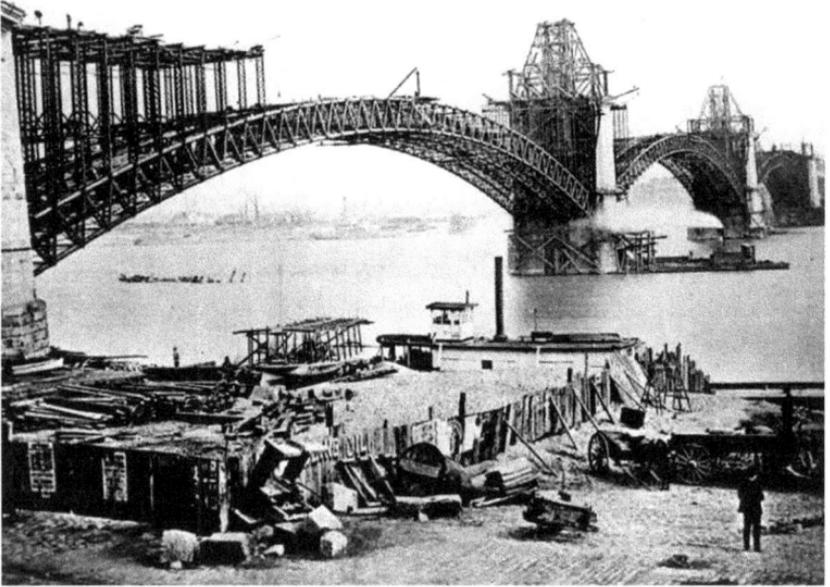

The bridge over the Mississippi at St. Louis, shown here under construction, was completed by James Eads, though some said that it was impossible.

Cables installed to carry the arches into place proved a problem, solved when Eads found that it was the temperature that affected them. Over all obstacles, the bridge was completed, with a center span of 520 feet, using fabricated steel made to Eads's harsh specifications. Pedestrians crossed it on Sunday, May 24, 1874, cars in June; the official opening was July 4, 1874. A total of fourteen men died in the construction. But it was, most agreed, "the greatest engineering feat of that sort," known today as the Eads Bridge. Forgotten were the attempts that Congress made to scuttle the bridge and continual objections by the army, which had charge of rivers. *Scientific American* urged Eads for president.

"The love of praise is, I believe, common to all men, and whether it be a frailty or a virtue, I plead no exception from its fascination," Eads told the bulging crowd that packed St. Louis when the bridge opened. Onlookers included President Ulysses S. Grant.

The accomplished engineer, who had proven his theories, was not through with the Mississippi yet. Eads now proposed to open its delta at New Orleans by a novel method so oceangoing vessels would not have to wait for high tide to reach the city.

"I shall certainly open the mouth of your river," said Eads. His proposal to use jetties was ridiculed by some. "I will give the Mississippi River…a deep, open, safe and permanent outlet to the sea," said Eads in May 1875. With approval from Congress, work began on "the most difficult piece of engineering in river hydraulics which the world has ever seen."

Eads's aim was to make willow mattresses that would fill naturally with silt. This, he said, would increase the current and force unwanted silt out to sea. Eads invented equipment to help produce these jetties. When the jetties were completed in 1879 after four years of work, the cost of $5,250,000 was half the estimated cost of bypass canals that had been proposed.

Now Eads had earned the plaudits of the world. He became a consulting engineer for the State of California in July 1879. Others wanted jetties to clear streams. Eads got requests from around the world to inspect rivers and improve their mouths. His papers, addresses and communications to Congress and to technical magazines, newspapers and societies became valuable for their insights into improving rivers. By 1872, he had nine patents. The University of Missouri gave him an LLD degree. He was elected to the National Academy of Sciences.

Eads turned to a new challenge. When the Panama Canal Congress was held, Eads offered a plan to carry boats across the isthmus by rail instead of the proposed tidewater canal. His perpetual foes labeled the rail idea foolhardy and unworkable.

Undeterred, by 1880 Eads obtained permission from Mexico to build his ship-rail at Tehauntepec, the shortest route across the 135-mile isthmus and close to New Orleans, now an important port because of his river-clearing jetties. Eads displayed a thirty-foot model of his ship-rail in London and Washington in 1883–84.

Eads envisioned a six-track railroad, locomotives on the four outer tracks, tenders with coal and water on the other two tracks. The ship would move on 1,200 wheels for the twelve-miles-per-

hour crossing. In 1884, Eads moved to New York City, closer to Washington, to lobby for his ship-rail. He decided to finance the ship-rail if he were guaranteed 6 percent dividend for fifteen years, should his project suceed.

A bill passed the U.S. House but failed in the Senate. In 1885, Eads got a revised proposal before Congress. "I shall not die until I accomplish this work and see with my own eyes great ships pass from ocean to ocean over the land," he said. The measure failed again.

It was too late. Eads's failing health worsened, and he was ordered to rest. He sailed to Nassau to recuperate in February 1887. Reservations to return home had been made when he died on March 8, 1887. His last words were said to be: "I cannot die. I have not finished my work." The body was taken for burial to Bellefontaine Cemetery in St. Louis. Not until 1914 was the Panama Canal that we know opened, using locks and not tidewater. Six years later, an article in an engineering journal stated: "What might have been the history of isthmian transportation if the ship-railway had been built can only be a matter of conjecture. It may be that engineers will again consider the possible application of the ship-railway for transportation in commercial and military service."

In his lifetime, Eads had been a member and once vice-president of the American Society of Civil Engineers and a fellow of the American Association of Arts and Sciences, the British Institute of Civil Engineers and the British Association of Civil Engineers. He was the first American to get the Albert medal from the British Society for the Encouragement of Art, Manufacture and Commerce. He was president for two terms of the St. Louis Academy of Science and was chosen a member of the National Academy of Science. He received a doctor of laws degree from the University of Michigan. He had worked on harbor and river projects all over the world.

Eads, in his way, fulfilled one of his own measures of success. Early in his career he had stated:

The man who can by his inventive genius cheapen light or heat or the supply of water to the masses is greater than a general...He

who by his genius can cheapen bread or clothing to the poor, or any of the common necessities of life, such as sugar, salt, soap or fuel, deserves the thanks of the nation, and to have his name inscribed in the temple of fame.

BEAUTY FOR ASHES

Mrs. Albion Fellows Bacon

No one can look at me without thinking of slums.
—Mrs. Albion Fellows Bacon

Certainly someone in Indiana would have taken up the crusade that Mrs. Albion Fellows Bacon shouldered in 1909 and pushed to success in 1917. It almost put her in bed in Evansville; she already had been bedridden once before her tussle with the Indiana General Assembly even started. But the frail one-hundred-pound woman persevered. She obtained Indiana's first tenement law in 1909, expanded it in 1913 and in 1917 won a widespread housing law, rescuing the slums that she abhorred. Her subsequent book *Beauty for Ashes*, although somewhat rambling and naive in many ways, became a sort of guidebook for seeking laws to change urban slums and all their attendant evils.

"I have only made a good beginning," said Mrs. Bacon with passage of the 1913 law. "The revenge of the slum falls not only on the individual, but upon the city, in all its interest and activities," she wrote. "I feel no triumph, but a deep sense of shame that it has been necessary to fight so hard and so long for air, for sunshine, for water, for space. It is a stifling thought."

She became a director of the National Housing Association, spoke widely on housing programs and was nominated ten times by Indiana club women for recognition as one of the ten most prominent women in the nation.

Albion Fellows was born on April 8, 1865, in Evansville to Mary Erskine and the Reverend Albion Fellows, a Methodist minister.

Writing legislation for housing in Evansville launched Mrs. Albion Fellows Bacon on a campaign against slums that widened to include all of Indiana.

When Albion and her sisters were young, the Reverend Fellows died, prompting the mother to seek the small-town atmosphere of streetless McCutchanville, just north of Evansville.

After grammar school, Albion went to Evansville for high school and then attended what she called an "art university." Upon graduation, she got a post as secretary for her uncle, Judge Asa Ingleheart, and learned shorthand on the job.

She married Hillery Bacon, a prominent Evansville businessman, and settled into a life of servants and refinement. Details on their meeting and wooing are lacking. She spent two years recovering from what she called "nervous prostration": "Sheltered—that is what I was, and what thousands of other women are who have not seen life and who do not want to see it as it really is," she wrote. "For hours I would sit idly, not making an effort even to read."

Awakening began when she saw the school playground of her daughters Margaret and Albion. Mrs. Bacon campaigned through

the Civic Improvement League, obtaining additional land for a school playground. Soon she discovered schoolmates in poor homes. She sought out Caroline Rein, secretary of the Evansville Charities Organization, who was considering a Friendly Visitors Circle. Rein took Bacon on her first tour of the Evansville slums.

"My first visit to the poor haunted me," said Bacon. She was stimulated to visit the poor on her own. What she discovered was

> *no kitchen sink, no water in the house, or even in the yard, no place to throw dishwater and suds, except into the yard; with no closet, no shelves, with rough floors, still gray after continued scouring, plaster in loose patches, shedding powder all about and defaced woodwork whose cracks held vermin and dirt, and let in dust and soot; with musty, dark rooms that had no window, or a small one, and could not be decently sunned or ventilated; low floors that were always damp, and cellars standing in seep water.*

She also found typhoid and other sickness and babies in need.

She helped found a Flower Mission, through which girls gave flowers to the poor. "Down deep in my heart came a knowledge that I could never rest until I could do something—something to wipe out the poor of the slums, to lift the shadow, the horror of the ugliness—to give beauty for ashes," she wrote. After the Flower Mission, she organized a group to assist girls arriving in Evansville without friends or money. Bacon also helped found the Working Girls Association to aid women in the workplace, especially factories, providing "dorms" and a lunchroom with meals for about eleven cents. From that developed a summer camp that later merged into the YWCA.

"It was a case of frenzied philanthropy," wrote Bacon. It was fully supported, both emotionally and financially, by her well-to-do husband. "Instead of looking for the poetry first in magazines and papers, I hunted up articles on sanitation, house flies, etc., and even read bits of local politics," she said. Evansville was considering a building ordinance, and Bacon was urged to write the proposed legislation. She studied laws in New York and Chicago and fashioned

her own. It came to naught, but a sleeping giant had been stirred. She envisioned a housing law for Indiana.

Through the charity organizations in which she was involved, Bacon surveyed the state and found slums everywhere. Based on the survey, a slum bill was drafted for the 1909 Indiana General Assembly by the naïve Bacon. "I never saw a legislature, and I hadn't any idea what to do," she said. In June 1908, she launched a letter-writing campaign.

"One by one I had given up all forms of recreation," she later wrote. "Reading had been cut down to housing legislation. Society was abandoned, and even my best friends complained of my neglect." She got her bill endorsed by the State Charities Conference.

The legislation, applying to properties on which two or more families lived, provided that every tenement should have at least one window and dealt with the minimum size of rooms and requirements for water, toilets and drainage, among other things. When the bill reached the floor of the House of Representatives, landlords denounced the measure. Small towns objected, fearing that the law might devastate their small budgets. The bill was amended to apply only to first-class cities—in those days Indianapolis and Evansville—and passed. Bacon soon suffered a painful loss when her daughter Margaret died.

A new bill was drafted for 1911. The frail lady from Evansville now had a greater knowledge of the political process. The bill was introduced in the House, where she had support, and passed. Not that it was easy. "Trip after trip I made home, and back again. It was a severe winter, snow storms delayed the trains, and I was sick half of the time from exposure in icy sleepers and from going to and from the statehouse, in sleet or rain," she said. After some maneuvering, the Senate defeated the bill.

Bacon was undeterred. She gained support from the State Federation of Women's Clubs with its sixteen thousand members. She chaired the federation's housing committee. She made speeches all over Indiana and enlisted the help of churches.

In 1913, the housing bill was introduced again in the Indiana Senate. Prospects were good. In the House, less so. The House

committee started a stalling technique over the ninety-eight sections of the bill. In response, Bacon started a letter-writing campaign directed at the committee. She gained support from Lake County because the bill now would affect at least one hundred Indiana cities, including some in Lake County. The bill was released from committee, passed and became law. "I have only made a good beginning," said Bacon.

By 1914, spurred by the Bacon Bill, Evansville had become active in enforcing housing laws; it tore down some tenements. One new apartment complex was named the Albion. Not until 1917 was legislation passed to give the state control over dangerous and uninhabitable buildings in all the state's 373 cities and towns.

Bacon received letters from everywhere requesting lectures and help with housing legislation. She served as a director of the National Housing Association. Bacon was chairman of the child welfare commission created by the Indiana legislature in 1919 and worked for child labor and compulsory education laws. She organized the Indiana Child Welfare Association. For ten years she was a member of the Evansville City Planning Commission. She was active in the Indiana Tuberculosis Association and the Legislative Council of Indiana Women, chaired the Indiana Juvenile Advisory Commission on Probation and was a member of the Family Welfare Association, Visiting Nurses Association, National Child Welfare Association and the Indiana Historical Association.

"It is with joy that I hear, in the distance, the busy hammers at work on model homes for our people," she said, as housing reform began. "I trust some day that the wailing of sick babies will be drowned entirely by the shouts and laughter of happy children." She died on December 10, 1933. She was sixty-eight years old.

SWING INTO OBLIVION

Elmo Lincoln

We made it [Hollywood] *great. Now they just give us bit parts that don't even pay for the groceries.*
—*Elmo Lincoln*

He was big in stature and big in the movies—he was the first Tarzan of the apes—but then talkies came along and Elmo Lincoln of Rochester joined the ranks of people who had created a world-famous Hollywood only to be put in storage like old, rotting film.

In his day, Elmo had been one of the luminaries. He played at least five roles in *Birth of a Nation*, the D.W. Griffith movie of 1915 that launched movieland's love affair with blockbuster films. Elmo was once cited by the Hollywood Chamber of Commerce as one of those who helped make Hollywood the "film capital of the world." He starred opposite one of the early big-name film females—Lillian Gish. His brawn earned him the title role in *Elmo the Mighty*, an eighteen-episode serial in 1919, one of some one hundred films in which Lincoln appeared. But he is seldom listed among noted actors and actresses of the past. Once, when being given a minor honor by the Hollywood community, Lincoln said, "I'd rather have a job."

He was born Otto Elmo Linkenhelt on February 6, 1889, to Eldora and Louis R. Linkenhelt, the second marriage for Louis. His mother had been reading a book about St. Elmo, which inspired his middle name. Little has survived from his early days. Former schoolmates, by the 1970s, had only vague memories of the strapping gentleman.

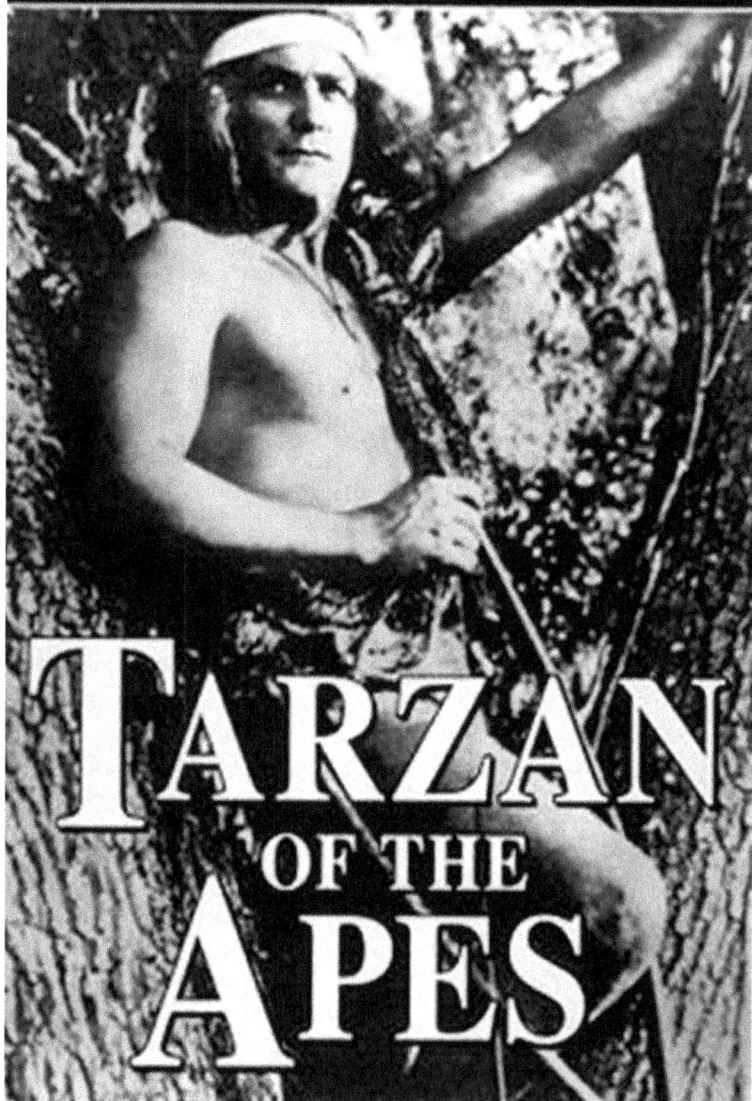

Elmo Lincoln, the first movie Tarzan, also had so many roles in *Birth of a Nation* that the director lost count.

On a return to Rochester, Elmo visited Della Morris, who had borne a son. Lincoln allowed Della to raise the boy as Maurice Linkenhelt, evidence of a Rochester affair, before Elmo left for California when he was a youth. "He was sort of a medium boy," said one woman who had gone to school with Elmo Linkenhelt.

Once Elmo, about eighteen, reached California, he seemingly got a job as a lifeguard at Santa Monica Beach. According to Lincoln, director Griffith encountered him one day and growled, "How would you like to be in the movies?" Griffith gave Linkenhelt his stage name of Elmo Lincoln.

At 210 pounds, five feet, eleven inches tall, Lincoln had a chest expansion to fifty-three inches. In Griffith's *Birth of a Nation*, Lincoln played Union and Confederate soldiers, a Ku Klux Klan raider, a bartender and a blacksmith, whose role called for him to throw a man through a window. Griffith used the Hoosier in several of his films, including *Intolerance* and *The Greatest Thing in Life*, with Lillian Gish.

The first Tarzan book by Edgar Rice Burroughs came out in 1914, and Lincoln got the lead part in the first film, *Tarzan of the Apes*. His selection for the part, he said, came at the filming location in the swamps at Morgan City, Louisiana. "They had two or three Tarzans, but none of them could go through with the part," he said. "The fellow I replaced was from Chicago. He was a ukelele player. He got up a tree, fell out, sprained his ankle and quit. So they called on me." He got either seventy-five or one hundred dollars a week—the amount is disputed. Lincoln played opposite Enid Markey as Jane, and they also appeared in *Romance of Tarzan*, filmed in 1918. *Tarzan of the Apes* is said to be the first film to make $1 million for the producers.

Two other actors played Tarzan in films in 1920, but the next year Elmo returned in a fifteen-part serial called *The Adventures of Tarzan* with Jane played by Louise Lorraine, who turned sixteen during the filming. Lincoln played with a bared chest during the first of the serials, but then he covered up. "Censors claimed it was poor taste for family viewing," Lincoln said later.

The Hoosier did not think much of the Tarzans who came later. "They're sissified," Lincoln told a writer. "They've refined Tarzan

down today. He doesn't run through trees any more or tangle with lions. When I played Tarzan I was up in the tree tops most of the time. We had no doubles in those days."

Between Tarzan pictures came *Elmo the Mighty*. Rochester played up the 1919 serial: "Think of it," the ads said, "a man from our own city, one of the greatest and strongest men on the motion picture screen today can be seen at the Paramount every Monday for eighteen weeks starting October 20. Otto is casted [*sic*] in a suitable role in this exciting serial which contains adventure, excitement and mystery galore." Lincoln played in a similar vein in *Elmo the Fearless*.

In 1922, Lincoln played a blacksmith in *Quincy Adams Sawyer*, which included two other Hoosiers, John Bowers of Rushville in the title role and Louise Fazenda of Lafayette as one of the "hired help." Other pictures in which Lincoln appeared included *Rupert of Hentzau, Whom Shall I Marry, The Flaming Disc* and *Under Crimson Skies*. In 1927 came Lincoln's final Tarzan performance in *King of the Jungle*, considered less than distinguished. That same year saw release of *The Jazz Singer*, the first talkie. Lincoln, whose movies all had been silents, didn't give up completely, but his Hollywood days were numbered.

He left for business in Salt Lake City "fed up with make believe," according to some sources. In 1939, stories reported that Lincoln had signed for some western films. A year later he was reported taking voice instruction under contract to Warner Brothers. In post-Tarzan days, Lincoln was in such movies as *The Hollywood Story*, in which he played himself, *The Battle of Elderbush Gulch* and *Judith of Bethula*, films all mostly forgotten. He had bit roles in *The Iron Man* and *Carrie*. Lincoln's last picture was *Joan of Arc*.

Lincoln, his success in film waning, lived very close to Paramount Studios. His Screen Actors Guild card, No. 17732A, brought him little success. He came up with at least two original story ideas to no avail—*Strange Stowaway* and *Fanged Sentries of the Morada*. In 1949, Lincoln sent for his mother, who lived with him.

Lincoln reportedly became bitter about being shunted aside by a modern Hollywood. He had an idea for a Hollywood Stock Company for the old-time stars. All the actors would form a group

with the major studios paying them a living wage and using them for any roles. The plan never got off the ground.

Lincoln also developed and patented something he called the No Draft, Sleeping and Sun Swaying Cabinet in 1936, the same year that his daughter was born. The cabinet, Lincoln explained, was designed for safety, health, comfort and amusement during the first twenty to twenty-four months of a baby's life. "The cabinet can be made into a very dainty and attractive bassinet by suspending a detachable lace or silk flounce from the top of the cabinet and around it and meeting in the center, making a curtain that can be opened or closed," said the description of the device. Photos showed the swaying cabinet as rather large and cumbersome.

There are a couple versions of Lincoln's attempt to find a job in circuses. One version is that he was offered a job touring with one circus but lost the opportunity in a pay squabble.

Lincoln's daughter Marci'a, who assembled a book of pictures about her father's life, said that she was born on March 13, 1936, to Ida Linkenhelt when Lincoln was forty-seven. Elsewhere, his first wife is listed as Sadie, although either Ida or Sadie may have been nicknames. The couple divorced when Marci'a was three or four years old.

Marci'a said she talked to Lincoln the evening before he died, arranging to spend the summer with him. She was eager to turn sixteen, because Elmo said at that age he would help her break into the movies. The woman who lived below Lincoln and managed the apartment told authorities that she heard him get up the morning of June 27, 1952, and go the kitchen, which was his habit. She knew that he had a bad cold or flu. She then heard him return to the bedroom and heard a thud. Lincoln was found dead. He was sixty-three years old. He was buried in Hollywood Cemetery.

At one time, Lincoln said, he had a set of Tarzan books, all autographed by Burroughs, but they all had disappeared over time. In the end he had few mementos.

DOUGHBOYS AND
OTHER HEROES

E.M. Viquesney

Every community should have its Doughboy Memorial for many reasons, but one reason above all—that memory may not die after the veterans of the last Great War have passed on.

—E.M. "Dick" Viquesney

H e was somewhat of a mystery. Nobody knows for sure about Ernest Moore Viquesney's artistic training. Nobody knows exactly how many *Spirit of the American Doughboy* statues he created and sold; the count is past 135 in thirty-five states. It is unknown why he was called Dick. Nobody knows why he took his own life, although he wrote that he couldn't continue without his wife. And, of course, nobody knows why he sculpted a statue called *The Unveiling*, which stands over the graves of him and his two spouses in Spencer, his hometown. There are no definitive reasons for why he built several buildings in Spencer, although obviously one was to serve as his studio. But it seemed odd to build a movie theatre in a town of less than two thousand, call it the Tivoli and say that it was an anagram of "This Is Viquesney's Own Little Idea."

Viquesney has fans today. Mostly they are intrigued by hunting for locations of his most famous *Doughboy* statue, the figure of a rifle-bearing American soldier. In Indiana at least eleven towns have or had *Doughboy* statues, created by an industrious Hoosier artist so adept at promoting his art but so negligent about keeping records and leaving biographical material.

There may be as many as eight or ten different *Doughboy* statues from the era of the two world wars, but no records list them.

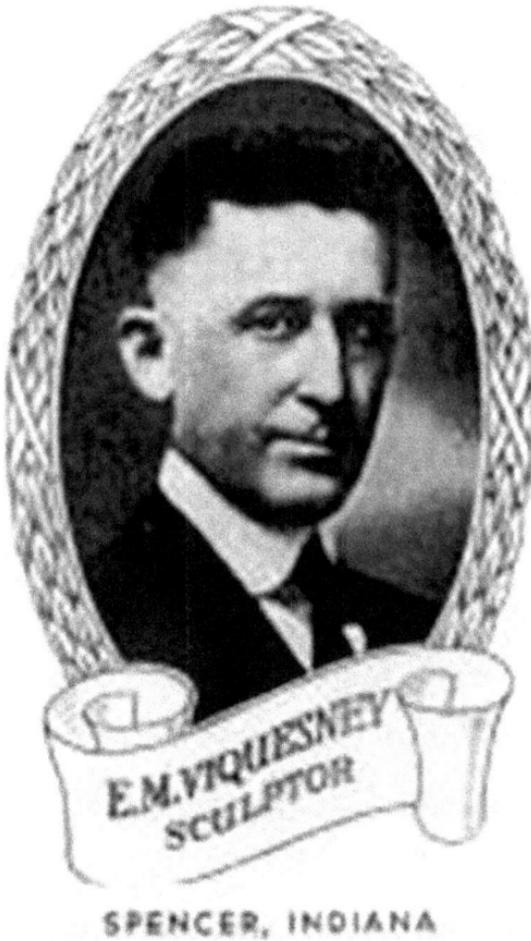

E.M. VIQUESNEY
SCULPTOR

SPENCER, INDIANA

Sculptor E.M. "Dick" Viquesney kept few biographical records, so his artistic training and reason for his suicide are unknown.

Viquesney gave at least five different names to his business, but it is known that the sculptor seemed to concentrate on heroes, either heroes defined by war or heroes by virtue of their civilian actions, such as Abraham Lincoln.

Viquesney spent some time in Georgia, where he helped creating memorials related to the Confederacy, such as the memorial for Anderson National Cemetery and one at the nearby former Civil War prison. The first sale of his most famous statue, *Spirit of the American Doughboy*, probably occurred at Nashville, Georgia. It is his most famous and enduring masterpiece, a figure standing seven feet tall, dressed in the American uniform of World War I, rifle in

hand, boldly entering no man's land, accurate in every detail, even down to the stitching on the knapsack.

The *Doughboy* adorns courthouse lawns from Alabama and Maine to Virginia and Washington. Viquesney once claimed to have produced 870 statues, an obvious exaggeration. He also produced other "Doughboys" besides the *Spirit* and also *Doughboy* statues in versions only ten and a half or twelve inches tall. He also created *The Spirit of the American Navy* for seamen in World War I. For veterans of World War II, he created *The Fighting Yank* and *The Navy Again at Sea*. His Lincoln figures included one depicting Abe as a boy. Second to the *Doughboy* in popularity was a figure that Viquesney gave a leprechaun-like appearance, called *Imp-O-Luck*. He placed an eleven-foot version of the Imp atop his studio and office space in Spencer. Hundreds of the Imps, each wearing a horseshoe over his shoulders and decorated with four-leaf clovers, were produced as ashtrays, incense burners, lamps and other pieces, plus a metal pocket piece about the size of a half dollar. These were heavily promoted by mail, and it was said that at least eighty thousand were shipped in a single year through the Spencer Post Office.

Viquesney's father, Paul Alfred Viquesney, was born in Paris, France, in 1828. Grandfather Viquesney, a stone carver, brought the family to America in time to help work on the U.S. Capitol building, then under construction. Paul came to Spencer to work as a stone and marble carver. There Ernest was born on August 5, 1876.

Evidently, Dick learned carving in his father's monument shop and had some sketching talent. According to Viquesney, he sketched many family portraits around Spencer in his teenage years and opened a portrait business. Little else is known about those early years.

He did serve in the Spanish-American War, perhaps a clue to his fascination with heroic war figures. In 1905, Dick went to Americus, Georgia, to work for C.J. Clark's Monuments. He went back to Spencer occasionally and also worked in Peoria, Illinois, and Atlanta, Georgia. He had married Cora Barnes in 1904, but little data survives about their courtship or her origin. They spent

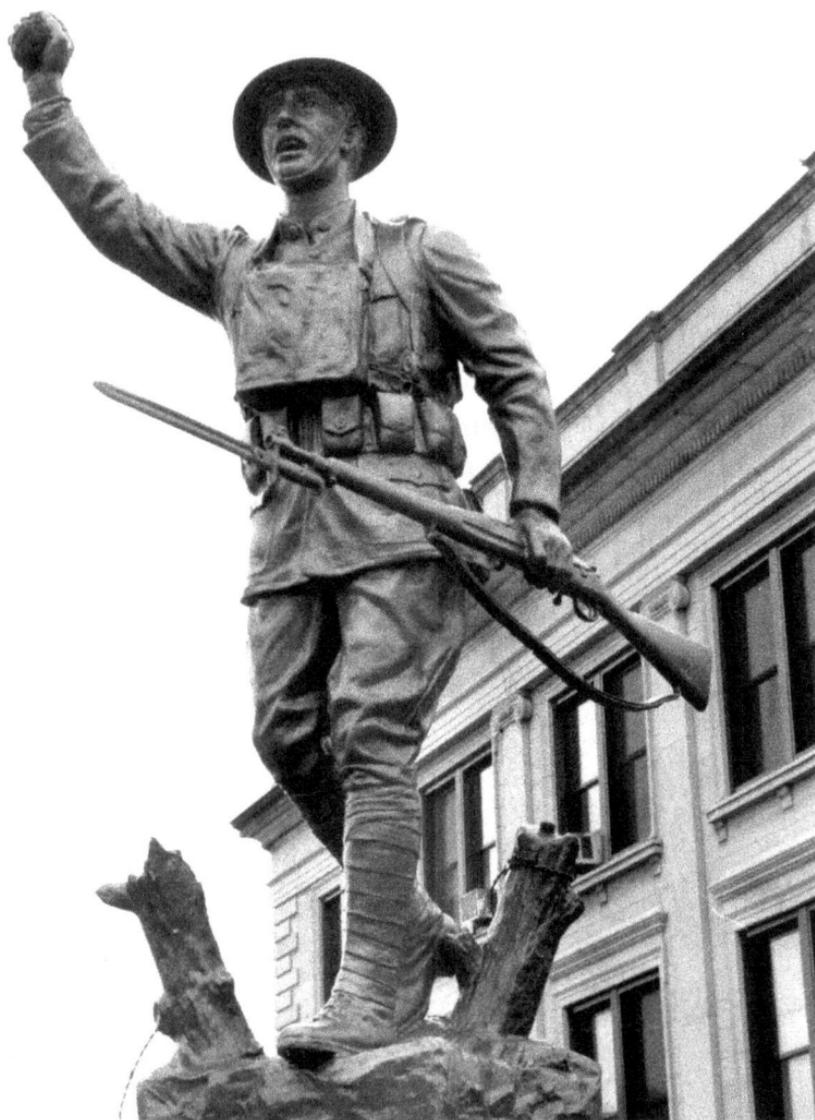

In 1927, this *Spirit of the American Doughboy* was erected in Spencer on Memorial Day weekend. A newspaper campaign raised the funds. *Photo by author.*

a year back in Spencer, but 1916 found them back in Americus, where Viquesney became head of the designing department and sales manager for the Schneider Marble Works.

From 1917 to 1920, the sculptor moved from one business to another, but details as to why don't exist. In 1920, he started to develop "the only absolutely perfectly equipped and historically correct example of what the United States infantry soldier was, and stood for." Viquesney studied hundreds of photographs, interviewed returning veterans and, it is believed, used two Americus veterans as models in their full combat uniforms. In August 1920, the first *Doughboy* sale was made to Nashville, Georgia, for $5,000. This is what Viquesney said in an undated newsletter that he distributed from Spencer in response to his continual avalanche of mail.

The sculptor saw the potential of the *Doughboy* and announced in 1921 a miniature version to sell for six dollars. The miniatures are rare today. Even rarer is a "Spirit of the American Doughboy Lamp." By 2004, only three were known to exist.

In January 1922, Walter Rylander, one of the men who had posed for the statue, bought out Viquesney's interest in the *Doughboy* business. By the end of the month, Viquesney and Cora were headed back to Spencer, both there to remain for the rest of their lives.

Viquesney constructed a two-story building in Spencer; his workshop, office and display areas were located on second floor. On the first floor were a Kroger Grocery store, a small electric sign shop and some rental office space. In January 1926, he reacquired the rights to the *Doughboy*. Small towns could afford a *Doughboy* because Viquesney created a version made of sheets of copper that could be put together with a welder's torch. In the early days, the copper sheet version sold for about $1,000, the cast version from $9,000 to $11,000.

The next year Viquesney spent $45,000 to build his Tivoli Theatre, perhaps as an outlet for his intensive carving in the decor. The theatre opened on December 31, 1928, with the film *Fallen Angel*. Although it suffered a fire much later, the theatre was restored and still was in operation in the twenty-first century.

Viquesney's wife, Cora Barnes, a Spencer girl, died in 1933; again records fail to reveal details. He remarried in 1938, he said in the obituary that he wrote himself, to Elizabeth Sadler, described as "one of Spencer's talented musicians." Also in 1938 he started working at his home. Viquesney's original studio later burned.

For three years during World War II, Viquesney and his second wife, known as Betty, traveled to Bloomington six nights a week, where she gave organ concerts for men and women in the service. Viquesney suggests that the outing produced a strain that his wife could not surmount. She died on August 21, 1946. Said Viquesney, using the third person in his own obit: "This couple was, we believe we can see, the greatest pals that any married couple can ever hope to be. But her death brought a blow...too heavy and Dick failed to rally from the strain on him during her illness and he told friends that he was just about to break as he couldn't take it since he was the only one of his line alive," wrote Viquesney.

Viquesney continued: "It is believed that this three years strain told on these two patriotic citizens of ours until Mrs. Viquesney succumbed and Dick could not stand alone, so joined her." On a Friday in October 1946, the seventy-year-old sculptor was found by his housekeeper, Mrs. Margaret Stevens Strong, slumped in the front seat of his running car, a garden hose attached to the exhaust pipe and stuck into the vehicle. The coroner ruled it a suicide. Viquesney had made his own funeral arrangements. He also arranged for Mrs. Strong to deliver his "biography" to the Spencer newspaper. In it he summed up his career this way: "He has designed more war statuary than any other sculptor in the nation and has standing to his credit nearly 870 statues, memorials of his famous 'Doughboy' of World War I."

His promotional material read:

> *For 25 years I have been modeling and furnishing statuary for all classes of Memorials but mainly World War Memorials because of the fact that my statue, "Spirit of the American Doughboy" was selected and endorsed by Veterans and civilians as the most perfect and outstanding statue of the World War.*

Well known for his flamboyance, Viquesney might have exaggerated a bit.

Viquesney's production included numerous small figures, from ten inches to two feet tall. He created "Service Plaques" for homes, church, schools, etc., on which could be placed stars for those in the service. His *Unveiling* over the graves in Spencer was duplicated in twelve-inch versions and also in sizes two to three feet tall.

Viquesney fans keep track of authenticated *Doughboy* statues through a Viquesney website. Probably no one will ever know how many *Doughboys* suffered mishaps or were destroyed. The bayonet on the one in Spencer was broken and replaced by a real bayonet brought back from the war as a souvenir. It seemed to illustrate how much people wanted to keep authentic the famous statue, whose maker left behind more questions than answers and remains as unsung as the nameless doughboys whom he saluted.

THE SAGE OF FORT WAYNE

George Jean Nathan

Criticism is the prevailing of intelligent skepticism over vague and befuddled prejudice and uncertainty.

—George Jean Nathan

H e only spent his first six years in Fort Wayne. He was a bright, pampered child who attended public school but was tutored privately in English literature, history, piano, French and Spanish in new digs in Cleveland, Ohio. It was not the usual upbringing of a young Hoosier. But George Jean Nathan was not the usual Hoosier. He had read Goethe's *Faust* by the time he was twelve years old and, in three more years, got through all of Shakespeare. Nathan rejected Harvard, choosing Cornell. He was in the honor society there and became an expert fencer.

His life's work was as a journalist, drama critic, author, editor and playwright. Nathan, by most standards, changed the character of drama in America. In 1952, Nathan's works were collected in *The World of George Jean Nathan*. Wrote compiler Charles Angoff: "He has written on marriage, politics, doctors, metropolitan life, the ballet, love, alcohol—on virtually every major aspect of contemporary life and he has had something shrewd or amusing to say about them." Even today Nathan's barbs are often quoted.

The closest thing to biographical data on Nathan exists in the 1917 *Pistols for Two*. Completed by Owen Hataras, a friend of Nathan's, the pamphlet lists all of the details that Hataras knew about Nathan and H.L. Mencken, with whom Nathan was in harness on the magazines *Smart Set* and *American Mercury*.

Nathan was a complicated man, a Beau Brummell who had his shoes shined daily, even when it rained, sardonic, a sucker for great art, played the piano by ear, was a hypochondriac, an anarchist in criticism but a student of philosophers, a good listener who seldom contradicted but one so wary of women that he cursed every time a female was announced at his *Smart Set* office. Nathan liked women well enough as a group, but found most of them individually unintelligent. He rejected the idea of love and saw misery for himself in marriage. Nathan did not wed until he was seventy-two years old, and we are not privy to what attracted him to actress Julie Haydon.

This Hoosier was a drama writer for several publications and wrote more than thirty books, many of them dealing with the theatre. He used at least sixteen pen names. His comments in those books, articles and elsewhere have placed him firmly among Hoosier epigrammatists.

From Nathan came such comments as: "Love demands infinitely less than friendship"; "In words of a friend of mine, I drink to make other people interesting"; "Love is an emotion experienced by the many and enjoyed by the few"; "Humor is truth in an intoxicated condition"; and "Marriage is based on the theory that when a man discovers a particular brand of beer exactly to his taste he should at once throw up his job and go to work in the brewery."

His birth on West Berry Street in 1882 was on February 14—or perhaps the fifteenth. Delivery came at midnight to Ella Nirdlinger Nathan and Charles Naret Nathan. Father owned the Eugene Peret vineyards in France and a large coffee plantation in Brazil. He had lived in several countries and spoke several languages.

George Jean's boyhood ambition was to become an African explorer. At Cornell he excelled in the arts program, was editor of the college daily, the *Sun*, and was a member of Kappa Sigma fraternity. He won the Amsler gold medal in fencing and competed as an amateur in France, Germany and Italy. He was described as "straight, slim, dark, with eyes like the middle of August, black hair which he brushes back a la francaise, and a rather sullen mouth."

The graduate planned to study for a master's degree, but the death of his father changed that. Nathan joined the editorial staff

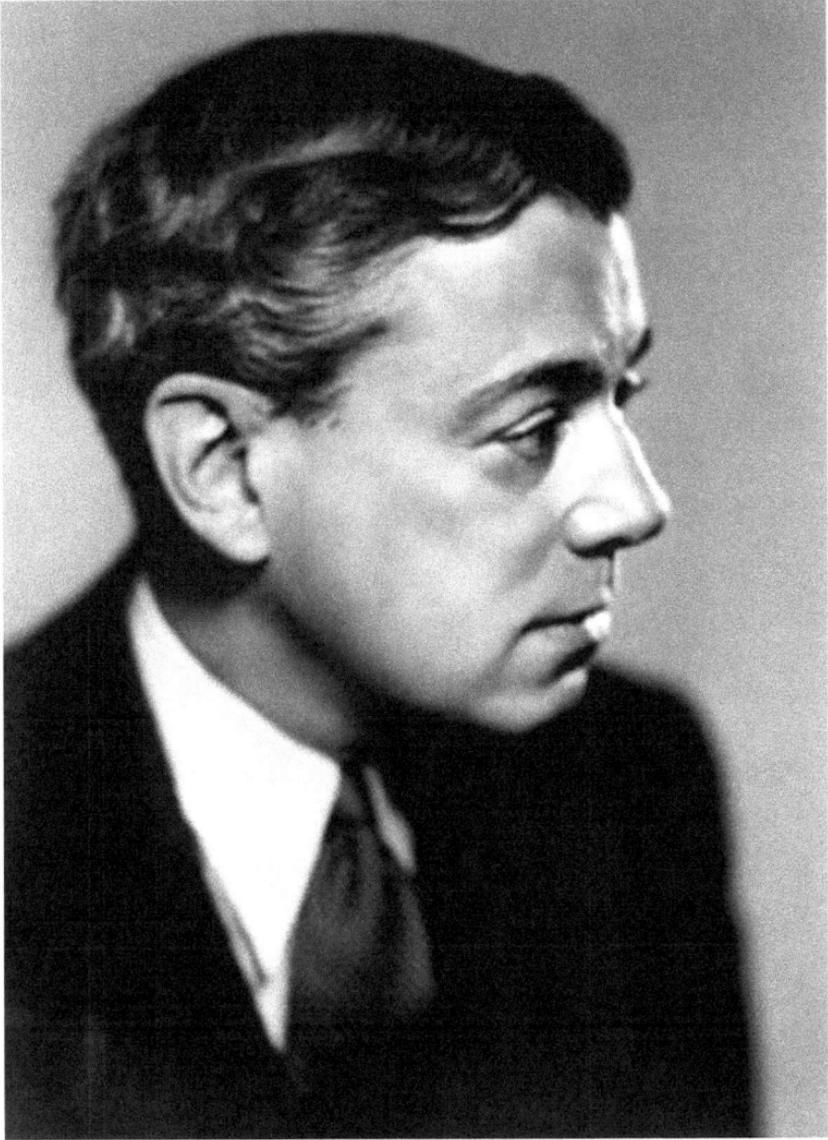

George Jean Nathan was so slender that he ate two eggs a day in hopes of gaining weight.

of the *New York Herald* in 1905, working there about a year. He wrote a story about the Vanderbilt Cup races without attending them; it was a rainy day, and he opposed going to Long Island. Nathan also wrote about a hermit on Long Island whom he invented.

Nathan haunted bars favored by newspapermen and met contemporary luminaries, including fellow Hoosier Booth Tarkington, who had just spent the day with Hoosier George Ade. Ade offered Nathan a job as head of the drama department for *Bohemian* and *Outing* magazines. He took it.

Nathan's critical writing in the two magazines brought him attention, and he began selling material to other magazines and writing a weekly article on the theatre for *Associated Sunday* magazines, which appeared in supplements of forty-seven newspapers. Norman Boyer, editor of *Smart Set*, had just hired H.L. Mencken, the acid-penned writer from Baltimore, to handle arts and sciences for the magazine. Nathan, who already had been writing for *Smart Set*, took over doing theatre and drama. Mencken and Nathan hit it off; only later did they part company. Their partnership on *Smart Set* and later *American Mercury* was to last from 1914 until 1930.

Although Mencken traveled to New York, often for work on *Smart Set*, he stayed in Baltimore most of the time. Nathan remained in the Manhattan office, where his secretary scrutinized manuscripts. She eliminated those committing infractions on a list established by the editors. Manuscripts emitting scents or odors, plays opening with soliloquies into a telephone or cover letters of more than one hundred words brought immediate rejection. If politeness was desirable toward a rejected author, Nathan blamed Mencken and Mencken blamed Nathan.

Smart Set had considerable influence, bringing before the public the plays, poetry and prose of such authors as Hoosier Theodore Dreiser, James Joyce, Aldous Huxley, Ben Hecht, F. Scott Fitzgerald and Eugene O'Neill. By now Nathan's work was appearing in Italian, German, French and Dutch magazines. Nathan was stinting with praise; he disliked Noël Coward and was cool toward Clifford Odets, T.S. Eliot, Sherlock Holmes and Ambrose Bierce. And he cherished his career. "The life of a writer has always seemed to me to be about as good a one as any low human being could hope for,"

wrote Nathan. "His office is in his hat; his tools are in his pocket; his boss is himself; he is foot-loose, free, clockless, independent. He can say what he wants to, however inexpedient, injudicious and discommodious, and get paid handsomely for what other working men would promptly get sacked for." Nathan thought that he was probably unpopular. "I do not care to hear what other persons think of me. They may be right," he wrote.

Nathan also loved to smoke cigars (but usually finished only half); he lit up from the morning shower until bedtime. Nathan also loved cocktails; he and Mencken often repaired to a watering place to discuss life.

Naturally many people wanted to get published in *Smart Set*. Nathan and Mencken, who sometimes conversed in whispers, had a procedure for handling "talentless" women seeking publication in the magazine. They would agree to meet them in the park and never show up.

Nathan lived in the same room in the Royalton Hotel and in the very same apartment for more than twenty-eight years. It looked, said a friend, like a second-hand bookstore. The apartment was cluttered with such things as a papier-mâché Indian head, unused wine glasses, plaques and pictures (including an autographed photo of Rasputin), with a bust of Nathan himself serving as a doorstop. A large, heavy writing table was located near a window, piled with paper, pens and penciled notes; Nathan wrote in longhand and had it transcribed by a professional typist.

Nathan had no interest in politics; Mencken had little liking for theatre. He accompanied Nathan to the theatre once and left within twenty minutes. Nathan did not think that politics belonged in *Smart Set*.

Partly because of their differing views on politics, *American Mercury* was born in 1924 with Nathan and Mencken sharing fifty-fifty. Mencken was to have wider range for politics in it. One piece in the first issue, no doubt a bow to Nathan's interest in theatre, concerned their friend O'Neill's play *All God's Chillun*. *Mercury* was a great success. For reasons stated differently by Nathan and Mencken, by January 26, 1925, Nathan was out, although he remained dramatic critic and contributing editor until 1930.

In 1932, Nathan founded *American Spectator* with O'Neill, Dreiser, James Branch Cabell and Ernest Boyd. In the years following, he did dramatic criticism for *Esquire, Saturday Review of Literature, Scribner's, Newsweek, Liberty, New York Journal-American, King Features Syndicate* and *Theatre Arts.* This writing was done for the most part in his New York apartment, although he did travel widely. He disliked interruptions at his hotel—especially before 5:00 p.m. Nathan's forty years of suffering from neuralgia was partly to blame for his isolation. He paced his apartment in a satin bathrobe, dictating articles between cigar puffs and champagne sips. He often wore a cornflower blue boutonniere. He received numerous pleas to speak and declined almost all of them, using rejection slips to do so.

A New Yorker, he could neither drive nor cook. He had, at least around the 1920s, nineteen pairs of shoes, three sets of evening clothes and thirty-eight overcoats, all tailored, as were his numerous suits. Each had two breast pockets, one for a handkerchief and one for his horn-rimmed glasses. He got a haircut every ten days from his barber of fourteen years named, believe it or not, George J. Nath. He carried a tube of menthol that he repeatedly sniffed. Although he often took days to find the right adjective when he was writing, he admitted that some of his sentences didn't make sense even to him. At one time in 1910, on a bet, Nathan wrote sixteen magazine articles in a month.

Nathan read, besides two New York newspapers daily, an estimated 150 plays a year, most of them foreign. As a critic, Nathan once demonstrated that a play would have been much better if done backward. It was not surprising that the acerbic Nathan was barred from several theatres. When asked if it were true that a theatre manager had called him a pinhead, Nathan retorted: "That is on the face of it absurd. 'Pinhead' is a word of two syllables." Nathan was shot at three times in America—although we are not told who held the gun—but never hit.

Nathan's writings contain much discussion about marriage—he was against it. But he married Miss Haydon in 1972. She told the press, "I worship him." The only other liaison attributed to Nathan was a long-standing affair with actress Lillian Gish. Yet Nathan admitted that bachelorhood was not the gay life it was thought to

be. It was false to believe that bachelors always have happy times, he said. "The married man's misery is confined to one woman. The bachelor's emotional aches spread over a dozen or more." He seldom attended dinners (lying if necessary to avoid one) and didn't go to weddings, either.

Nathan considered marriage a man's compromise with the illusions of his first sweetheart. He did not consider falling in love to be trivial. "No less than one thousand times in my life have I tried to fall in love, but to be baffled," he said. His standards were high, and he avowed, "To ask me to marry a girl I don't like is to ask me to go to Buffalo when I have business in Chattanooga."

Nathan had extensive knowledge of economics. He disliked dogs, cats, children, automatic pianos and grace before or after meals. Nathan placed little value on religion (or doctors). "When ultimately they get down the big white and black ledgers on the Day of Judgment and begin checking up the accounts of moral man, I have a feeling that it will be the Devil and not St. Peter who will get the Pulitzer Prize," wrote Nathan. "Virtue is going to have a tough job proving its realistic superiority to sin." Yet two years before his death in New York in 1958 (about which few details survive), both Nathan and his new wife adopted the Roman Catholic faith.

For all of his curmudgeonly views, Nathan denied being a "professional dissenter." He thought a man's belief should be as personal as his underwear, he once wrote, but he gave this philosophy of life:

> It is simply, merely this; to forget the miseries of the past and remember only its charm, to live the present to the limit of its utmost possibilities, and to view the future as one who has traveled romantically in a colorful far country views the skyline of his nearing homeland—with a sense of great content and slightly sad resignation.

Nathan and Mencken coined numerous words, including *yokelry*, *boob-bumper*, *boobletariat*, *yokel-yankel*, *hazlittry*, *hickpricker* and *dooflickus*. Clearly the boy from Fort Wayne had added an "engaging liveliness to the American scene," as one observer noted. In a moment of droll

philosophy, Nathan offered the two pieces of advice that he said he had found worthwhile: "1. Never eat corned beef and cabbage and ice cream at the same meal; and 2. pulling down on the eyelid and blowing the nose has not succeeded in getting a cinder out of one's eye since 416 B.C."

FINGER LICKIN' RECIPE

Harland David Sanders

Work keeps you young. A man who sits around and does nothing will soon rust away. I am against retiring.
—Harland David Sanders

You can mention Kentucky Fried Chicken all over the world now and it will be recognized—in Europe, Tokyo, Tel Aviv, Tehran, Madrid, China and points in between. Yet thousands who know the name, the product, perhaps even some of its secret eleven herbs and spices, don't know that Colonel Harland Sanders was born in Indiana and spent most of his first sixteen years as a Hoosier. He later spent additional time in Indiana. Had he come back to Hoosierland after his six months of soldiering in Cuba (he lied about his age to enlist), it is possible that the world's most famous fried chicken might be marketed in the name of Sagamore Sanders. The colonel designation was merely the Kentucky version of the Sagamore—an honor bestowed by the governor.

Kentucky Fried Chicken, or KFC, is going full bore years after the colonel's death and more than half a century after the colonel sold the business that he had nurtured mostly from the seat of his white Cadillac. Colonel Sanders didn't begin his fried chicken franchise until he was sixty-six years old, with no real inkling of its success.

Before that, the colonel was a streetcar conductor, a railroad fireman, a mail-order lawyer, a ferry operator, an insurance salesman and, finally, near the start of his empire, the operator of a service station and then a motel in Kentucky.

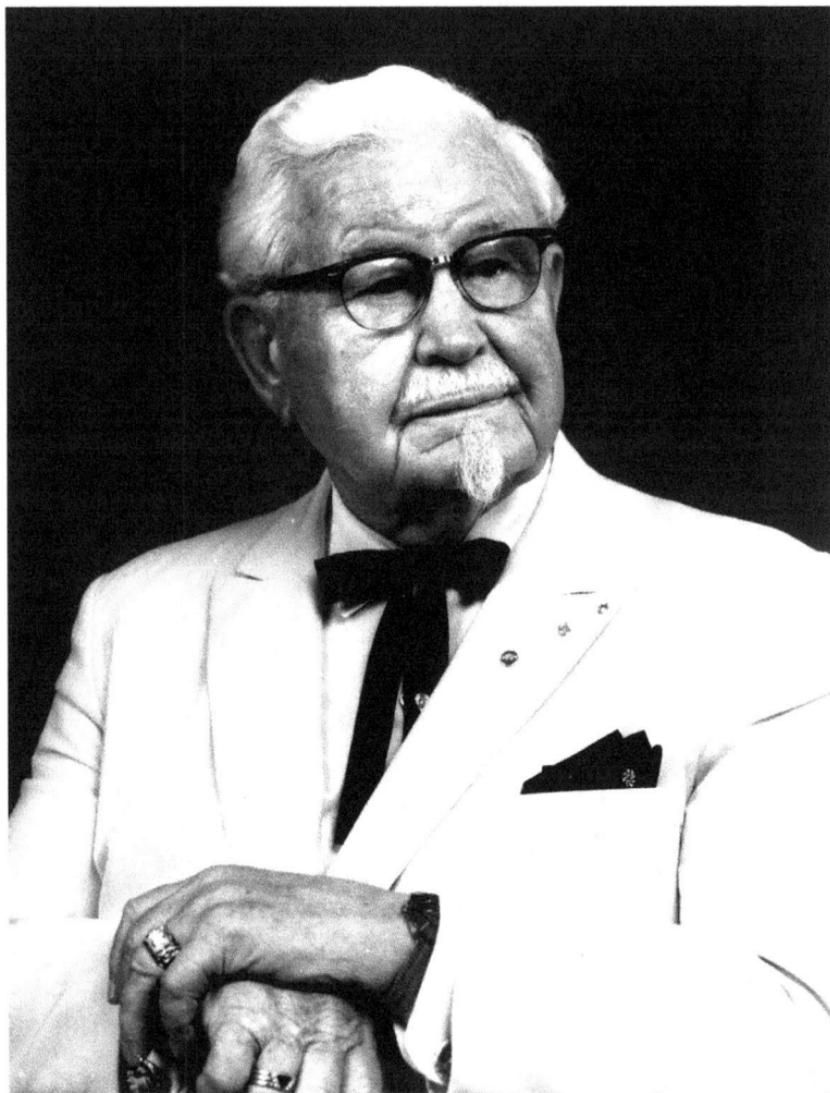

Harland Sanders, the Kentucky Colonel, was crafty and ambitious and readily embellished stories, but most found him honest in business. *Courtesy of KFC Marketing Department.*

The colonel's success was partly timing—not to denigrate his considerable ability as a cook. But he developed his recipe just when the culture was changing: more women were working outside the home and welcoming well-prepared takeout meals. The final

ingredient of success was the colonel's indefatigable energy and determination—aided by his second wife, Claudia. She often traveled with him as he negotiated the well-known handshake contracts by which the colonel received five cents royalty on chicken sales.

The colonel was somewhat driven and was a complicated and difficult man. He cussed and fussed his entire adult life. He philandered without doubt, although nothing scandalous. He had a violent temper to match his (early) red hair. Bleaching stabilized the shock of white hair and goatee that later became his trademark. He fought—literally—with legal clients and once was involved in a shoot-out. He was briefly in jail at least once. He was generous with charities, especially those involving children, yet avoided picking up a dinner tab. He was a perfectionist with insight into business opportunities, yet sometimes put stock in horoscopes. The colonel seemed to have an affinity for fire and hated locks. He was persnickety about food, especially eggs, and generally ate good food but was overweight; he didn't smoke or drink. And he picked out his own grave site in Louisville.

On September 6, 1890, in Henryville in Clark County, Indiana, Harland was born to Wilbert and Margaret Ann Sanders, preceding his brother Clarence and his sister Catherine. Wilbert Sanders, a farmer, suffered a fall that ended his farming, and he became a butcher in Henryville. He died when Harland was five or six. The boy's mother took a job in a Henryville tomato cannery, and Harland tended his siblings. Prophetically, Harland learned to cook. He left school in the sixth grade.

At ten Harland's mother got him a farm job for two dollars per month and keep, but he got fired. Next Harland worked all summer on a farm near New Albany at four dollars per month. He was eleven years old and already tough as nails. Soon after that his mother married Henry William Broaddus, operator of a truck garden, with a home at Greenwood in Johnson County, Indiana. Harland rose before dawn and helped his stepfather set up vegetable stands around the Marion County Courthouse. When Harland was twelve, he and Broaddus had a physical run-in, and Harland's mother suggested that the boy leave. He went to work on

the farm of his uncle Dick Dunlevy, also near New Albany. Dunlevy also worked for the New Albany Street Car Company, and Harland became a streetcar fare collector.

When U.S. troops were organized to go to Cuba, Harland lied about his age and joined the army. In Cuba he tended army mules. Discharged, he hopped trains, worked on riverboats and finally got a job as a railroad section hand in Alabama, soon advancing to train fireman. However, Harland became active in the union, sometimes became unruly and was fired.

Sanders met and married Josephine King in Jasper, Alabama, and they lived in Tuscombia. Two daughters, Mildred and Margaret, and a son, Harland Jr., were born to the couple over time, but they separated. However, Harland and Josephine eventually reunited and stayed married thirty-seven years, although often living apart.

Sanders took a correspondence course in law and got victims of railroad accidents to seek claims. He had some success until a client hesitated to pay. The dispute, unfortunately, took place in the courtroom, ending Harland's legal career. He headed for Louisville, finally connecting with his brother Clarence, now a barber in New Washington in Clark County. Josephine and the kids lived in Jeffersonville while Sanders worked as a section hand when nothing else was available, driving spikes on the line in Indiana from Sellersburg to Scottsburg. Itching for success, Sanders started selling for Prudential Life Insurance Company but was fired in a dispute over commission payments.

He organized a ferry business across the Ohio River from Louisville to New Albany and Jeffersonville, but the chance to become executive secretary of the chamber of commerce at Columbus, Indiana, seemed enticing. Upon arrival, the town seemed too small and unpromising to the thirty-three-year-old Sanders, and he quit.

For a while, he tried marketing acetylene lamps to farmers and then switched to selling Michelin tires, with all of Kentucky as his territory. Tires revealed the growing automotive age, and in 1925 the colonel purchased a Standard filling station at Nicholasville, Kentucky, and bought a house there. A drought dried up income, and a Depression finished the venture. Sanders bought a Shell

station (he never hesitated to borrow when necessary) near U.S. 25 in Corbin, Kentucky.

With the unexpected death of Harland Jr. from a blood clot, Sanders threw himself into the filling station business. When he posted an advertising sign down the road, a competitor, Matt Stewart, objected. Harland, accompanied by a Shell representative, got in a gunfight with Stewart. The Shell official was killed, and Stewart, wounded in the shoot-out, was charged with murder. Charges against Sanders of shooting to kill were dismissed after a hearing.

Harland started a restaurant in Corbin, a small affair operated out of the family dining room and then expanded to six tables. Soon after the business became too big for Sanders alone, the first waitress became ill, and her sister, Claudia, took over in 1932.

Sanders ran for the Kentucky state senate but lost. By 1937, he was ready to open a second and third restaurant but spent some time in jail over a permit for the restaurants. He paid the required fine because of the "slop" being served in jail, opened both restaurants (although they failed) and in the spring started Sanders Court, a motor tourist business—a second motel was soon established in Asheville, North Carolina.

Sanders began experimenting with cooking chicken in pressure cookers, just on the market. He took a recipe from a woman named Eula Gordon and began doctoring it. He and Josephine finally divorced in 1947, and two years later Sanders married his waitress, Claudia. The same year he was made a Kentucky colonel; he felt he had finally attracted official attention for business success.

The Sanders chicken recipe involved not only eleven special herbs and spices but also cooking time and temperature. He began traveling around the country, taking his spices with him, cooking chicken in restaurants and selling his franchise if the restaurant owners and/or customers liked the chicken. His barber suggested that he start wearing a white suit and a string tie, in keeping with the colonel image. His hair was a suitable white by that time, but his red beard was unsatisfactory. Lorayne Campbell in Corbin, the same beautician used by the colonel's wife, bleached the beard.

Sanders had been active in restaurant owner organizations, and at a convention he met Leon "Pete" Harmon, a restaurant owner in Salt Lake City. In 1954, Leon Harmon reluctantly became the first to sign a Sanders chicken franchise.

When U.S. 25 was rerouted at Corbin, away from the colonel's motel, he auctioned off the place. He got $75,000 for it. By the time he had paid all the bills and purchased a home in Shelbyville, Kentucky, he was a sixty-five-year-old man with no business, an owner of a home and a white Cadillac and a possessor of a monthly Social Security check of $105. He started promoting himself as much as the chicken. He traveled, often sleeping in the car. "It was right hard going for a while," he told an interviewer.

Business improved. Sanders bought a warehouse in Shelbyville to store his spice mixture and other franchise equipment. "He was going most of the time and sometimes I went with him," said Claudia. Harland's grandson, Harland Adams, helped in the office. Pete Harmon was selling the franchises, too. Daughter Margaret and her new husband were selling in Florida. Under the pressure of success, Sanders became even more fearsome than before as an employer, but Claudia knew how to handle him. "Now, Harland," she would say when he went into a rampage. By 1960, he had more than two hundred franchises. Maureen McGuire, who became the office secretary, formed a distributorship, doing the mixing and shipping of the spices. Later it was done by Durkees for a time and finally Stange of Chicago put the spices in the flour and shipped it from there.

Seeking an attorney (he doesn't make the reason clear), Sanders was steered to John Y. Brown Jr. in Louisville. (Brown was later to become governor of Kentucky.) Brown had Porky Pig House barbecue and chicken, so he knew the colonel's franchising. Brown connected with John Massey of Third National Bank in Nashville, and they decided to buy Kentucky Fried Chicken.

Brown had the legal mind and restaurant experience, and Massey knew banking business. Sanders blew hot and cold, he hemmed and hawed, cussed and fussed, but a deal was struck. On February 18, 1964, Sanders sold Brown and Massey the franchise but withheld rights to part of the United States and all of Canada.

Brown, a promoter, recognized the colonel's value to KFC and hired him at $40,000 a year, eventually upped to $125,000, as a director and to provide his image. "I knew from the first that he was our ace," said Brown. Brown got the colonel on the television show *What's My Line?* and eventually on more than thirty national TV shows. The slogan "Finger lickin' good" came into play. The colonel became a national figure and reveled in it.

Sanders did like the money. He often told people that he had all the money he could use. He liked the freedom to do many things for children, especially via the March of Dimes. He complained that KFC had lost the human touch when headquarters moved to Nashville. He once threatened to quit because a seer in New York said his horoscope called for it—until the woman, prompted by Brown, "revised" the horoscope.

The colonel was displeased when KFC went public in 1966, but he couldn't argue with the success. The 1966 gross was about $15 million, and within ten more years it was to be $292 million. Naturally, the colonel objected when KFC began distributing food items besides chicken, and he never was comfortable with the KFC crispy version. He was somewhat mollified when KFC headquarters moved back to Louisville after a short time in Tennessee.

The colonel's arthritis was killing him; he was nearing eighty in the summer of 1969. By that time, Brown had expanded into Japan and England. Stockholders earned millions.

Sanders retired from the board at eighty as the firm opened a new building in Louisville. By then, the colonel had taken some eighty-five foster children under his care over the years. He was made Poster Boy of the Year of the National Arthritis Foundation. He was still traveling abroad, usually with Claudia.

At home, the colonel still cooked; Claudia did the vegetables. They moved into a Louisville suburb, but Sanders disliked it and returned to the country near Shelbyville. A high point for him was when Corbin made him Citizen of the Year in 1971. On May 10, 1981, KFC became part of Heublein Inc. of Hartford, Connecticut, which made packaged food and premixed drinks, and later it was sold to Pepsico. The colonel was unhappy. He had often complained publicly that Brown and Massey had taken away his company.

In 1973, Sanders and Claudia visited Hong Kong, New Zealand, Australia and other places. That year he also picked out his burial site in Louisville. At eighty-six he traveled to Canada and Mexico. In 1977, he testified on aging for the second time in Washington, D.C., stating, "I am against retiring." On his eighty-eighth birthday, the KFC museum was dedicated. He was still active, although he had undergone intestinal and throat surgeries and had diabetes, cataracts and arthritis, which forced him to use a cane. When that was revealed, Sanders received canes from all over the country.

The colonel reached eighty-nine and all the family was gone. He was battling ailments and ignoring as best he could the advice of Dr. Angelo Ciliberti of Louisville, who was to be his friend and physician for the rest of his life. On June 10, 1980, Sanders entered Louisville Jewish Hospital with pneumonia and leukemia. He was in and out of the hospital, returning December 15. He

Colonel Sanders chose this burial site. Late in life, he adopted nostrums such as copper bracelets, hyperbaric oxygen tanks and herbs.

had leukemia, diabetes, pneumonia, arthritis, arterial problems, eye problems, heart trouble, kidney failure, bladder infection, had suffered a stroke and also had chronic constipation for years. He died at 7:30 p.m. on December 16.

Hall-Taylor Funeral Home made burial preparations at Shelbyville. The body lay in state in the Kentucky Statehouse at Lexington. Then the body was placed in the colonel's home in Shelbyville, lay in state in the KFC Inc. offices in Louisville and made a stop at Southern Baptist Theological Seminary. At last it was interred in the site he had chosen at Cave Hill Cemetery, where columns flanked a bust created by his daughter Margaret.

He had given away millions of dollars, partly because he hated to pay taxes and used charity to blunt them. His will showed an estate valued at less than $1.5 million. It included his home and thirty-one acres, a certificate of deposit, a 1974 Cadillac, thirty-eight shares of Heublein stock and a promissory note from an attorney friend. The bulk of the estate went into a bank trust.

PIONEER, SHOWMAN, PROMOTER

Carl Graham Fisher

It's going to be the automotive laboratory of America.
—Carl Graham Fisher

Had Carl Fisher only built the Indianapolis Motor Speedway, he still would have been a celebrity to Hoosiers. But the Speedway might be considered one of his minor achievements. Fisher introduced the automobile to Indianapolis. The Presto-Lite Company, which created his first fortune, was a logical outgrowth of his belief in the automotive age. But his love affair with the car was only a springboard prompting him to spearhead construction of the first highway reaching the Pacific and a similar route from north into Florida.

Florida brought him to Miami and to his creation of Miami Beach out of a swampy wilderness. Although a pioneering promotional genius and a tireless builder and remarkably insightful, Fisher avoided exultation. Miami Beach has the only real memorial to Fisher, a bust erected after his death with the legend, "He carved a great city out of a jungle."

Today, even most people in Miami Beach likely have forgotten "Crazy Carl," the idea-per-minute man. Fisher was only a shadow of his former self when he died. His once considerable fortune was wounded by the Depression and nibbled away to satisfy collateral that he had pledged in trying to build another playground city, even bigger than Miami Beach.

By that time, excessive drinking had produced liver disease; death came from a gastric hemorrhage in one of the Miami

Beach hospitals he helped create. Along the way, Fisher had been a bicycle racer, created promotional stunts so daring they often brought out the police, built speedboats, built or bought twenty-six houses, smoked cigars, chewed tobacco, hobnobbed with celebrities all over the nation and made "hell" and "dammit" mainstays of his vocabulary.

Fisher was born on January 12, 1874, in Greensburg to Ida Graham and Albert H. Fisher. The parents separated, and Carl grew up with little knowledge of his father. Ida Fisher took in boarders. Carl grew up with a well-developed sense of daredeviltry; he once built stilts eleven feet tall. But Carl had only about 50 percent vision (the cause seems unknown), and some of his boyish mischief may have been compensation and to show himself fearless. It caused him to drop out in the sixth grade. He worked in a bookstore, served as a bank messenger and sold newspapers, magazines, cigars, cigarettes and peanuts on the New York Central rail line running through Greensburg. He ate peanuts the rest of his life.

With $600 saved, seventeen-year-old Fisher opened a bicycle repair shop in Indianapolis, where he and his brothers Rolly and Earle charged twenty-five cents for each flat fixed. Fisher formed a couple of bicycle racing teams, the Zig-Zag and the Flat Tire.

Fisher got an Ohio firm to send him $50,000 worth of its top bicycle model. He embarked on promotions. He dropped a bicycle from a building and eluded pursuing police. He launched one hundred balloons, ten of which contained a ticket for a free bicycle. He rode a bicycle on a tight wire stretched across the main street in Indianapolis.

One who saw this tight wire adventure was Jane Watts, fifteen years old. They met later at the Canoe Club in Indianapolis, and the crush was mutual. They were married October 23, 1909, less than four months after they met, although Jane's stepfather was slow to accept Fisher, who was twenty years older than his bride.

Racing and foresight led Fisher to the automobile, and he opened one of the first showrooms in Indianapolis, selling the early cars Premier and Winston. Fisher pulled such promotional stunts as dropping a car off a building (after deflating the tires so it wouldn't bounce too high) and sailing over Indianapolis with a car (minus

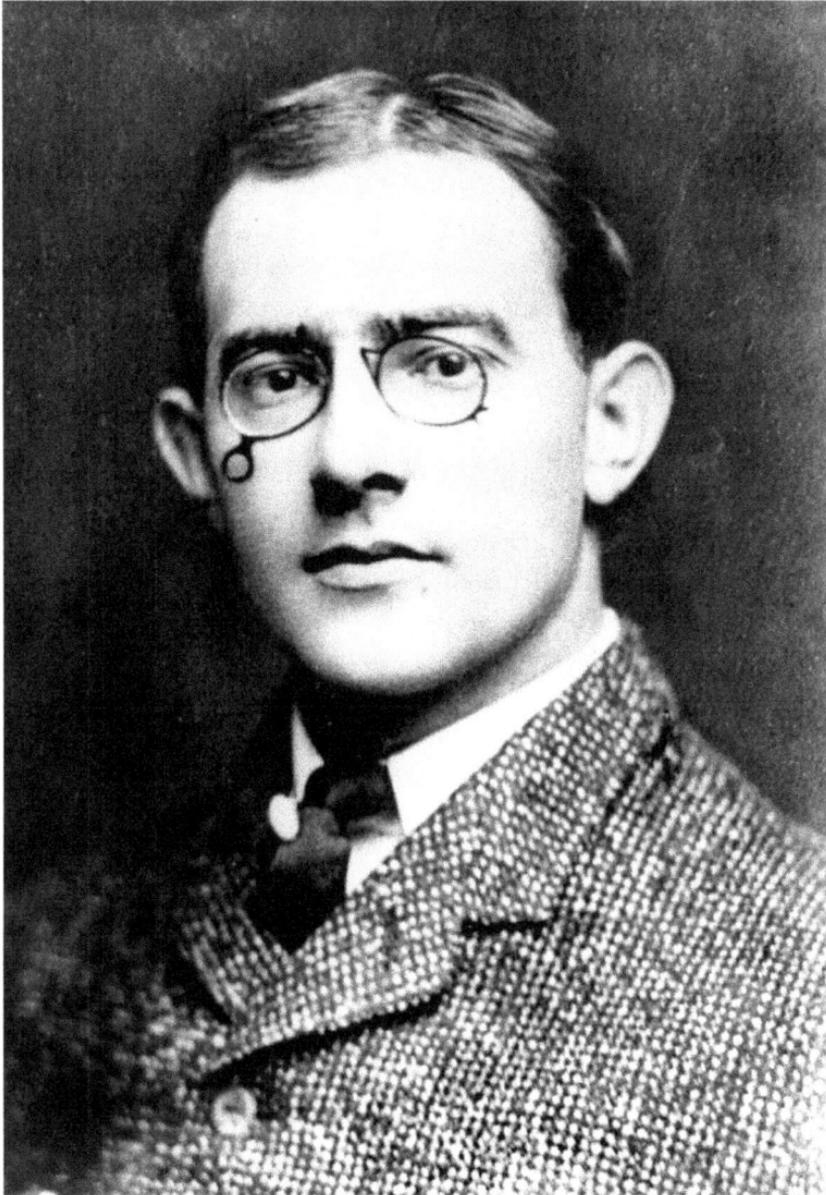

Carl Graham Fisher may have looked much like this when he formed bicycling racing teams that included Barney Oldfield.

the motor) dangling from a balloon. Fisher organized Big Four Racing, a touring team racing and promoting cars; he set a two-mile speed record in Chicago, going the distance in two minutes and two seconds. A conviction about the future of cars led him to build the Indianapolis Motor Speedway on a tract then far west of Indianapolis. Joining him in the venture were James Allison, founder of what later became the Allison Division of General Motors Corporation; Arthur C. Newby, president of the National Motor Car Company and builder of an Indianapolis bicycle racing track; and Frank Wheeler, president of a carburetor company.

"It's going to be the automobile laboratory of America," Fisher declared. Funds to build the Speedway came from the Presto-Lite company, founded by Fisher and Allison.

The first race at the Speedway in 1909 was a fiasco. Crashes and injuries abounded. Fisher, seeing that the gravel and tar track was insufficient, had it torn up and replaced with bricks, thus the track nickname "the brickyard." The bricks remained until the Speedway was later paved and repaved in 1977 and 1995, except for a section of bricks at the finish line. Short races were held at the Speedway in 1910 on the new paved raceway, but thereafter the partners decided on a five-hundred-mile race annually. Races were interrupted only in 1917 and 1918 for World War I and during World War II.

In 1912, Fisher decided to build houses near the Speedway track for workers in the nearby Presto-Lite factory. Today the town Speedway is known worldwide because of the track. Fisher liquidated most of his holdings in Indianapolis except the Speedway track; he remained associated with it until 1927. With these funds he went to Florida, intent on becoming a retired millionaire.

The life of Jane and Carl had been a whirlwind. Fisher was unpredictable but had some lifelong habits—he preferred to eat steak, fried potatoes and apple pie, favored white and yellow colors and liked a fireplace fire at all times, in any season—and was quick to seize opportunities. He once bought a home sight unseen on Biscayne Bay at Miami. He built a house on the river at Detroit and abandoned it after one stay because he found the river traffic disturbing. His introduction to Florida had come as a surprise shortly after he and Jane were married.

Fisher had a forty-five-foot boat called the *Eph*. He and Jane, with friends John Levi and Harry Buschmann, took the Mississippi River to the gulf. In crossing the gulf, the boat lodged on a sandbar during a hurricane. The group lived on the beach for some ten days. When the yacht was dislodged, Fisher asked John Levi to take it to Jacksonville. The others returned to Indianapolis by train; Fisher was to meet Levi in Jacksonville later. Soon Levi wired that he had stopped in Miami, "a nice little town. Why not meet me there instead of Jacksonville." Fisher did.

Fisher liked the "nice little town," and the couple moved into the Biscayne Bay home called the Shadows due to the shade on the lane. Fisher noticed a half-built wooden bridge that John S. Collins, seventy-five, was trying to extend two and a half miles to get his avocados to market. Fisher loaned him $50,000 to complete the bridge in return for bonds on the bridge and a strip of land 1,800 feet wide through a jungle on the isthmus. He bought 260 more acres after that. Fisher soon planned to create a city on the isthmus, but other duties called first.

Because of his interest in automobiles, Fisher decided to lay out an east–west route across the nation. Fisher enlisted pledges for construction of a highway. The Lincoln Highway Association (Fisher was a great admirer of both Lincoln and Napoleon) was established on July 1, 1913, and a caravan of some seventy people and supplies set out from Indianapolis. The Trail Blazers, as they were called, crossed to California in thirty-four days. Today U.S. 30 covers much of the route traveled by the Trail Blazers.

Soon Fisher was entreated to do the same for a north–south road, to be called the Dixie Highway. Because of his holdings in Florida, he agreed. By that time, 1915, road building was widespread across the country. Simultaneously, Fisher was deep into his "crazy" idea to clear the jungle across from his Biscayne Bay home. Collins had finished his bridge, which was dedicated June 12, 1913; he became the avocado king and a millionaire.

The isthmus jungle resisted taming, however. The palmettos were too tough for axes. The swampy part of the land Fisher attacked by dredging sand from the Biscayne Bay bottom and depositing it in the swamp; headway was slow. Clearing sometimes cost $1,500 an

acre and sometimes $52,000 a day. But the sand finally took hold in the swamp. Fisher heard of a plow that he wanted and ordered one, only bigger—it was built in Gasoline Alley at the Speedway and shipped to Miami. The plow, at last, demolished the palmettos.

That was only the beginning. All trees, flowers and even the Bermuda grass had to be planted by hand. In keeping with his idea of a playground, Fisher built a harbor and slips for boats in the yacht basin. The Yacht Club was built on an island. The local term of Miami Beach couldn't be denied, and the city was incorporated on March 26, 1915. Fisher had done the physically impossible, but it became difficult to sell lots. Publicity, always his forte, was necessary.

The opportunity came when Jane wore a new one-piece bathing suit that came above her knees. A local minister decried such impropriety and headlines resulted. Fisher hooked up with Steve Hannagan, who plastered the newspapers with pictures of scantily clad bathing beauties sunning at Miami Beach. Fisher conducted regattas and golf tournaments and invited every polo player in America to come to Miami Beach, where he built a polo field for them.

Fisher invited every known celebrity to visit, among them Will Rogers, James Whitcomb Riley, Booth Tarkington and George Ade. Sometimes the Fisher grocery bill ran $1,000 a month.

Meanwhile, Jane had convinced Fisher to visit Europe, as she had long desired. When the Fishers arrived in Paris, Carl recognized the many rumblings of war and insisted that they return home at once. That was not easily done. They fled to London and eventually found passage on a ship home.

During World War I, sales at embryonic Miami Beach did not improve. Even after the war, in 1920, the would-be town had only 644 residents. But the bathing suit publicity barrage finally paid off. At last, sales of lots in the new city were reaching $23 million a year.

Fisher had succeeded, yet he maintained his long-standing limelight avoidance. "He hated personal publicity. The only publicity he wanted was for the new city," Jane wrote in her biography of their life together. A son was born to the Fishers

in November 1921, but he lived only twenty-six days; his death initiated Carl's drinking.

The Miami Beach boom (the population had swelled to thirty thousand) brought in speculators and the common ill of cities: gambling and crime. Fisher lamented the small, insubstantial houses that were springing up. On top of it all, Jane and their adopted son Jackie left for Paris, without Carl, in 1925. Fisher turned to a sandy point on Long Island, New York. He and Allison bought nine thousand acres for $2.5 million, intending to develop Montauk Point into the northern version of Miami Beach.

In 1926, after seventeen years of marriage, Jane and Carl were divorced; he arranged it so that she could remarry. They remained friends and confidants. That same year, Fisher received a telegram: "Miami Beach total loss. Entirely swept away by hurricane. Untold damage." In fact, damage at Miami Beach was not nearly that bad, but the telegram caused him to halt developments at Montauk

Carl Fisher was cremated, and his ashes were placed in this Indianapolis mausoleum that was built for him, his mother and his two brothers. *Photo by author.*

Point and rush to Florida. In the meantime, Fisher had married Margaret Collier of Washington Courthouse, Ohio. Not much is known about their courtship.

Although Miami Beach was not devastated by the storm, restoration was needed; Fisher suspended development at Montauk. As a result, Montauk failed. The failure began sapping Fisher's bankroll. Some of his Miami Beach holdings went because they had served as collateral. Soon Fisher was suffering physically and so was his wealth. He was going into St. Francis Hospital in Miami Beach weekly to have fluids drained.

"Never did I admire Carl more than during these days when he was going down fighting. Never once did I hear him…complain or sound bitter. Carl took it for granted that the fair-weather thousands who once haunted his door came no more," Jane Fisher wrote in *Fabulous Hoosier* in 1947.

Fisher died in July 1939. Among his last words were "Where's Jane? It's getting dark." His ashes were returned to Indianapolis and placed in a Crown Hill mausoleum. He left behind two cities—Miami Beach, still one of America's playgrounds, and Speedway, the town that still lures fans of speed each May when cars are tested on the automotive laboratory that Fisher had envisioned.

POLITICS AND POETRY

John Milton Hay

I would not do as a Methodist preacher, for I am a poor horseman. I would not suit the Baptists, for I dislike water. I would fail as an Episcopalian for I am no ladies' man.

—John Milton Hay

John Hay only lived in Indiana two years after his birth, and he is generally forgotten except for his memorialized birthplace in Salem in Washington County. But his career is so full of drama (he was part of the Lincoln administration), his writings so historic (he co-authored a ten-volume biography on Lincoln) and his government service so extensive (diplomat and United States secretary of state) that Indiana once gladly applauded him as a native son. Hay served in the government from Lincoln through Theodore Roosevelt, with ambassadorships to Paris, Vienna, Madrid and London. He was a journalist and editor for the *New York Tribune* and a successful businessman. He wrote articles, books and poems (he was chosen poet of his college graduating class) and even one volume of fiction. Had living as a poet been feasible, he might have chosen that as a career.

Instead, Hay chose law, reluctantly. He also had considered and rejected the ministry—his grandfather was an ardent Methodist. He left the small town of Warsaw, Illinois, where he grew up, to study in the law office of his uncle Milton Hay in Springfield. The resulting law office of Hay's was next door to that of Lincoln's. Here Hay renewed his acquaintance with John G. Nicolay, whom he had known at Pittsfield, Illinois. Nicolay and Hay had helped Lincoln

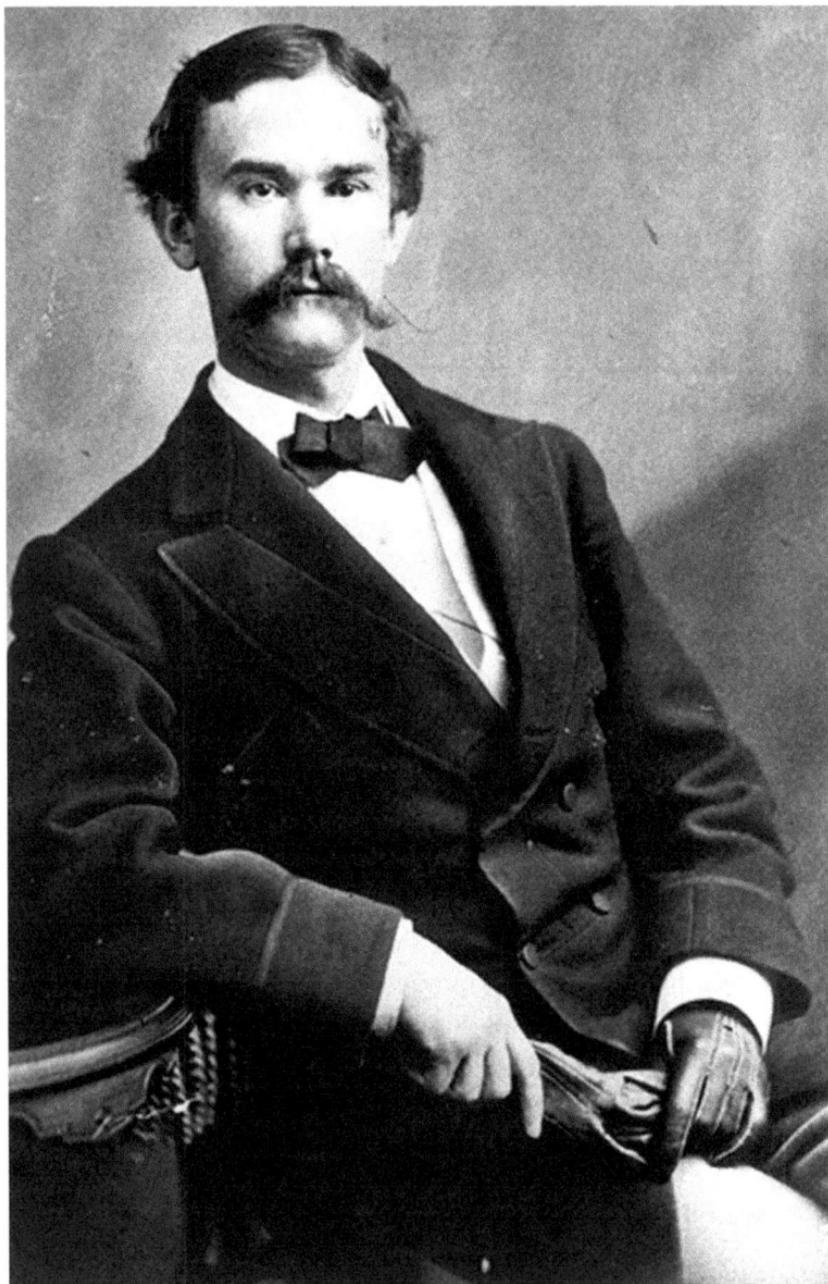

John Milton Hay as a young man was a member of a debating society at Springfield, Illinois, and he had a certain melancholy at Brown University.

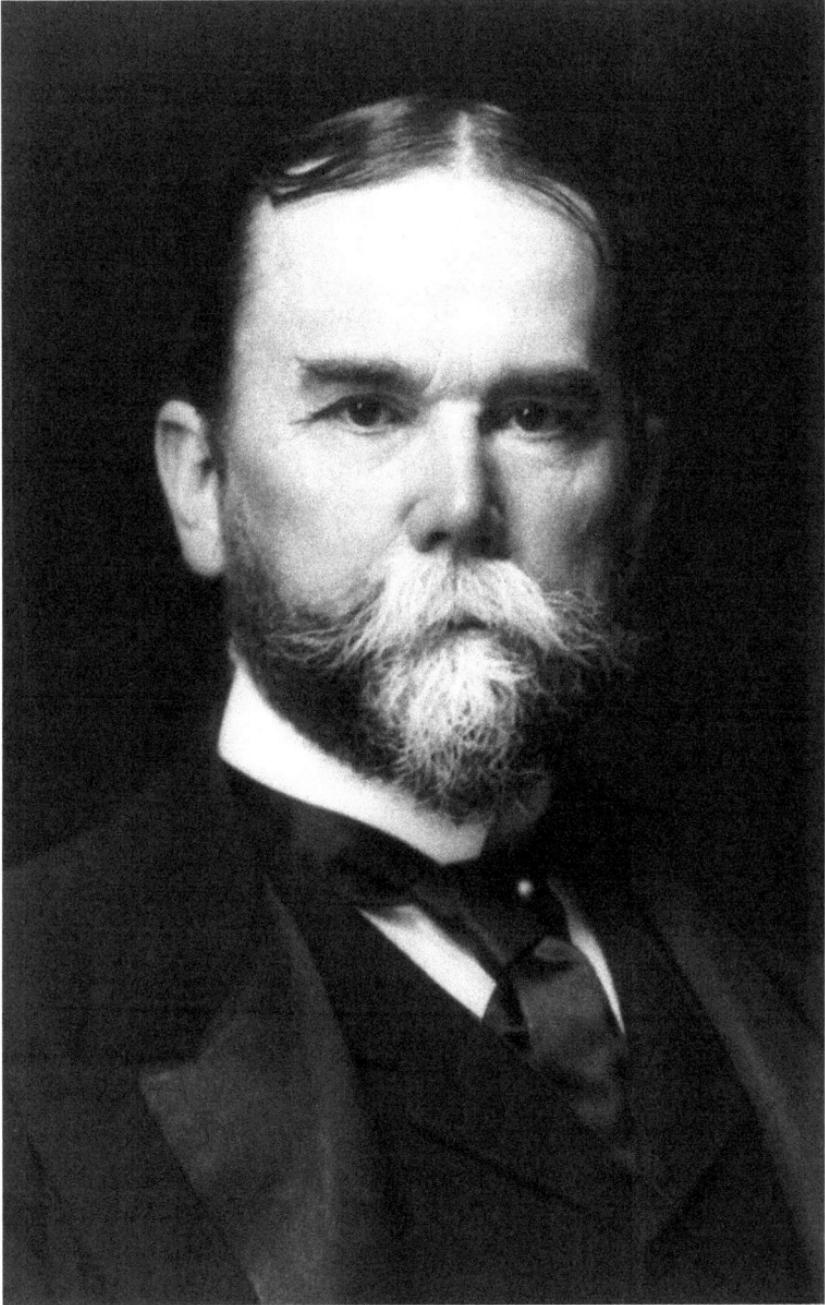

Of diplomat John Milton Hay, an Indianapolis newspaper wrote that "he proceeded frankly and honestly."

with his correspondence in Springfield. When Nicolay went to Washington, D.C., to serve as secretary to President Lincoln, Hay went too, becoming Nicolay's assistant.

Few intimate details survive of Hay's life. He destroyed a large mass of letters before his death. He kept a diary only sporadically, symbolic of his lifelong objection to fuss and fame.

Hay and Nicolay lived for a time in the White House, and Hay, although never officially Lincoln's private secretary, was later given a post with the Department of the Interior and assigned to the White House. From then on, Hay developed a reluctant affection for politics that led to a succession of appointments.

Hay was the fourth child of Dr. Charles and Helen Leonard Hay, born on October 8, 1838, in a one-story brick home in Salem that was a former grammar school. Dr. Hay bought it in 1829. There were already two doctors in the town of eight hundred, and the family soon moved to Warsaw on the Mississippi.

John Hay was tutored in Latin and Greek by his father and learned German from an acquaintance. Before going to Springfield, Uncle Milton "adopted" Hay in Pittsfield, Illinois, where the youngster studied in a private school and later at a school in Springfield subsequently called Lutheran Concordia College. At Pittsfield Hay met Nicolay, six years older, a printer's devil. At seventeen, Hay entered Brown University as a sophomore; his father could not afford it, but Milton and other relatives paid the expenses.

Hay, passionate about books and poetry, was a five-foot, five-inch self-conscious and stilted youth. But many of his classmates found him likable, frank, full of good fun and a punster though sometimes melancholy. He was reserved and thoughtful, with rosy cheeks and a peach bloomed face, they said. He was considered a good translator.

Hay made Phi Beta Kappa but didn't wear the pin later in life. He skipped the commencement exercises. His 436-line verse "Erato: a Poem" earned him class poet honors and was printed in pamphlet form. When he returned to Warsaw in 1858, he considered literature as a career in "this barbarous West," as he called it. "Forced," as some biographers put it, into law, he started reading it in 1859 at Springfield, where Uncle Milton had moved after the

death of his wife in 1857. Nicolay also was in Springfield with a clerk's job in state government. After Lincoln won the presidency, Hay and Nicolay worked together to handle Abe's ever-increasing correspondence.

It is unknown whether Hay fully appreciated the opportunity to go to Washington with Lincoln. Only weeks before, on February 4, 1860, he had been admitted to the bar. At age twenty-two, Hay arrived in Washington, getting a salary of $1,600, later raised to $1,800, as Nicolay's assistant. In the White House, Lincoln often crossed the hall at night to talk to Hay and Nicolay, sharing a joke or a passage he was reading, but Mrs. Lincoln was difficult—"hellcat," Hay called her. Soon the secretaries moved out of the White House and into the Willard Hotel.

Although Hay became the equivalent of a military aide to Lincoln, he was never a military man. He was made an assistant adjutant general in the army with the rank of major, then lieutenant colonel and finally colonel. He became Lincoln's eyes and ears. "I am the keeper of the president's conscience," he once joked. Hay went on presidential errands to Florida, St. Louis, New York City and Niagara Falls. "I went where I was sent and did what I was ordered," Hay wrote.

On the night Lincoln was shot at Ford's Theatre, Hay was studying Spanish with Robert Lincoln, the president's son. Hay went to the house where the president had been carried and was among the twenty who witnessed Lincoln's death. He had been appointed secretary of the legation in Paris even before Lincoln's assassination.

Paris gave Hay a rich life and a chance to resume his writing, especially describing the lively culture that he observed. He was back in the United States by 1867, but by June, 29, 1867, he was in Vienna, sent by Secretary of State William Seward. Hay enjoyed Viennese life but resigned in August 1868. For about a month Hay was editor of the *Illinois State Journal* in Springfield. Then he took an assignment as secretary of the legation in Madrid in June 1869. Hay's Madrid stay resulted in *Castillian Days*, first serialized in *Atlantic Monthly* and published in book form in 1871.

That year, in fact, provoked a blizzard of writing from Hay. He produced a number of magazine articles and pamphlets. Considerable verse was composed, much of it appearing in *Harper's Weekly*. *Pike County Ballads and Other Pieces* also came out during that period, and he was working on a translation of *The Republican Movement in Europe* by Emilio Castelar. The one and only novel written by Hay, *The Bread-Winner*, which was published anonymously, did not come out until 1884; it got good reviews. When Hay returned from Madrid, he got a job with the *New York Tribune* for sixty-five dollars per week, a handsome wage.

In 1873, Hay met and became engaged to Clara Louise Stone, daughter of a wealthy family, who was visiting an uncle in New York City. They wed on February 4, 1874; within a year Hay quit the *Tribune*. "Journalism," he once said, "is a good mistress, but a bad wife." He joined his father-in-law, Amasa Stone, in business in Cleveland, Ohio.

In 1878, Hay was made assistant secretary of state under President Rutherford Hayes and served until March 31, 1881, when James Garfield came into the presidency. Hay declined Garfield's offer to become the president's private secretary and abandoned Washington in 1881, returning to the *Tribune* as editor. Nevertheless, in 1884 Hay purchased a lot in Washington and two years later built a house on it, across the square from the White House.

Hay and Nicolay had published in 1890 the ten-volume biography *Abraham Lincoln: A History*. Nicolay had been at work on the book for several years before Hay joined in the writing, and together they worked for ten years, creating a volume 4,700 pages and 1.5 million words. Hay and Nicolay also published in 1884 *Complete Works of Abraham Lincoln*.

From 1881 to 1896, Hay made frequent trips to Europe. During the presidential campaign of 1896, Hay became an advisor to William McKinley, whom he had known in Cleveland and who won the presidency. In 1897, Hay was named secretary to the legation in London, reaching there April 21. His seventeen months in London were among the happiest in his life. His charm and dignity quickly won him friendships, and with the outbreak of the Spanish-

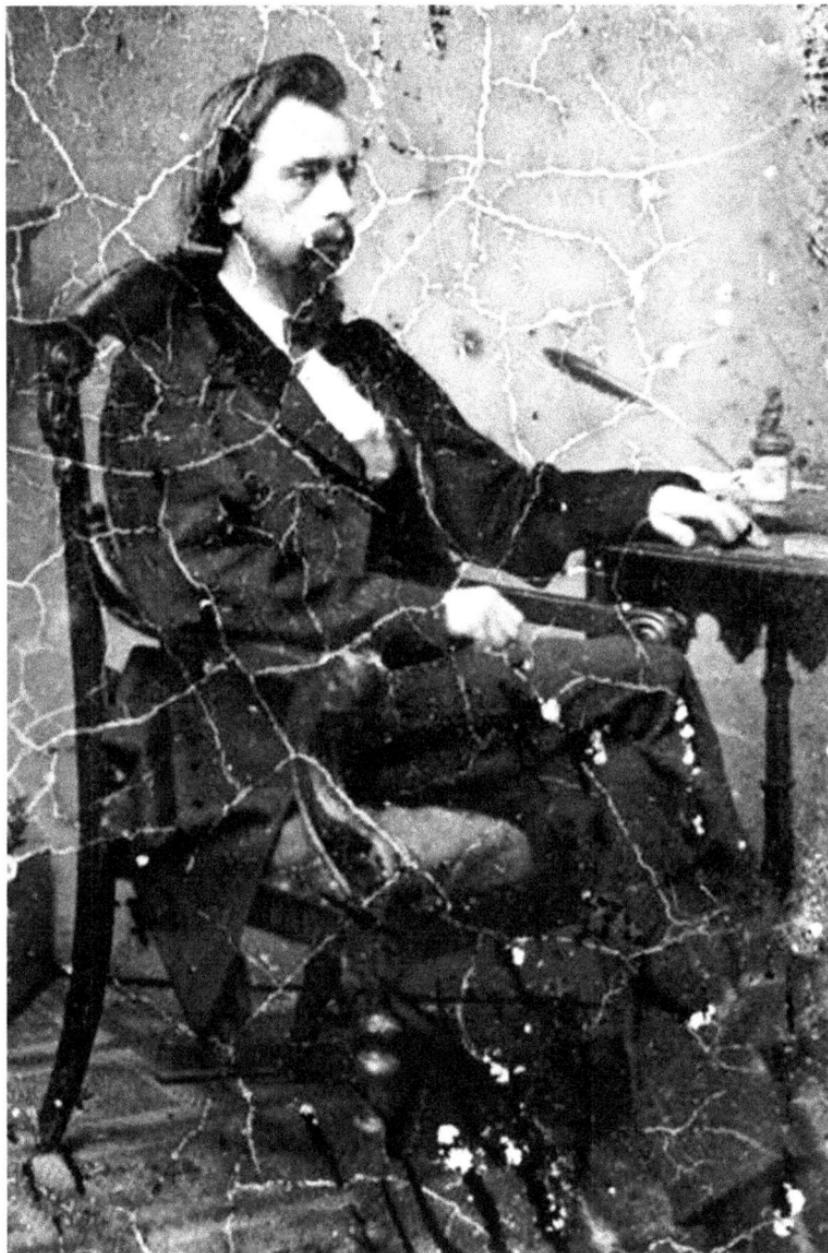

John G. Nicolay was the avenue through which John Milton Hay moved to Washington, D.C., and into the Abraham Lincoln White House.

The birthplace of John Milton Hay is memorialized at Salem, although the future writer and secretary of state only lived there a short time. *Photo by author.*

American War in 1898, Hay was able to gain British support for the United States. In August of that year, McKinley called Hay back to become secretary of state, in part to use the diplomat's good standing with Spain. Hay accepted reluctantly, partly because of poor health.

Throughout this period, Hay was called on frequently for speeches. Although he did not like to give talks, he was reportedly pretty good at it. Some of his speeches were published after his death.

When McKinley's presidency ended with an assassin's bullet in September 1901, Theodore Roosevelt continued to have Hay serve as secretary of state. Hay already had suffered a personal tragedy that year. In June his son, Adelbert, twenty-five years old, fell to his death from a window while attending a reunion at Yale.

Roosevelt and Hay did not have the same mutual respect that Hay had enjoyed with McKinley, but the president prevailed on Hay to stay as secretary of state. One of the highlights of Hay's tenure under Roosevelt was what was called the "open door" policy, achieved by sending troops to aid beleaguered China.

Hay also persuaded England to abandon an 1850 treaty calling for joint control of Panama, which along with Nicaragua was a site for a proposed canal. This done, a treaty with Columbia resulted and made the Panama Canal possible. In all, Hay supervised fifty-two international agreements while secretary of state.

Hay sought to resign in 1903—his health was bad—but Roosevelt insisted that he stay. By the time of Roosevelt's second-term inauguration in 1905, Hay was sagging under illness and work. He began having repeated colds.

In January 1905, he departed for Europe for rest, but he was so feeble that he had to board the steamship by wheelchair. In Europe, he was too ill to respond to the invitations from heads of state and many other diplomats. Hay came back to the United States on June 15. He had caught cold again. Hay rallied for a few days but collapsed and died on July 1, 1905.

It was raining when Hay's body was hauled in a wagon drawn by his favorite horse to the railroad station in New Hampshire, where he had a summer home. He was buried in Lake View Cemetery

Chapel in Cleveland. Memorials also were held in Presbyterian Church of the Covenant in Washington, D.C. Services also were held in London and Rome.

Before his death, Hay had received honorary doctor of law degrees from Western Reserve University, Brown, Dartmouth, Princeton, Yale and Harvard. In 1910, the John Hay Library was opened at Brown, financed by twenty-nine friends of the distinguished alumnus, including Dale Carnegie. In 1916, a bronze plaque was erected in Salem citing the Hay birthplace, and in 1971 Salem opened a complex including the Hay home and a new museum, which contained one of the best genealogical collections in southern Indiana.

The *London Times* wrote of Hay: "Not until the secret history of our days is made public will mankind be able to pronounce upon the greatness of his work and its significance for generations yet unborn."

THE RELUCTANT
EMPIRE BUILDER

Alvah Curtis Roebuck

I do hereby give to the said Sears, Roebuck and Co., corporation, etc., full right, authority and privilege to use said name of "Roebuck" in their corporate name.

—Alvah Curtis Roebuck

Today one of the most recognized stores in the world carries merely the emblazoned name of Sears. Many Hoosiers have forgotten the time when the store also used the name Roebuck. At his birthplace of Lafayette, the city named the street past the Sears store Alvah C. Roebuck Drive.

There are other reasons why Roebuck faded from prominence. He never had the drive of Richard Warren Sears; Roebuck mostly wanted to fix watches. His health was poor; described as a man slender, almost emaciated, Roebuck came to dislike the seven-days-a-week regimen necessary in the early days. He fretted when Sears began selling merchandise for examination cash on delivery (COD), without deposit, which nearly bankrupted the fledgling firm. Worried about the finances, Roebuck removed himself as an officer and stockholder of record by 1897. Thus, Roebuck and his name left a firm that would have made him billions.

Once he left Sears, Roebuck went to Florida in the booming real estate business. When it went bust, he went west for a time, returned to Chicago in 1929 and within four years was back at Sears. This time he was a mere employee, spending much of his time working on his own personal account of the firm, titled *Early and Some Late History of Sears, Roebuck and Co.* In 1934, Roebuck appeared in a store

Alvah Curtis Roebuck never had the irrepressible drive of his partner, Richard Warren Sears, and only wanted to fix watches. *Courtesy of the Hammond Public Library.*

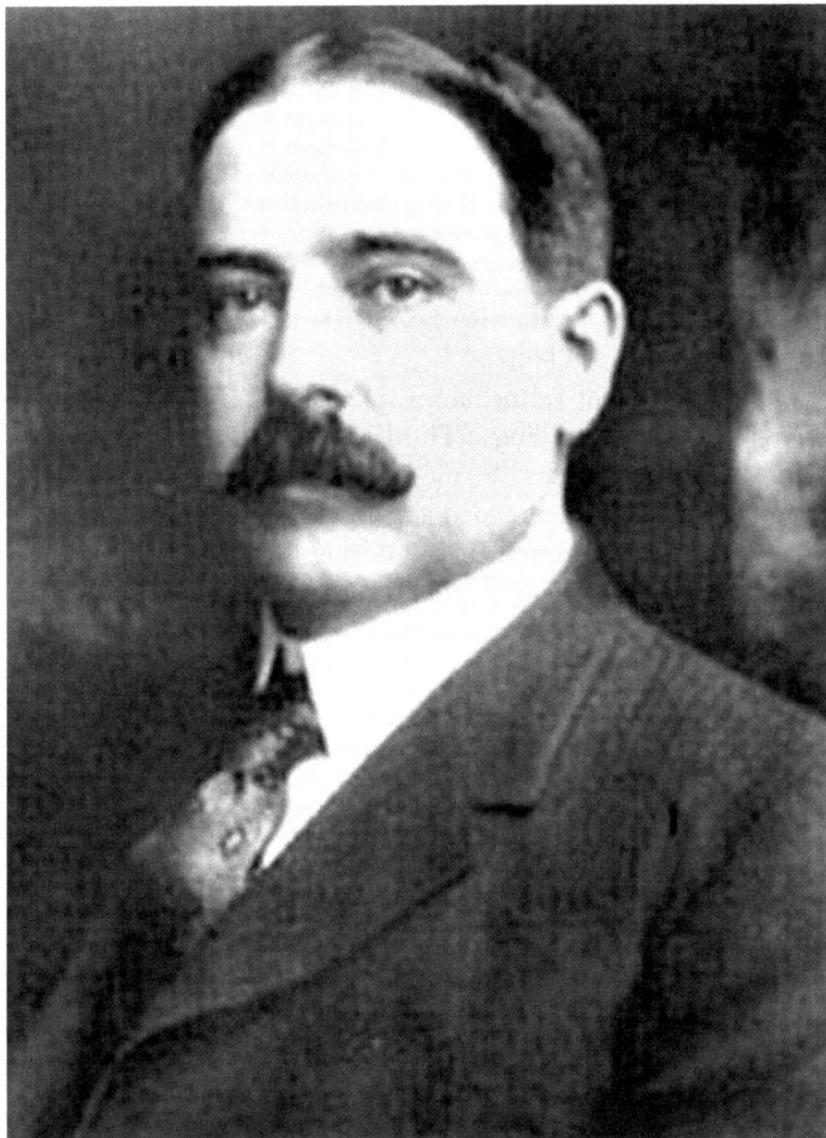

Richard Warren Sears gained Roebuck as a partner because he accepted without question the watch repair that Roebuck submitted.

as a public relations gesture—Sears had already been dead for twenty years. Soon Roebuck was visiting stores all over the country, forty-five of them in 1935. He also appeared at some county and state fairs. Then he returned to work on the history, continuing until his death on June 18, 1948, at the age of eighty-four. Once Roebuck noted: "Sears made $25 million—he's dead. Skinner [the first general merchandising manager] made millions—he's dead. Rosenwald [a partner after Roebuck left] made $100 million—he's dead. Me, I never felt better."

On January 9, 1864, Roebuck was born to English parents in the three-story Curtiss building at Third and South Streets in Lafayette. When he was three years old, the family moved to a farm five miles out of town. Roebuck attended a nearby country school.

He was a born tinkerer. In 1876, when his father died, twelve-year-old Roebuck took over handling the family farm equipment. At sixteen, he was adept at watch repair. By the time he was seventeen, he was making his own business cards on a used printing press and operating a small printing business. He had also learned to engrave on metal and telegraphy and had constructed a neighborhood telegraph line.

The watch repairing took Roebuck to Hammond. There he repaired watches in a delicatessen or, by some accounts, had his own watch and jewelry business by 1885. He was planning to go west until he saw an advertisement in a Chicago newspaper that read: "WATCHMAKER WANTED—with references, who can furnish tools, state age, experience, and salary required. Address T39, Daily News."

The ad had been placed by Richard Warren Sears, a railroad agent at Redwood, Minnesota, who had purchased a box of pocket watches and advertised them to other agents down the line. In a year he had made $5,000. Soon he formed the R.W. Sears Watch Company, began selling more and was getting watches returned for repairs. That's why he advertised for a watchmaker.

When Roebuck applied, Sears said: "I don't know anything about watch making but I presume this [the work Roebuck showed him] is good, otherwise you wouldn't have submitted it to me. You look all right to me and you may have the position." At first business

dropped, but it did not take long for Roebuck's end to become seven days a week. He and his staff were kept busy assembling the movements, which Sears was buying as closeouts. Wrote Roebuck to his mother: "Mr. Sears is well pleased with me and said I must stay with him."

Sears also had opened a branch in Toronto, Canada. Sears sold his R.W. Sears Watch Company for $75,000.00. Half interest in the Toronto branch, however, was purchased by Roebuck and bookkeeper Arthur Lawrence for $2,950.00, the value of the inventory. Sears kept a half interest. A year later, Sears sold the rest of the Toronto branch to Roebuck for $5,190.18.

Sears went to Iowa, where he invested $60,000 in real estate. Aware that it was risky, he got another job as a hedge against failure. He sold the Warren Watch Company, which he had founded, to Roebuck, who named the business A.C. Roebuck. In April 1892, A.C. Roebuck was incorporated with Roebuck holding 250 shares and Sears 499 shares. Sears's sister held one share so she could sit on the board. Roebuck was secretary, treasurer and a director. On September 16, 1893, six years after the complicated business juggling between Sears and Roebuck began, the firm was named Sears, Roebuck and Company.

Sears realized that a catalogue would satisfy the firm's inability to easily reach far-flung communities. The first catalogue, dealing mostly with watches, was 52 pages, but within a year it was 100 pages and soon 322 pages. The catalogue, said one biographer, was "the key to Sears' success." He spoke the farmers' language.

"Cheapest Supply House in Earth," the slogan of the catalogue, rankled Roebuck. Work quickly reached sixteen hours a day, seven days a week; the profusion of advertising caused an avalanche of orders. But Sears was taking orders for products the company didn't have and sometimes couldn't acquire. Sears began shipping men's clothing for examination COD without any deposit, and the large number of returns spelled trouble, Roebuck perceived. He was ill and under a doctor's care. His hands trembled, his hair was falling out and his stomach was in knots.

By August 17, 1895, Roebuck decided to remove himself as an officer and stockholder of record. Sears paid him $25,000 for his

third interest in the firm. Roebuck became head of the watch and jewelry department and sometimes was a sounding board for Sears's complaints about the new company executives. Chief among the complaints were those about Julius Rosenwald.

Rosenwald was the brother-in-law of Aaron E. Nusbaum, who had made a fortune at the 1893 Columbian Exposition in Chicago. Sears got Nusbaum to invest in Sears, Roebuck, the deal arranged over coffee and written on stationery in pencil. Nusbaum and Rosenwald, brought in on the deal, became equal partners with Sears; Nusbaum handled finances and some administration, Rosenwald handled merchandise lines and some administration. Their presence brought changes, and Roebuck finally left the company altogether.

Roebuck had long since signed all his interest over to the company in a document dated September 6, 1895, that said:

> *Know all men by these presents, that I, A.C. Roebuck...for and in consideration of one dollar and other good and valuable considerations to me in hand paid by Richard W. Sears...do hereby release and forever discharge said Richard W. Sears from any and all claims or demands I may now have against him and from any and all claims or demands, right, title, or interest in the business carried on by said Richard W. Sears in the name of Sears, Roebuck and Co., by reason of said Richard W. Sears having used my name in said business...and I do hereby give to the said Sears, Roebuck and Co., corporation, etc., full right, authority and privilege to use said name of "Roebuck" in their corporate name.*

After leaving the firm, Roebuck spent some time as president of the Woodstock Typewriter Company, a big seller for Sears. Roebuck also developed equipment for motion pictures, which made him a modest fortune, reportedly $150,000. Again, he sold out early. When a Sears store opened in Evansville, Roebuck made a successful personal appearance. Later that year, Roebuck went to Florida to join the real estate business. When it went bust during the 1929 Depression, he returned to Chicago. Little is known about

what Roebuck did until 1933, when he accepted a minor clerking job with the firm, then run by General Robert E. Wood.

Roebuck began working on his story of the firm and later, working in adjunct with the public relations department, began making personal appearances. Sears had died in 1914, five years after he, too, had retired from the company. When Roebuck was seventy-five he made a midsummer visit to the Sears store in Indianapolis, giving children pistols, balloons and whistles and telling them jokes. He told a reporter that he rose early each day and took a walk. A year later, Roebuck retired completely. On June 18, 1948, Roebuck died. He was interred in a mausoleum in Chicago.

Although the firm was large by the time Roebuck died, it still had not grown to the giant it was yet to become. He was not around when reproductions of the famed Sears catalogues became newsstand commodities and were preserved on film as a cultural icon. He had, of course, been long gone and forgotten when Kmart purchased Sears in the twenty-first century. Yet his part in the phenomenon should not be forgotten. A wire service bureau chief in the late 1960s commented: "Two innocent articles of American life—the Sears, Roebuck catalog and phonograph records—are the most powerful pieces of foreign propaganda in Russia. The catalog comes first."

The Reluctant General

General Ambrose E. Burnside

Probably very few of the general officers in the army have seen more dark hours than I have.

–General Ambrose E. Burnside

One of Indiana's most active military figures in the Civil War was the origin of the term "sideburns"—hair that runs down the side of the face. The name of Ambrose E. Burnside was semantically juggled into "sideburns." Ambrose had a rich set of sideburns magnificently set off by bright brown coloring and descending from a bald pate. Of course, most have long forgotten the origin of the word sideburns.

Some considered Burnside a military failure but were incorrect, according to later evaluations. He had proved incompetent to successfully lead an army, but as General Ulysses S. Grant noted, "No one knew this better than himself." Burnside twice declined President Abraham Lincoln's call to lead the Army of the Potomac, agreeing to take command only after presidential insistence. Also, biographers note, he sometimes relied on incompetent officers and sometimes was given too much to do with too few men.

Burnside succeeded at some things. He was a competent railroad administrator, even during the Civil War. He was elected governor of Rhode Island, his adopted state, and reelected twice. He was chosen Rhode Island's senator and also reelected. One of his biographers noted that this "maligned figure of the war" was neither a genius nor a blockhead.

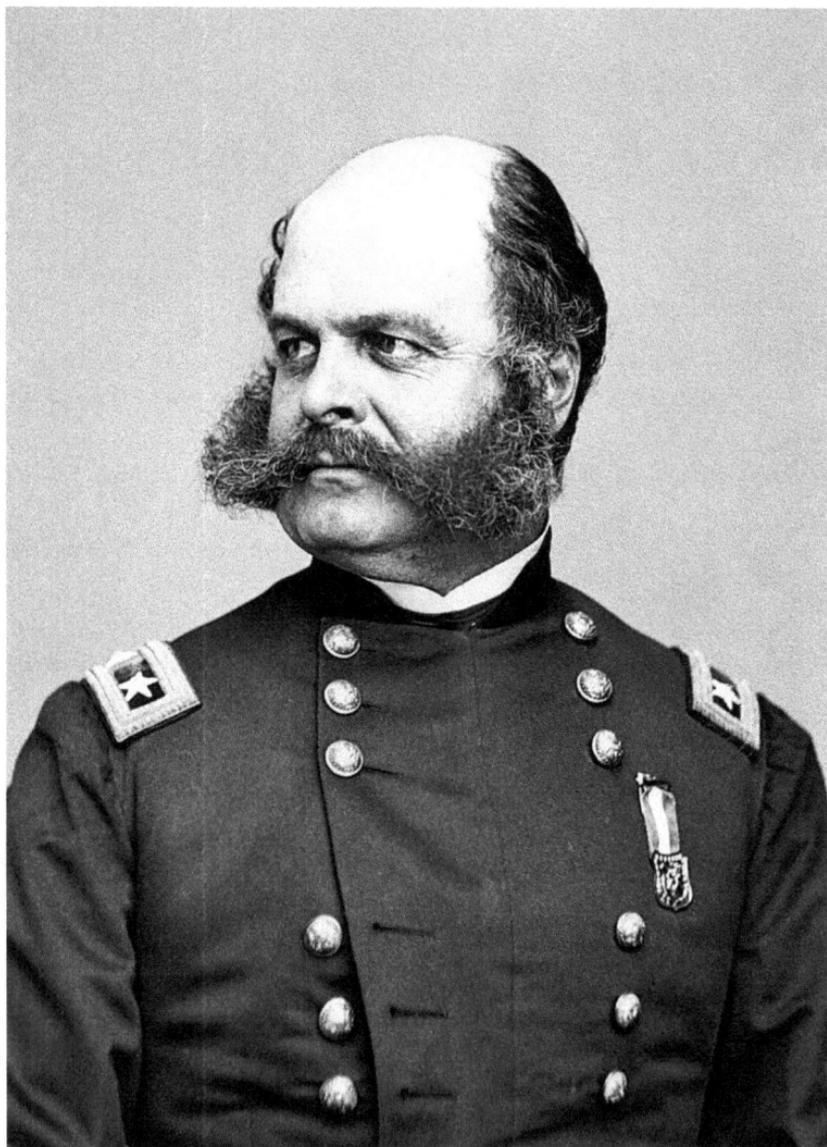

Some attribute Ambrose E. Burnside's Civil War military actions to "his own honest, humble, and trusting manner." *Courtesy of the Union County Historical Society.*

Burnside was born at Liberty in Union County to Edghill and Pamela Burnside. The name Ambrose was given in honor of the dead son of the doctor who delivered the boy on May 23, 1824. Ambrose helped on his father's farm while attending a one-room school.

In 1840, Ambrose became apprenticed to a tailor at Centerville. When his mother died, he returned to Liberty and opened a tailor shop about 1841. While tailoring, Burnside read *Cooper's Tactics*, a foretaste of his interest in the military. Brose, as some in the family called him, foresaw little future in tailoring. His father, by then a member of the Indiana General Assembly, asked Indiana governor Samuel Biggers to get Ambrose a military school appointment. It came in March 1843.

At West Point, Burnside acquired many demerits, mostly for minor infractions, but he did well in math. He graduated eighteenth among thirty-eight survivors in his class. Burnside chose the artillery for service. He was commissioned in the Third U.S. Artillery and left for Mexico, although the fighting there was mostly finished.

After Mexico, Burnside had several tedious assignments, including a tour in 1849 at Las Vegas, where he sometimes rode along with troops to protect the mail. Occasionally, there were fights with the Apaches of New Mexico, and he once was wounded in the neck by an arrow. During this period, Burnside got an idea for a new carbine rifle design. But the tour in Mexico had provided him with an intestinal ailment, which took him back to Liberty to recuperate. Burnside was back on active duty in May 1851. Duty at Fort Adams in Rhode Island resulted in meeting and marrying Mary Richmond. Burnside was twenty-eight years old and she was twenty-three.

In October 1853, Burnside resigned his commission and formed the Bristol (Rhode Island) Rifle Works to produce the Burnside carbine that he had conceived and designed. Government officials had promised to purchase the weapon for the cavalry, but that vow was broken, which bankrupted the rifle company. Burnside signed over all rights to the weapons to creditors in 1858. Eventually, fifty-five thousand of the carbines were purchased for use in the Civil War. Burnside also had become a major general of the Rhode Island Militia.

Faced with bankruptcy debts, Burnside moved to Minnesota, where booming railroad work offered employment. He found a clerk's job with an old West Point classmate, George B. McClellan, who was vice-president of Illinois Central. For about two years, Burnside lived in Chicago with McClellan while working off his debts. Eventually, Burnside became treasurer of the railroad and by 1860 was living with his wife in New York, site of the main offices, when Sumter was fired upon; he answered a call to resume command of the Rhode Island Militia and took the unit to Washington, D.C., one of the first state militias to arrive.

Burnside's first engagement in the Civil War was at the First Battle of Bull Run, where he was left in command when General Hunter was wounded. Although Burnside's troops were successful at first, the Confederates were reinforced and routed the army. During a period of inactivity that followed, the Rhode Island Militia was

Ambrose Burnside served in the militia in Rhode Island, where he resided, and posed for his reunion photograph with some troops in the unit. *Courtesy of the Union County Historical Society.*

mustered out at the end of its term of service, and Burnside was given command of other regiments assembled at Washington. As fall of 1861 approached, Burnside conceived the idea of taking troops by boat to Hatteras Island and thence inland to capture Confederate posts and to interrupt supplies to the South. The sea assault was successful.

The Union forces captured Roanoke Island, Beaufort, Fort Macon and the 6,000-citizen town of Newbern, which became headquarters. About 2,500 Rebels were captured. The commander returned to Washington on leave, much lauded for the effort, but he refused when President Lincoln asked him to replace McClellan as commander of the Army of the Potomac. Burnside said that he did not think he was competent for such an assignment. He soon organized the Ninth Corps, with which he was to be associated during much of the war.

Burnside had spurned Lincoln's second request that he replace McClellan in September 1862. But by November, when pressed a third time, Burnside accepted. He still doubted his ability but feared that the job otherwise might go to General Joseph Hooker, whom he disliked. Burnside also had long shown loyalty to the government and considered himself duty bound to obey at last.

Burnside was sent with the reorganized Army of the Potomac to meet the advancing General Robert E. Lee, whose troops Burnside dislodged at South Mountain. They retreated, and Burnside set up his army about thirty miles from the Confederates on the north side of the Rappahannock River. Burnside waited for pontoon bridges to span the river, which took several days. By then, the Confederates were 78,000 strong and dug in. Fourteen charges by Burnside's troops were unsuccessful, and an artillery barrage, made before the assaults, destroyed the town of Fredericksburg. Said Burnside in his report to superiors: "For the failure in the attack I am responsible." There were an estimated 12,700 Union soldiers killed or wounded before the retreat.

The army remained in winter quarters until January 1863, when Burnside determined to recross the Rappahannock and drive toward Richmond. But the moving troops were beset by two days of cold rain, which bogged them down in mud. Burnside issued Order No. 8, which

This Napoleon-like image of General Ambrose Burnside was taken at an unknown location sometime during his service in the Civil War. *Courtesy of the Union County Historical Society.*

sought to dismiss Generals Hooker, Brooks, Newton and Cochrane for nonperformance, and went to Washington to press Lincoln to honor the order. Instead, Lincoln said he was dismissing Burnside and replacing him with Hooker. The Hoosier said that this was fine with him—now he could go home. But Lincoln insisted that Burnside continue serving. Burnside did go to Providence on a thirty-day leave on January 27, 1863. When he returned, he was assigned to the Department of the Ohio, which included Ohio, Michigan, Indiana, Illinois and most of Kentucky. Burnside left Washington on March 22, 1863, to assume that command, taking rooms in Cincinnati.

Indiana required his attention. The state was ready for open rebellion because of the newly enacted Conscription Act. Kentucky also was developing rising support for the South, causing Burnside to move troops into that state. He also had to deal with the notorious raid by renegade John Morgan into Indiana and Ohio in July 1863; he left pursuit to other officers.

In Cincinnati, Burnside issued his controversial Order No. 38. It established a death sentence for such activities by the pro-Southern Copperheads as carrying secret messages, serving as agents behind Union lines and recruiting members for secret societies. Under the command, Burnside ordered the celebrated arrest of Clement Vallandigham for a speech in Ohio. Vallandigham was tried and banished to the South. When Burnside issued Order No. 84, suppressing distribution of the *Chicago Times*, which had supported Vallandigham, Lincoln cautioned Burnside to check with Washington before again sending troops to close down a newspaper.

On September 10, Burnside again asked Lincoln to relieve him. Burnside's troops had pushed into the South but, when attacked by superior forces, had retreated to Knoxville. Burnside was relieved of duty and spent time reorganizing his old Ninth Corps.

April 1864 saw him attached once more to the Army of the Potomac, now under Grant's command. This culminated in the siege of Petersburg, Virginia. A plan was formulated to tunnel under the fort at Petersburg and set off a blast, followed by an attack. It took days to dig the tunnel. When the blast was set off, Burnside was to attack, but the assault failed. General George Meade, in charge of the operation, ordered a pullback. Burnside blamed Meade for the failed assault, an outburst that brought orders for a court-martial of Burnside. Grant intervened, however, and a mere court of inquiry was held. The court, which had four officers friendly to Meade, found Burnside answerable for the failure.

Again Burnside's offer to resign was rebuked. So, after a furlough, during which he worked on railroad business and traveled to New Hampshire to visit his wife, Burnside returned to Washington, working on a report on his military career; Lincoln had given him no assignment. In 1865, the Committee on the

Conduct of the War found that Meade had indeed interfered with Burnside's plans at Petersburg and that the Hoosier was without fault. Burnside again tendered his resignation on the last day of President Lincoln's life; the assassination ended Burnside's career. Lincoln's successor, Andrew Johnson, accepted Burnside's resignation, retroactive to April 15, 1865. Burnside sat with other military leaders in the East Wing of the White House at the Lincoln wake, but he was in civilian clothing.

Less than a year later, Rhode Island elected Burnside governor by a threefold majority. It reelected him to that office, which was mostly part time, in 1867 and 1868. Burnside continued to work for the railroad. Once he visited Paris on railroad business.

On March 5, 1875, Burnside took his seat in Congress as a senator from Rhode Island. That summer Brown University gave Burnside an honorary degree. In March 1876, Burnside's wife died at the age of forty-seven. The Hoosier threw himself into his Congressional work.

When President Garfield was shot, Congress recessed and Burnside returned to his summer place near Bristol, called Edghill. On September 12, 1881, after attending dinner at a senator's house, Burnside went home and experienced chest pain while dressing for bed. At dawn, he was still pacing in discomfort, unable to sleep. A doctor arrived about 10:00 a.m. on the thirteenth. Burnside threw himself on his bed and asked for morphine. At 11:05 a.m. he died.

Services were held in St. Michael's Church in Bristol, and then Burnside's body lay in state in city hall in Providence. One of the pallbearers wore sideburns. Burnside was buried in Providence.

Once when Burnside had been urged to publicly respond to his critics, he said, "I have simply to do my duty. I can safely leave any claim that I have to judgment of future years and the justice of my fellow countrymen." And so the tall Hoosier, well liked by Civil War foot soldiers and beloved by his adopted state, died without ever knowing that his name was memorialized, not so much for his actions, but because of the whiskers descending from his bald head.

INDELIBLE
DIPLOMATIC IMPRINT

John Watson Foster

One of the strongest characteristics of genius is the power of lighting its own fire.
—John Watson Foster

John W. Foster was considered the dean of diplomats in his day. Although some might question some of his associations and activities, his loyalty to the United States as secretary of state and his willingness to serve were never doubted. John Watson Foster began a sort of government dynasty. His son-in-law and law partner, Robert Lansing, was also secretary of state and so was his grandson, John Foster Dulles. Before becoming secretary of state, the Hoosier Foster was ambassador to several countries and represented the United States in several arbitrations. Some viewed his representation of foreign legations in the United States in private life as a conflict of interest. But his stature and integrity evidently overcame any hint of scandal. Foster was dubbed the first professional diplomat.

His service in the Civil War, Foster reported, convinced him of the idiocy of war, but as a diplomat he seemingly never shrank from force or its threat to achieve a purpose. Foster became rather wealthy from his robust Washington law practice. He was named secretary of state by President Benjamin Harrison, a fellow Hoosier, when Joseph G. Blaine became ill. Before that, Foster had worked ex-officio in the secretary of state's office and also in his home on development of treaties.

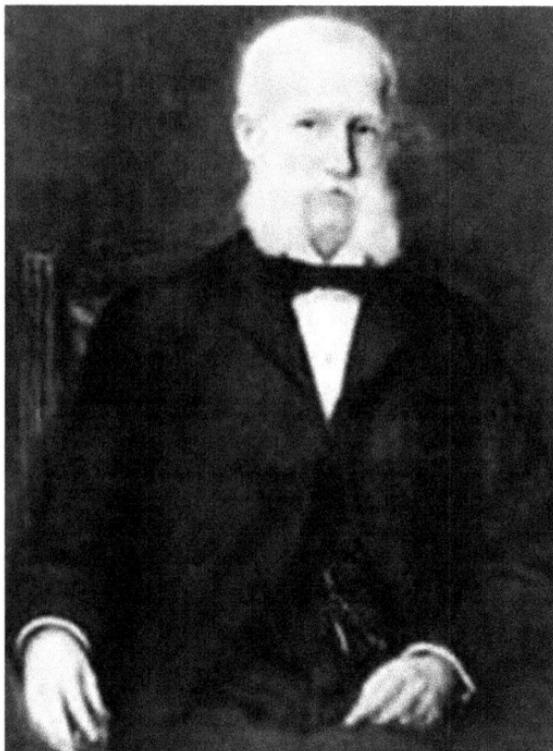

One of John Watson Foster's diplomatic posts was located in Mexico, where he added Spanish to his knowledge of Latin and Greek.

Life for Foster began on March 2, 1836, in a two-room log cabin in Pike County built on eighty acres by his twice-married and onetime probate judge father, Matthew Watson Foster. Young John had opportunities unusual for the era. He attended a German school and then a private academy. He graduated from Indiana University at nineteen in 1855 as valedictorian of his class. Law school at Harvard was his next stop.

He evidently spent a year at Harvard and then some time in a law office in Cincinnati. But he soon returned to Evansville to the firm of Conrad Baker. The Civil War was brewing. As the call for men increased, he enlisted on July 24, 1861, one of the 1,046 members of the Twenty-fifth Indiana. Primarily because his father had pushed Republican organization in southwest Indiana, Republican governor Oliver P. Morton made Foster a major.

Service at Fort Donelson in Illinois brought Foster promotion to lieutenant colonel, and then he became a full colonel under

General Ulysses S. Grant at Shiloh. He took over command of state troops at Evansville.

Foster was called from duty by the death in Tennessee of his brother-in-law, Lieutenant Alexander McFerson. Foster took the body back to Evansville for burial. After service at Knoxville with General Ambrose Burnside, a fellow Hoosier, Foster was called from the front again by the death of his father. When handling the estate took longer than expected, Foster resigned his commission.

By the spring of 1864, Governor Oliver Morton, a major Hoosier figure in the war, summoned Foster to help support General William T. Sherman. Foster agreed to serve for one hundred days in Kentucky and Tennessee. "But my life in the Army did not alter the views I had formed in my college life of the horror and brutality of war, but rather strengthened and confirmed them," Foster said.

After the war, Foster joined his brother in the grocery business in Cincinnati, but that was short-lived. Then he bought interest in the *Daily Journal* in Evansville. He served on the paper until 1869. That year he was appointed, courtesy of Morton, as postmaster at Evansville. In 1872, he became chairman of the Republican State Committee and a delegate to the national convention in Philadelphia. Foster meanwhile had met and married Mary Parke McFerson, who was well educated. Like her husband, she was a student of the classics and a linguist.

Ulysses S. Grant was elected president in 1872, and Morton, now a senator who had supported him, told Foster to pick any appointive office that he desired. The Fosters chose Switzerland, but when it was found that this post had been promised to somebody else, Foster was sent to Mexico. Foster served seven years in Mexico, although he knew Latin and Greek but not Spanish.

In 1880, President Rutherford Hayes, whose presidential campaign had been aided by Foster during a short return to the United States in 1876, sent Foster to Russia, where he spent about a year. Foster was shocked when Alexander II was killed by a bomb, and in August 1881, he took a leave to return to America and shortly resigned.

Foster, now a private citizen, did well in law practice in Washington. Foster's son-in-law, Lansing, eventually joined him in

the law firm. When Chester A. Arthur became president after the assassination of James Garfield, Foster became minister to Spain in 1883. In 1884 and 1888, Foster supported his good friend Walter Q. Gresham for president, but both times Benjamin Harrison got the nomination. Ben lost in '84 but won in '88.

Both Foster and Lansing worked ex-officio on treaties for the state department, and Foster worked as advisor to Harrison. Foster had traveled to Cuba as representative without portfolio and routinely met with state department representatives. So when the ailing Blaine quit in July 1892, fellow Hoosier Harrison appointed Foster. Some considered it a conflict of interest that lawyer Foster represented foreign nations making claims against the United States. Wrote one biographer, "At times it proved difficult to distinguish his public service from his private practice." But the press mainly found him sensible and businesslike.

Foster's initial job in his new role was to forestall war with Chile, a threat arising from of the death of two U.S. sailors and the wounding of seventeen during a fight in Santiago harbor. A Foster memo helped avoid the conflict, with the United States getting reparations. Foster was in Harrison's cabinet from June 29, 1892, to February 23, 1893.

Grover Cleveland won election a second time in 1892, and Foster passed off the secretary of state reins to his old friend Walter Gresham. Three years later, civilian Foster was sent to the Chino-Japanese War Peace Conference at Shimonoseki, Japan. Foster helped conclude a treaty appreciated by the Chinese and still managed to retain the friendship of Japan.

Li Hung Chang, the plenipotentiary agent, wanted Foster to stay as an advisor to China, but the Hoosier declined. Foster emerged from the Japan conference as an expert on East Asia. Soon he was to write *American Diplomacy in the Orient*, one of several books. He began representing the Chinese legations in the United States. In 1907, at the Second Hague Conference, John Foster Dulles went to the conference with his grandfather, serving as secretary to the Chinese.

The bond between Foster and Dulles was strong. When Dulles was thirteen, Foster gave him a twelve-foot catamaran boat;

the entire family was fond of boating. When Dulles graduated, his grandfather's letter got him a job. Dulles, whose father was the Reverend Allen Macy Dulles, might have gone into the ministry—his family wanted it—but for the example of his granddad.

Nor did Foster overlook his son-in-law, Lansing. Foster prevailed on a friend to recommend Lansing for a job in the secretary of state's office, where he advanced to secretary of state under President Woodrow Wilson.

In 1897, Foster was made a special ambassador by the McKinley administration. Foster met fellow Hoosier John Hay on a trip to London, where Hay was U.S. minister. The pair met again when Hay became secretary of state under McKinley and Theodore Roosevelt. "You know what the place requires better than I do," Hay was quoted as saying.

Foster had declined McKinley's request to serve as ambassador to Peking, Madrid or Constantinople. But he continued to aid the State Department. He assembled a six-hundred-page presentation of the case for the United States, complete with maps and charts, in a dispute with Britain over the Alaskan-Canadian boundary. The United States prevailed.

Foster was meanwhile amassing a fortune through his Washington law practice, at times representing Spain, Russia, China, Chile and Mexico. Foster's trip to the Second Hague Conference, representing China, was his final journey outside the country.

Within a decade, at eighty-one years of age, he was rewriting his will to make Lansing and Dulles executors of an estate valued at almost $500,000. He often had said that diplomats must be gentlemanly. "A boor in manners, or one disagreeable instead of affable in his demeanor, can hardly expect to make himself popular in social circles or even hope to be successful in the dispatch of the business of his country."

Foster was a devout Presbyterian and considered Christianity a major force in the world. Although no spellbinder, Foster gave numerous speeches and lectured at George Washington University. He wrote for periodicals and also wrote *Arbitration and the Hague*

Court, The Practice of Diplomacy, Diplomatic Memoirs and *War Stories for My Grandchildren.*

He had been a founder of the American Society of International Law, the Carnegie Endowment for International Peace and the American Red Cross. While secretary of state, Foster had proposed that foreign ministers take competitive exams and urged that merit be considered in appointments to government service.

During the later years of his life, Foster became ill and reclusive. He destroyed most of his personal papers. A year before his death, Foster received the Order of the Golden Grain from China in commemoration of thirty years as an advisor. Death came on November 15, 1917. Lansing took the body to Evansville, where an abbreviated service was held because, as secretary of state, Lansing had to return to Washington quickly. Foster was buried in Oak Hill Cemetery in Evansville. He had been called distinguished and a master of backroom bargaining.

"Few may be able to enter the diplomatic service," Foster said, "but every citizen may exercise an influence in so shaping our foreign policy that the government shall continue to occupy a worthy position among the nations of the earth."

ABOUT THE AUTHOR

Fred D. Cavinder is the author of five books on Indiana topics, the first appearing in 1985 and others following in 1990, 2003, 2005 and 2007. He is retired after thirty-seven years as editor, reporter and feature writer at the *Indianapolis Star* newspaper, during which he served sixteen years as editor of the paper's Sunday magazine supplement. His photographs and articles have appeared in numerous regional, state and international publications.

Photo by Chris Cavinder.

Visit us at
www.historypress.net